Conversations with Cinematographers

David A. Ellis

THE SCARECROW PRESS, INC.
Lanham • Toronto • Plymouth, UK
2012

Published by Scarecrow Press, Inc.
A wholly owned subsidiary of The Rowman & Littlefield Publishing Group, Inc.
4501 Forbes Boulevard, Suite 200, Lanham, Maryland 20706
http://www.scarecrowpress.com

Estover Road, Plymouth PL6 7PY, United Kingdom

British Library Cataloguing in Publication Information Available

Library of Congress Cataloging-in-Publication Data

Ellis, David A., 1947–
 Conversations with cinematographers / David A. Ellis.
 p. cm.
 Includes index.
 ISBN 978-0-8108-8126-6 (cloth : alk. paper) — ISBN 978-0-8108-8127-3 (ebook)
 1. Cinematographers—Interviews. I. Title.
 TR849.A1E45 2012
 777.092'2—dc23 2011026407

To my wonderful wife, Margaret;
my late caring father, John Arthur Ellis;
my late caring aunt, Violet Dimeloe;
my two lovely stepchildren, Nicky and Tracy;
and my two wonderful grandchildren, Chloe and James.

The British Society of Cinematographers (BSC) was formed just over sixty years ago. The founding members came from the prevailing studios, Elstree, Pinewood, and, in my case, Ealing Studios. At the time there were only about twenty or thirty of us, but since then the numbers have grown considerably, particularly since the beginnings of the independent productions that were developed after the 1950s. Sadly a lot of the original members are no longer with us, but the standards set by them have been more than kept up by the new generations who have also taken full advantage of and contributed to the new developments and techniques that have appeared since then. In the ever-changing world of cinema and the rapid application of new technologies, I am confident that the BSC will continue to play its full part in the new era.

—Douglas Slocombe

Contents

Acknowledgments

Thanks to Lucas Film and Dreamworks for permission to use the photograph of Douglas Slocombe and Steven Spielberg (front cover) on *Raiders of the Lost Ark*.

Thanks to *American Cinematographer* magazine for permission to reproduce "Artistry and Conscience" by Mark Hope-Jones and a question-and-answer session by Bob Fisher.

Thanks to Alan Lowne (Laws Publishing) and Stuart Walters (Open Box Publishing), publishers of *British Cinematographer* magazine, for permission to use pieces on Anthony Dod Mantle and Chris Menges by Ron Prince, editor of *British Cinematographer* magazine.

Thanks to my wife, Margaret Ellis, for her great help in putting it all together.

Introduction

In this book we have twenty masters of the moving image speaking about their life behind the camera, producing some of the greatest movies of all time. In these pages they talk about the great directors they have worked with, the artists they have photographed, and much more.

Conversations with Cinematographers takes you behind the camera, giving a glimpse of the goings-on that produce great cinema.

CHAPTER 1

Billy Williams, OBE

(1929–)

Billy Williams was born on June 3, 1929, in Walthamstow, London. His father, Billy senior, was a cinematographer, and young Billy became his father's assistant at the age of fourteen.

After working in documentaries, he got a job in television advertising and then features. He went on to win a number of awards for his work, including an Ocsar for *Gandhi* (1982). Williams taught cinematography at the National Film Theatre (NFT) starting in 1978. He became a member of the British Society of Cinematographers (BSC) in 1967 and was president from 1975 to 1977. He has appeared in two documentaries, *Behind the Camera* (2000) for the BBC and *Reflections on Golden Pond* (2003). Williams says that on the first day of shooting *On Golden Pond*, Katharine Hepburn wanted to shoot in the clothes she turned up in. There was an argument between her and the director because he wanted her to wear something different and she insisted filming in what she was wearing. In the end she relented. Williams believes this was a test by Hepburn to see if the director was confident enough to stick to his guns. Apparently she had tested other directors. In 2009 he was given the OBE for services to the film industry, which was given to him by the queen.

I understand your father was a cinematographer. Which films did he work on?
He started in the film industry in 1910 at a studio in Walthamstowe, London. He went into the navy during the First World War and filmed the surrender of the German fleet at Scapa Flow in 1919, which is archive material now. He then went on to shoot documentaries. They included expedition films, *Cape Town to Cairo* in 1928, an endurance test for General Motors, and feature films in the 1920s and '30s. So I grew up surrounded by film equipment, cameras, lenses, and filters. When I left school during the war, I became my father's apprentice.

Did you always want to work with films because your father was in the business?
I left school at fourteen and didn't know what I wanted to do. I had been immersed in films for as long as I could remember, so it seemed a natural thing to do. I had a choice, actually, because my mother wanted me to go into something more secure. I had an offer to go into the city and work for a stockbroking firm, but I decided that might be rather dull, so I decided I would take the chance and go with my father.

That was at the age of fourteen?
Yes. It was very young to make a decision like that, but that was the school-leaving age during the war.

How long did you work with your father?
I was with him for about four years. The highlight was going to East Africa at the age of seventeen to make educational films for the Colonial Film Unit.

I spoke to Sir Sydney Samuelson, who also worked for them.
He came a year after. It was a good training ground. It was a marvellous experience living under canvas and in mud huts at that age and really living in the wild.

How did you get into feature films?
I always wanted to get into feature films, but in those days features were like the premier league, and I wasn't in the premier league. To move from being a documentary filmmaker to moving into features was almost impossible. It rarely happened unless you trained under the studio system as a clapper/loader and then focus puller. What happened to me was I did my national service after I'd worked for my father and was a photographer in the RAF.

When I came out, I found a job with British Transport Films. They made films about all forms of transportation. I was there for five years and then decided it was time to make a break. I then got an offer to photograph a film for the Iraq Petroleum Company in Europe, so I left this regular job and invested all my savings in a 35mm Arriflex camera. I was literally following in my father's footsteps because he always owned his own cameras. You did in those days because there weren't any rental companies. It was long before Samuelson's, so I invested all my savings in this camera and went off to shoot the film in Europe. That was followed by another film for the same company in Iraq. That was a marvellous experience, going to Iraq and Syria. Then I spent a few years in various documentary films and was still hoping and trying to get into features, but nothing was happening. In the 1950s commercial television arrived, and I got an offer to work for a commercials company. I started off with just a day here and

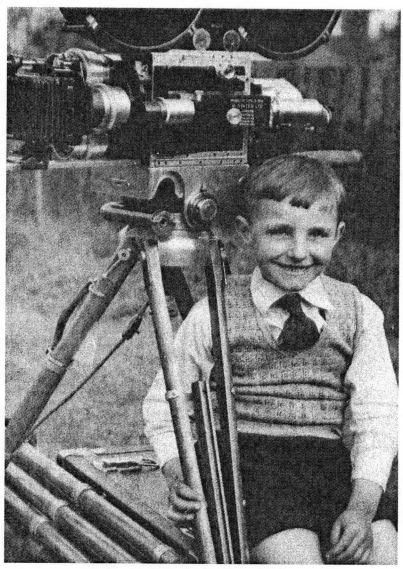

Billy Williams as a boy. *Courtesy of Billy Williams*

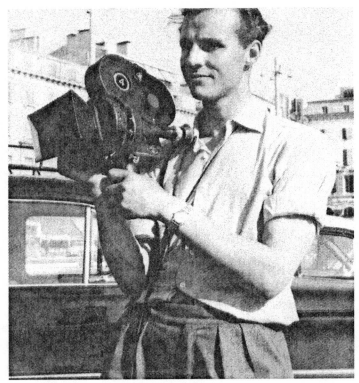

Billy Williams with Arri camera. *Courtesy of Billy Williams*

a day there, and it soon became quite a regular job. It was a firm called Television Advertising. They worked in the basement of premises in Wardour Street, London. I then started to learn something about lighting. During my stay there, I worked with a number of people that went on to become well-known directors. There was Ken Russell, John Schlesinger, and Ted Kotcheff. A few years after I worked with them on commercials, I was fortunate enough to shoot feature films for them.

My first feature film was in 1965. It was a silent film in black and white with original music by Burnell Whibley, conducted by Ron Goodwin. It was a comedy with a lot of actors from the *Carry On* series called *San Ferry Ann*. I got the job through David Anderson, who I had worked with on commercials. He was the film's production manager. I did several low-budget feature films, and then I got a big break through Ken Russell. He was going to do a film for Harry Saltzman called *Billion Dollar Brain* (1967) with Michael Caine. A very well-known cinematographer called Otto Heller [1896–1970] had been engaged to photograph the picture. Well, there was going to be a lot of work in Finland

during the winter, and it was going to be extremely cold, so the production manager, Eva Monley, insisted that Otto was to have a medical, which he refused. They couldn't insure him for the picture, so this left an opening. Harry Saltzman said to Ken Russell, "Who do you want to photograph it?" and Ken asked for me. I went along and was able to get a reel or two of a film I'd been doing with director Tony Richardson called *Red and Blue* (1967), which was a musical. They kind of liked it, and Harry Saltzman said, "Well, let's give the kid a break." I was then thirty-eight years old.

You bypassed the focus puller and operator stages?
I operated in documentaries. It's just a two-man crew in documentaries. So I was never a studio operator or a studio focus puller. I did *Billion Dollar Brain* with Ken, which was in Finland and at Pinewood Studios. There were huge sets at Pinewood, which I found quite daunting, but I had a wonderful gaffer by the name of Johnny Swann and a wonderful operator, David Harcourt [1915–], who became a life-long friend. It was quite nerve-racking working on that scale because I hadn't any experience of working in a big studio. My next notable film was *Women in Love* (1969), with Ken Russell as the director. This was the best visual script I ever had. It had all the opportunities that you could wish for as a cinematographer. It had, in addition to straightforward day interiors and day exteriors, night interiors, night exteriors, and a very extended magic hour scene. It had a lot of firelight and candlelight and then a very long sequence in the snow in Switzerland. So it was a very broad and interesting palette to work with. I talked to Ken about this, and he was in full agreement that we should go for very strong colour effect like the colour of firelight, which is very orange. In the famous wrestling sequence, I filtered all the lamps to be the same colour as the fire and created a flickering effect.

The wrestling scene with Alan Bates and Oliver Reed was played in a large room on location.

How long did it take to shoot the wrestling sequence?
They only did one day fully nude, and then we did another day from the waist up. We shot it with two handheld Arriflex cameras shooting mute, which gave us great mobility to follow the action. We had two days to shoot it. Shortly after that we went off to Switzerland. When we came back, the editor said to Ken that we need something more. Ken wanted to do a sequence in high speed, but we no longer had the location. All we had was the rug they had been wrestling on, so we went to a little studio in Merton Park, London, and I recreated the effect of the flickering firelight. By using the same techniques of lighting, shooting everything very close, and just having a couple of dark flats, candles, and the rug, it cut together perfectly.

Where in the world have you been on location?
I have been to most countries in Europe. I have been to Mexico a couple of times to shoot westerns. The first one with Dennis Hopper was called *Kid Blue* (1973), which was very exciting. A few years later I did another, which was a British western for the Rank Organisation called *Eagles Wing* (1979), which I won the British Society of Cinematographers (BSC) Best Cinematography Award for.

You liked working on westerns?
I loved working on westerns. I love horses, and they are so visual. I also liked the landscape. I went to India for *Gandhi* and was absolutely enthralled with the landscape and the people. It was the story of this remarkable man, and we tried to stay as close as we could to his life in all regards really. We looked at hours and hours of newsreel material, and the actors were all cast to look like the characters. Ben Kingsley was just remarkable as Gandhi. When he played the old man in his seventies, he remained the old man in rehearsals and on the set. He stayed in character even when he wasn't acting.

There were times after we had lined up the shot, I thought, "Oh dear, we are going to take a little while to set this up." I then said to Ben if he would like to sit down for a while, we would set up. He would smile at me and nod his head. He was thirty-six years old. He was so convincing as the old man.

How long did it take to shoot *Gandhi*?
I think it was about twenty-three weeks. Unfortunately I suffered a slipped disc, and I had to go back to the U.K. for treatment. Fortunately cinematographer Ronnie Taylor was able to take over, and he shot a lot of the picture. Eventually I went back to finish it, and we shared the credit.

A few weeks prior to shooting *Gandhi*, I was working on *On Golden Pond* (1981), starring Katharine Hepburn and Henry Fonda. I got an Oscar nomination for *Women in Love* and another for *On Golden Pond*. I then got lucky with *Gandhi*, receiving an Oscar. Ronnie and I got an Oscar each. *On Golden Pond* was a memorable experience, working with Katharine Hepburn and Henry Fonda.

What were they like to work with?
They were absolutely delightful. She was very opinionated; she was a driving force, an absolute dynamo. I think she was seventy-three years old, and she had so much energy. Henry Fonda was about seventy-six and not in very good health. He was no problem at all; he would do anything you wanted. Hepburn could be very feisty and determined to get things her way. It was a marvellous experience. It was shot in an idyllic location in New Hampshire, U.S.A., and I stayed on the other side of the lake where we did all the filming. The whole film

was shot on location. We shot in this beautiful house on the edge of the lake, and again it was a film with lots of interesting opportunities. With the interior being on location, we were able to link up the interiors with the exteriors in a way you can't do in the studio. It was just a delightful film, a happy experience.

Did you have a favourite director you worked with?

Well, when you say *favourite*, all directors are different. Some are more demanding than others, but in the end you feel it was worth it all because you get good results. Ken Russell was very demanding and very imaginative, but I was prepared to stand my ground quite often with him and stick out for what I thought we ought to do. There was one particular case in *Women in Love* where there is a long, complicated scene with Alan Bates, Oliver Reed, and Glenda Jackson, all the principles sitting around a very long table under a beech tree. It is a scene with a fig. If you look towards Alan Bates, he was in complete silhouette with a very bright background behind him. When you look in the opposite direction towards Oliver Reed and Glenda Jackson, you had much more of a balanced picture. So I said to Ken, "I've got to put some lighting here to bring up the shadows on Alan Bates." He said, "No. I don't want you to lose light; I don't want it to look as though it is lit." I said to Ken, "I would light it so you won't know I've used any lights." I had a huge twelve-foot square white silk, which I shone a couple of brutes through. It was a very soft, diffused light, and it didn't look lit at all, and it just created a good balance so the scene cut together well. In the end he was pleased, but I had to fight for that.

Another very interesting director was John Schlesinger. A year or so after shooting *Women in Love*, I shot *Sunday Bloody Sunday* (1971). I got a BAFTA nomination for that as I did for *Women in Love* and *Gandhi*, but I never won a BAFTA. John came to a screening of *Women in Love* and invited me over to his office to discuss his next film. He asked me if I would shoot *Sunday Bloody Sunday*. He said, "I don't want you to do anything as colourful or flamboyant as *Women in Love*. This is a much more intimate piece." So it was a different style based in London and in a few small studio sets but again shot mainly on location. I think I have been happier on location, although I have done quite a number of studio pictures, too. I like the challenge of location and the unexpected, finding something you haven't anticipated, something that perhaps wasn't in the script.

There was a scene in *Women in Love* which was written as a straightforward scene between Alan Bates and Oliver Reed. We found a room on location in the same house as we shot the wrestling scene, and it had mirrors all the way around, and we used the mirrors, which gave us a very interesting effect. An art director would never have designed a set like that, so things like that made working on location a bit more exciting.

Did you not want to direct yourself?

I directed a few commercials, but no, I didn't feel I had the talent or the experience. Working with and understanding actors is the most important role of the director. Also being able to interpret the screenplay is important, and I didn't feel that I had the background. I was happy to stay as a cinematographer.

Another director I enjoyed working with very much and I did two pictures with him was Guy Green, who had been a cinematographer before going into direction. He was a lovely man and very good to work with. He let me do my own thing; he didn't tell me how to do it. Sometimes I wonder if it would have been better if he had given me a few hints.

Which was your most difficult film?

I suppose *Women in Love* was really my most difficult because I was doing things I hadn't done before, except in an experimental way in commercials. That film was difficult but worth it because it was so rewarding, and Ken was such an inspiration and sort of great visionary. He had wonderful vision. So that was all worth it. *Gandhi* was difficult physically, but an even more difficult picture from the physical point of view was a film I shot in Montreal, Canada, in the winter and then in the Arctic. It was a film called *Shadow of the Wolf* (1992). It was very difficult because we were shooting in extreme cold and igloos—real igloos and igloos that were created in the studio. That was difficult, and we weren't rewarded by a good movie at the end of it.

Have you a favourite film you have worked on?

I think *Women in Love*. Another thing that may be of interest is that in 1978 Colin Young, who was the director of the National Film and Television School at Beaconsfield, England, invited me to go and do a workshop, and that sort of opened a new chapter for me. I became very interested in talking to students, showing them a few tricks, and giving them encouragement. It led to a second career because ever since, I have done workshops, seminars, and master classes in many countries. One of the highlights of my career was in 2000. Camerimage in Poland presented me with a lifetime achievement award, which I thought was very thrilling and exciting. In 2001 the ASC presented me with the International Award, which was for a cinematographer who has mainly worked outside the U.S.A. I have worked in the U.S.A. quite a lot, but the majority of my films have been in the U.K.

What was it like working with Sir Richard Attenborough on *Gandhi*?

He was a lovely man. He was wonderful with the actors, very caring and considerate. I really liked working with him. Everyone called him "Dickie."

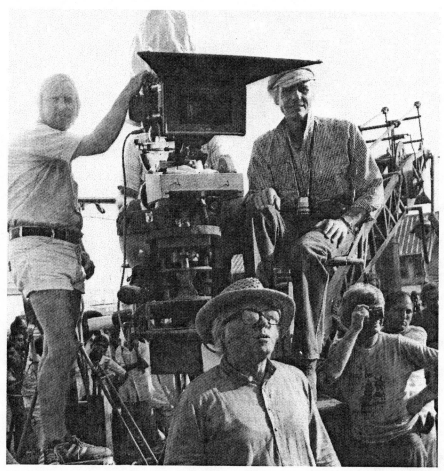

Billy Williams and Richard Attenborough on the set of *Gandhi* (1982). *Courtesy of Billy Williams*

What awards have you won?

I have an Oscar for *Gandhi*, and I have Oscar nominations for *Women in Love* and *On Golden Pond*. I have BAFTA nominations for *Gandhi*, *Sunday Bloody Sunday*, *Women in Love*, and *The Magus* (1968). I have BSC nominations for *Billion Dollar Brain* and *Sunday Bloody Sunday*. I also won the BSC award for *Eagle's Wing* and *Gandhi*.

Peter Yates was another director I enjoyed working with. I shot *Eleni* (1985) with him in Spain and *Suspect* (1987), a courtroom drama with singer Cher, which was shot in Washington.

Another picture I enjoyed working on was *The Wind and the Lion* (1975) with Sean Connery and Candice Bergen, which was shot in Spain with a lot of action scenes. It was written and directed by John Milius. I played a small part in that as the British consul Sir Joseph. The film was set in Morocco, and I had an action scene where I had to do a lot of shooting with an automatic. I was all dressed up in a white suit and Eaton tie. I had to shoot Berbers who were intent on kidnapping Eden Pedecaris, played by Candice Bergen. That was a departure for me.

Did you enjoy acting?
I did. It was quite difficult being in front of the camera because there are so many things you have to remember. At one crucial point there was a stunt setup with five cameras on it, and I had to fire the gun at a certain point. I did everything else except fire the gun. The stunt happened, and I hadn't fired, so we then had to shoot it from different angles to cover the scene.

Why were you asked instead of an actor?
I don't know. Perhaps he thought I looked like a British diplomat. I just walked into the office one day. He was casting. He looked up and said, "You can play Sir Joseph." I said, "What are you talking about, John? I am not an actor." He said, "Oh yes, you can do it." So I played Sir Joseph, which was a lot of fun.

A few years later when I was working with Peter Yates on *Suspect*, we didn't get to a scene in the courtroom. We had an actor cast, but he wasn't available the next day, so I stood in for him. So I had another small role in front of the camera.

I did two pictures with Elizabeth Taylor [1932–2011], and that was great fun. She's such a nice person. I had never worked with anybody who was so good technically. Whatever you told her to do, she would do it, and she would get it right the first time. She just knew so much about the camera, and she was just great fun.

When did you retire?
I decided to retire on New Year's Day 1996. For a while I missed the buzz of it, but I was able to continue with the work with students, so I spend a few weeks a year with them, which keeps me in touch with what is going on and the latest developments.

Did you do blue screen work?
I did a certain amount of blue screen work. I wasn't a specialist in that department. A specialist would sometimes be brought in. I retired before the advent of digital, so my experience of digital is really through being with students and going to places like Camerimage, where they have all the latest technology on display.

Do you have hobbies?

I've always been interested in carpentry. I was good at it at school, and I have always enjoyed working with wood. When I retired I bought a lathe, and so I became a wood turner and made bowls. I also enjoy the garden.

I feel I have been very lucky to have had a career in filmmaking, which has been the most satisfying, rewarding, exciting job I can imagine.

Filmography

San Ferry Ann (1965, Jeremy Summers)
Red and Blue (1967, Tony Richardson)
Just Like a Woman (1967, Robert Fuest)
Billion Dollar Brain (1967, Ken Russell)
30 Is a Dangerous Age, Cynthia (1968, Joseph McGrath)
The Magus (1968, Guy Green)
Two Gentlemen Sharing (1969, Ted Kotcheff)
Women in Love (1969, Ken Russell)
The Mind of Mr. Soames (1970, Alan Cooke)
The Ballad of Tam Lin (1970, Roddy McDowall)
Sunday Bloody Sunday (1971, John Schlesinger)
Zee and Co (1972, Brian G. Hutton)
Pope Joan (1972, Michael Anderson)
Night Watch (1973, Brian G. Hutton)
Kid Blue (1973, James Frawley)
The Glass Menagerie (1973, Anthony Harvey)
The Wind and the Lion (1975, John Milius)
Voyage of the Damned (1976, Stuart Rosenberg)
The Devil's Advocate (1977, Guy Green)
The Silent Partner (1978, Daryl Duke)
Boardwalk (1979, Stephen Verona)
Eagle's Wing (1979, Anthony Harvey)
Going in Style (1979, Martin Brest)
Saturn 3 (1980, Stanley Donen)
On Golden Pond (1981, Mark Rydell)
Monsignor (1982, Frank Perry)
Gandhi (1982, Richard Attenborough)
The Survivors (1983, Michael Ritchie)
Ordeal by Innocence (1985, Desmond Davis)
Dream Child (1985, Gavin Millar)
Eleni (1985, Peter Yates)
The Manhattan Project (1986, Marshall Brickman)
Suspect (1987, Peter Yates)
The Lottery (1989, Garry Marshall)

The Rainbow (1989, Ken Russell)
Women and Men: Stories of Seduction (1990, Frederic Raphael, Tony Richardson, and Ken Russell)
Stella (1990, John Erman)
Just Ask for Diamond (1990, Stephen Bayly)
Shadow of the Wolf (1992, Jacques Dorfman and Pierre Magny)
Reunion (1994, Lee Grant)
Driftwood (1997, Ronan O'Leary)
Ljuset Haller Mig Sallskap (2000, Carl Gustav Ngkvist)

Awards

Women in Love (1969), Oscar nomination and British Academy of Film and Television Arts nomination
Sunday Bloody Sunday (1971), British Academy of Film and Television Arts nomination
Eagle's Wing (1979), British Society of Cinematographers Best Cinematography Award
On Golden Pond (1981), Oscar nomination
Gandhi (1982), Oscar for Best Cinematography and British Academy of Film and Television Arts nomination
2000, Camerimage (Poland) Lifetime Achievement Award
2001, the American Society of Cinematographers International Award

Douglas Slocombe, OBE, BSC, FBKS

(1913–)

Douglas Slocombe was born on February 10, 1913, in London. He stands as one of the finest cinematographers of the twentieth century. He was educated in England and France. After leaving university, he followed his father, George Slocombe (1884–1963), into journalism and went to work for the British United Press in Fleet Street, London. His father was a Paris correspondent and during his time wrote several books, interviewed Hitler and Mussolini, and was instrumental in getting Gandhi released from jail. Slocombe went on to become a successful photojournalist, culminating in 1939, photographing reports of the Nazi infiltration of Danzig.

In 1940, he went to Ealing Studios in West London. He was one of four lighting cameramen employed on a contract basis. He worked on several documentaries, including *Find Fix and Strike* (1939). He went on to shoot a number of Ealing features before freelancing on some of the best films that have ever been made.

Slocombe was nominated for three Oscars. In 2002 he received the American Society of Cinematographers International Achievement Award. He was one of the founders of the British Society of Cinematographers and was given a lifetime achievement award from them and, after, several best picture awards. His last film was Steven Spielberg's *Indiana Jones and the Last Crusade* (1989), and he said it was his last crusade. In February 2010 there was a British Academy of Film and Television Arts tribute to him. Some of the people who spoke included songwriter Tim Rice; actors Harrison Ford, James Fox, and Vanessa Redgrave; and producers Norman Jewison and Michael Deely. Director Steven Spielberg also paid tribute. Spielberg had admired Slocombe's work, especially on *Julia* (1977), and asked him if he would photograph the final portion of *Close Encounters of the Third Kind* (1977) in India. Later, Spielberg wanted Slocombe for *Raiders of the Lost Ark* (1981).

He is nearly blind due to laser treatment that went wrong.

What age did you leave school, and why did you become a journalist?
I was educated in England and France, and after my education I came to England in search of a career. I was twenty-one. It was expected I would follow my father's career as a journalist, who was a Paris correspondent. I wasn't sure which direction to take, and I was interested in photography and cinematography. I used to run a movie show at school, and I used to shoot 16mm film. I tried to get into a film job at the Gaumont British Studios in Shepherds Bush, London. I was told there was an apprentice scheme being offered, but when I arrived for an interview, I was told they were oversubscribed. I then went to work for the British United Press based in Fleet Street, London, dealing with French matters, as I could speak fluent French. After a year or so, I got restless because of being indoors all day. At that time I carried a Leica camera, and on my way home, I would take pictures, and I suddenly found there was a market for them.

Would you tell me about Ealing Studios?
At Ealing we had two large stages that were divided into four. There was also a fifth stage, which was smaller. We had modern American equipment, such as Mole Richardson lamps and Mitchell cameras. We always managed to have two films on the go at the same time, usually overlapping. As one was ending, another was beginning, and the studio was shared. In my time there, I think I worked on more films than all the other cameramen combined.

Were the cameramen and directors employed?
We were all under contract. The directors would choose which cameraman they wanted to work with. Occasionally a DP [director of photography] was brought in from the outside. Cinematographer Jack Cardiff was brought in to photograph *Scott of the Antarctic* (1948) and Otto Heller [1896–1970] was brought in to shoot *The Ladykillers* (1955). His operator was Bernard Frederick (Chic or Chick) Waterson [1924–1997], who was credited on the film as Chick Waterson.

What was your first colour film at Ealing?
It was *Saraband for Dead Lovers* (1948).

Ealing was known for its comedies. What was your first feature?
Michael Balcon went to great pains to point out that Ealing didn't just make comedies. The first full-length feature I worked on as a DP was *Dead of Night* (1945). Several other cameramen, including Stan Pavey [?–1984], worked on it. Up until that time, I had only done exteriors as a DP.

What was your favourite Ealing film that you worked on?
My favourite is *Kind Hearts and Coronets* (1949). Alec Guinness [1914–2000] and Dennis Price [1915–1973] were superb in their roles. Guinness played several parts, and there was a sequence where all the characters were seen together. At that time optical work wasn't that good, so I decided to do the effects using the camera. What I did was to shoot a sequence and then rewind the negative, masking off what I had already done. For this, the camera had to remain rock steady. Because the sequences were shot over a couple of days, I slept in the studio to make sure the camera wasn't knocked. I was on edge until I saw the rushes. Fortunately everything worked out fine.

How long did you take to shoot an Ealing film?
On the whole it took between twelve and fourteen weeks. By today's standards that was quite long. I went from one film to another with only a few days' preparation.

Which of your Ealing films took the longest?
It was probably *Saraband for Dead Lovers.* The script demanded a lot of setups, and there was a lot of location work.

Was there an Ealing film that proved to be difficult?
They all had their difficulties. I have never considered one film to be more difficult than another. However, one film that was difficult at Ealing was *The Man in the White Suit* (1951), directed by Ealing stalwart Alexander (Sandy) Mackendrick [1912–1993]. We had to keep the suit clean under all circumstances. That film on the whole stands the test of time. Another of my favourites was *Hue and Cry* (1947), which had a lot of location work in London. There was still a lot of war-torn buildings around, so it is, apart from being a piece of fiction, an historic record of the times.

Did you have a favourite director at Ealing?
At Ealing it was like being with family. I got on with all the directors. I did several films with a number of them. All the directors became friends, and they were all different. I also got on very well with all the directors I worked with after Ealing. Among them were Steven Spielberg [1946–], Roman Polanski [1933–], Joe Losey [1909–1984], and Fred Zinnemann [1907–1997].

What was Michael Balcon like to work with?
Michael Balcon [1896–1977] was a sort of father figure. He came everyday on the set for around two minutes, having come back from rushes. We had to wait until the lunch hour before we could see them. He would watch a bit of the filming and make the director feel very nervous.

Did you ever want to be a director yourself?
Yes, I was approached by a documentary filmmaker by the name of John Grieson. I think he was based at Southall Studios, West London. He was going to make a film called *The Oracle*. He asked me if I would be willing to direct it. I said to him, "I would, but I have to tell you that I am under contract to Ealing. I have been there for years and hope to remain there." I told him, "If you want me to do it, you will have to ask Ealing if they will release me for two or three months." At lunch time the next day I was approached by the studio manager Al Mason. He said, "I would keep out of Mick's way if I were you. I could hear Mick shouting on the phone, telling Greison, 'I won't have my people taken away from me.'" So that was the end of that. I left it alone.

What was the length of your contract at Ealing?
My contract was always yearly. It went on automatically.

What was it like working with greats such as Alec Guinness and Peter Sellers?
Peter Sellers [1925–1980] only did one film at Ealing, which I didn't do. That was *The Ladykillers*, a wonderful film directed by Sandy Mackendrick, who did want me to do it, but I was working with Charles Frend [1909–1977] at the time. I would have loved to have shot it. I later worked with him on *The Smallest Show on Earth* (1957). This was a British Lion film, which I made in between Ealing films at MGM. My contract was changed when we went to MGM, and this allowed me to shoot elsewhere and then go back on an Ealing film. Sellers was marvellous as the inebriated projectionist. When he was working at Ealing on *The Ladykillers*, he would pop over to the Red Lion pub, which was opposite, and make us laugh. The Red Lion was used by most Ealing staff, and photographs of film people are on the walls.

Alec Guinness was a lovely man who had a great sense of humour. He also related some very funny stories.

What hours did you work on the Ealing films?
We started at half past eight and finished at six-thirty. Once or twice a week, we didn't finish until half past seven. On Saturday we worked from eight-thirty until one. I found that the time passed so quickly that when it was time to go home I couldn't believe it. I wanted to go on. Later in my career, the hours got longer.

Were all the Ealing staff under contract?
On the whole they were. There were one or two people called in to do the odd picture when we were busy. All the directors and camera people were under contract. Jack Cardiff was brought in for *Scott of the Antarctic* (1948). There were a few cameramen on it. Geoff Unsworth [1914–1978] went to the mountains to shoot, and Osmond Borradaile [1898–1999] went to the polar regions and was there for months getting background stuff. Jack Cardiff had to do the thread of the story, which was all shot on stage 2 at Ealing with around fifty tons of salt with wind machines. For a short period, Jack fell ill, and by that time I was free. I had just finished *Saraband for Dead Lovers* (1948), which was Ealing's first colour film. That coincided with Jack falling ill for around a week. I took over and tried to match what he had been shooting.

What sound equipment was used at Ealing?
It was RCA.

When did you go to Ealing?
I went to Ealing in early 1940.

What happened if you or the director fell ill?
One of the other cameramen or directors would take over. It happened to me on a film called *Dance Hall* (1950). I took ill, and Lionel Baines [1904–1996] took over.

Where did you go after Ealing's closure?
After the studio in Ealing closed in 1955, we moved over to Elstree, and we worked from the MGM studios, which was a very fine studio much larger than Ealing. I worked on *Davy* (1958), *The Man in the Sky* (1957) with Jack Hawkins [1910–1973], and *Dunkirk* (1958), on which I did the models. The films were still released under the Ealing name. This went on for around two years.

Was the bow-and-arrow sequence in *Kind Hearts and Coronets* shot in the garden at Ealing Studios?
No, people didn't shoot there. I can't remember where the bow-and-arrow sequence was shot, but it was definitely on location.

Were you still classed as a lighting cameraman when you only did exteriors?
I was still classed as a lighting cameraman when I was only doing exteriors. One of the films I shot the exteriors on was *Painted Boats* (1945), mostly shot on the canals. There was one interior shot inside the boat that was shot by someone else because at that time I hadn't any experience of shooting interiors. Because I

hadn't been in the studio, they weren't sure I could do the interiors. Everything I did for Ealing I was always the DP. The only one exception was when I operated on one picture because I hadn't had any studio experience.

Producer Alberto Cavalcanti thought it might be good for me to gain some experience in the studio, so I operated for Wilkie Cooper [1911–2001] on *Champagne Charlie* (1944), which was the first time I had been in the studio to work. I was too busy worrying about the parallax on the Mitchell camera to notice how things were being lit, but I still learnt something from Wilkie Cooper. At the beginning I wasn't very sure how to cope with the parallax. I never had time to experiment with it, so I had great difficulty. After that I was given *Dead of Night*.

Tape measures were used for distances, weren't they?

Yes, it was done by measurement. The focus puller would use a tape measure and then memorise the camera and artist's position. He would then move the lens barrel accordingly. Years later when Fox brought out Cinemascope, an anamorphic was attached, so two focus pullers were required.

What was your first picture for 20th Century Fox?

It was *The Third Secret* (1964), directed by former Ealing director Charles Crichton [1910–1999]. Though the film wasn't a success, the Fox people must have been pleased with what I had done because they gave me a three-year contract. Next came *The Guns at Batasi* (1964), starring Richard Attenborough and directed by John Guillermin [1925–]. It was set in the heat of Africa but was shot in January and February in the biting cold at Pinewood Studios. I still managed to produce something that worked. I then went on to shoot *High Wind in Jamaica* (1965), directed by Sandy Mackendrick. Some of it was shot in the studio.

Another Fox film I should mention is *The Blue Max* (1966), starring George Peppard [1928–1994], which was a great film to work on. In that one there was a scene where the George Peppard character was standing in the middle of an airfield to join the regiment. A plane swoops down, and he throws himself in the mud. I was with my crew, Chic Waterson, and Robin Vidgeon filming the plane. It came in and missed us by millimetres. I turned to the director, John Guillermin and said that was terrific. I was surprised to hear him say to the pilot, "That was too high you have to come down lower." I thought he couldn't come lower than that. I am sure he had only just missed us, and it more than filled the screen. Anyway, we had to wait for another take while the planes reformed. On the next take, I could see in no way would this plane clear us completely, so at the last minute, I threw myself flat on my tummy, having been on my knees. The next thing I knew, there was a crash, and the motor and magazine was torn off the Mitchell. The operator, Chick Waterson, was hit on the head by part of

the camera. I felt a terrible blow in the middle of my back as the plane literally landed on me. The wheel ran on my back and hit the ground a few yards behind me. My body rolled about twenty feet. Chick and the focus puller, Robin Vidgeon, were knocked to one side, and I lay in a pool of blood. A helicopter was standing by, which we had been using, and I was carted off to hospital, where I stayed for about ten days. Unfortunately it was the last ten days of the film. The plane had torn a strip of skin off my back and had just missed my spinal column literally by millimetres. My life was saved by my quick reaction. Cinematographer Ted Moore [1914–1987] took over. After Fox I had lots of offers.

What did you do after that?
Some time after that, I did another film for the same producer, Elmo Williams [1913–], called *Caravans* (1978), shot in Iran and starring Anthony Quinn. On that we used 35mm Todd AO equipment, which was very interesting. After Fox, I went on to work with a great number of directors, including John Huston [1906–1987], Roman Polanski, George Cukor [1899–1983], Norman Jewison [1926–], and Jack Clayton [1921–1995], who gave me one of my favourite films, *The Great Gatsby* (1974), starring Robert Redford. The film was shot in Rhode Island. We spent a couple of months there and also did sequences in

Douglas Slocombe, Robin Vidgeon, and Chic Waterson shooting *The Blue Max* (1966). *Courtesy of Douglas Slocombe*

New York. The rest of it was shot at Pinewood Studios, England. We built an extension to the main house, which had been built in the States. There is still the Gatsby extension at Pinewood. Also built at Pinewood was a swimming pool where the Robert Redford character was shot. It was a beautiful swimming pool. We wanted to keep it, but it was later destroyed. Shooting took around four months and was filmed using Panavision equipment. The Panavision camera and the process became my favourite. Another great director I worked with was Fred Zinnemann, who gave me *Julia*. I was nominated for an Oscar and also won a BAFTA for it. *Julia* was a very intriguing film. The interiors were set in Paris, and I think we were there for about a month. Zinnemann was a very demanding director, but one had an exciting story to work with. We were able to put in the sort of menacing mood of the Nazi system in the background.

Would you tell me a bit about your black-and-white films after Ealing?

One of my favourite black-and-white films was *The Servant* (1963), directed by the late Joe Losey. This film won me a first BAFTA. Another one I loved very much was *The L-Shaped Room* (1962), directed by Bryan Forbes. I was able to get a very powerful black-and-white effect, which had a lot of contrast. I'd been experimenting on black-and-white techniques on a film I'd shot with John Huston called *Freud*, also called *Freud or the Secret Passion* (1962). It starred Montgomery Clift [1920–1966] and was shot in Munich, Germany, and Austria. It went on for months because we had problems with Montgomery Clift, who

Douglas Slocombe on the set of *Julia* (1977). *Courtesy of Douglas Slocombe*

John Huston and Douglas Slocombe. *Courtesy of Douglas Slocombe*

couldn't remember his lines. The part demanded very long speeches, so it took a long time. I was able to experiment and get a very strong lighting effect on it. Those are three black-and-white films I like to think back on.

Going back to Ealing, I understand that some of *Kind Hearts and Coronets* was shot at Pinewood?
The whole film apart from one setup was done at Ealing. Because we had too many sets on at the same time, we had to use Pinewood. A very large set was required to replicate the House of Lords. At that time we had a tie-up with Rank, so we were able to go to Pinewood. That was the only time I shot at Pinewood for Ealing, and funnily enough that was the first time I had set foot in Pinewood, and it gave me an inkling what another studio was like. The Pinewood stages were very much larger.

Going back to Ealing, it had a tank where some sequences of *The Cruel Sea* (1953) were shot. Did you make use of it?
I can't remember using the tank for water sequences, but the tank was used sometimes if we needed a staircase to go down.

Would you tell me about *The Italian Job* (1969)?

That was a fun film that was shot at Shepperton and in Turin, Italy. We had a second unit on that shooting some of the chase sequences. Paul Beeson [1921–2001] was the DP on the second unit. The film starred a young Michael Caine [1933–] and featured Noel Coward [1899–1973]. I think Coward felt slightly at a loss in that film, but I think he did it as a favour to the young director, Peter Collinson [1936–1980], who he had befriended at an orphanage. Unfortunately Collinson died young.

How did you get on with Noel Coward?

I got on very well with him. He signed a few books for me. I also worked with him on *Boom!* (1968), which starred Elizabeth Taylor.

What was Michael Caine like to work with?

Michael Caine was great. I loved working with him. He was a wonderful raconteur and a very friendly, warm character. He was also a very good actor.

How long did it take to shoot *The Italian Job?*

It was around fifteen weeks. There was quite a lot to do in it.

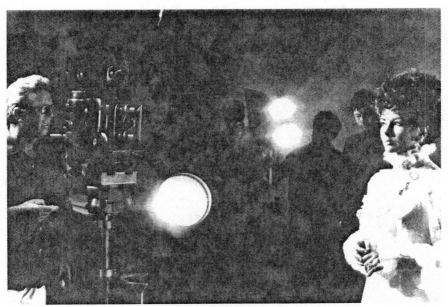

Douglas Slocombe and Elizabeth Taylor on the set of *Boom!* (1968). *Courtesy of Douglas Slocombe*

There is a famous scene in it where Michael Caine says, "You're only supposed to blow the bloody doors off." Was this done in one take?

We had two cameras, and there was only one take on it. For financial reasons we were very short of cars, and also because of the noncooperation of the car manufacturer, BMC. We wanted around ten minis, and they wouldn't give us any help. In the end we went to Italy to get the cars. We got a lot of help from Fiat. Fiat asked the producer if they would consider using Fiat cars. The producer, Michael Deely [1932–] wanted to stick with minis. Fiat, having failed to talk him into it, became wonderful hosts and gave us every single facility, even allowing us to shoot on top of their factory roof. We shot a sequence at the Fiat test track. They also allowed us to film the minis jumping from one roof to another in their factory grounds.

Would you tell me about working with Steven Spielberg?

Spielberg came in rather late in my life; I had already done a lot of films with a number of directors. Spielberg first asked me to shoot a short sequence for *Close Encounters of the Third Kind*. He was obviously pleased with it and said he would like to offer me a full feature in the future. As always, because he is wonderful that way, he kept his word, and later I was asked to shoot *Raiders of the Lost Ark*. At that time I didn't realise that it was going to be a trilogy. The interesting thing about working on the three *Indiana Jones* movies was, first of all, working with Steven, who is a great director, enormously imaginative, tremendously competent, and very fast. He was a great person to work with, and I also admired his fresh approach to everything; he seemed to know what to do automatically. Some directors are rather worried how to behave, however much preparation they do. Steven was very well clued up before he started to work on the floor. He was very quick at being able to adapt and find another way of doing things if it wasn't going to plan. He deserves to go down as one of the greats. Secondly, all those films involved very large, complicated sets, which were always a challenge. Part of the challenge was getting the mood into them. It was difficult to get the lights where you wanted at the strategic positions, but then we had a very tight schedule. Despite all the complications, they wanted them to be shot as quick as possible, so I was constrained by the amount of time. I was told not to spend too long on the various setups, so I had to work like mad. Very often, incidentally, I would still be putting in lamps when I'd hear Spielberg calling "Action." But the point is I enjoyed them enormously. Because of the number of special effects and the number of props and things involved, it was the first time I appreciated the number of drawings (storyboard). The storyboard is essential for all the units. Steven had obviously been able to do a lot of preparation beforehand, and very little time was wasted on the floor in getting setups. Steven was a delight to work with.

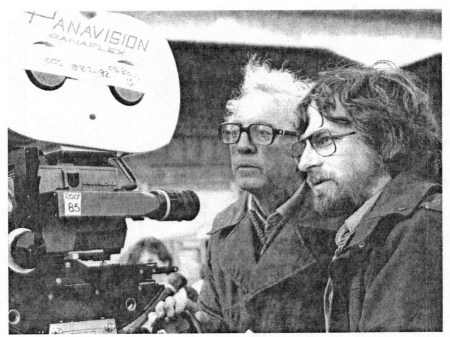

Douglas Slocombe with Steven Spielberg on the set of *Raiders of the Lost Ark* (1981). *Courtesy of Lucas Film and Dreamworks, photo by Albert Clarke*

Do you still keep in touch with Spielberg?

Yes, I do. I hear from him every now and then. It's a great pleasure when I do.

You were a friend of the great Katharine Hepburn. What was she like?

She was an unfailing delight. I first got to know her when we worked on *The Lion in Winter* (1968). She became a great friend after that. She wrote wonderful letters appreciating what she thought I'd done for her. Unfortunately I was to do only one more film with her called *Love among the Ruins* (1975), also starring Laurence Olivier. She was going to be the aunt in *Travels with My Aunt* (1972). I remember going on a recce with her in Italy, Spain, and Paris. When I got back to London, she rang me a week later and said, "Dougie, I've been fired." I remember saying to her, "Katy, nobody fires you." She said, "Yes, I've been fired." She was very argumentative about the script because she didn't like it, and the producer had wanted Maggie Smith for her part anyway. I often wonder what it would have been like if Katy Hepburn had been in it. I was asked to do another one with her afterwards, but unfortunately I couldn't do it. I was on a film that hadn't finished when that one started. She was also very angry with me for not doing that.

Douglas Slocombe and Katharine Hepburn on the set of *The Lion in Winter* (1968). *Courtesy of Douglas Slocombe*

What awards have you won?

I never got an Oscar but was nominated three times for *Travels with My Aunt*, *Raiders of the Lost Ark*, and *Julia*. My last film was *Indiana Jones and the Last Crusade*. I said it was also my last crusade.

What advice would you give to a new cinematographer?

Every era opens up new opportunities and new challenges, but the thing I found that worked for me all my life was being aware every minute of the day of the lighting conditions. Everyday when I worked onto a new film set, I went on with a completely open mind, and I treated every story in its own right. I never got bored, no matter how many times I had to work on the same set.

It is said that on some films you didn't use a light meter. Is that true?

I used a light meter in my early films but not on the last twenty or thirty. I found that as the schedules were getting tighter and tighter I didn't have time. But I found I could automatically give the set the right amount of light. I then realised I didn't need the meter, so I gave it up.

What do you think of today's cinema?

I can't see much anymore, so I do miss very much, not being able to see what is being done. I know they are doing a lot of digital enhancement work and a lot of the effects are done digitally. If I were working today, I would miss very much not having control in my hands. The great thing in my era was that everything on the screen was in control of the cameraman. Every single dot that went on the screen, lit or unlit, was his choice. Sometimes the cameraman had to do trick effects in the camera. Now all those things are inclined to be done digitally, and I think I would resent that being taken away from me or I would miss it not being part of my own handiwork. On the other hand, every generation and every new invention brings its own challenges and advantages, so therefore the cameraman can still make use of the knowledge that certain effects can be done in a way that perhaps he wouldn't have been able to do before. All the effects I did in the camera, such as winding back to create an image where an actor plays two parts, can now be done digitally. The original magic has now gone. I miss not being able to see what the modern films are like.

Are there any cinematographers that stand out for you today?

The trouble is I can't see anything, so I gave up voting for the Oscars and the BAFTAs a long time ago. I have been completely out of touch; I really don't know what's happening. I'm sure there must be some marvellous things going on, but I just don't know.

You damaged one of your eyes in an accident, didn't you?

One eye was damaged by an accident and the other by laser treatment that went wrong. I am now left with a little bit of vision. The accident happened in Tunisia when I was on a recce with Steven Spielberg for *Raiders of the Lost Ark*. We were in a jeep, and I sat in the back. We hadn't been going long when there was a colossal jolt. Part of the road we were on had been washed away by a flash flood and had sunk a foot or so. The jeep crashed down into the lower level, and I remember bouncing up and hitting the steel bar. When I got back to the hotel that night, I was conscious of a floater in my eye. I went to see a doctor about it, and they didn't know if it was damaged or not. After I had shot *Raiders of the Lost Ark*, I was working on another film called *The Pirates of Penzance* (1983), and when I was travelling back after a day's shooting, I noticed that I couldn't see through the damaged eye. It was as though a steel shutter had come down. It turned out that the retina had detached.

Filmography

The Big Blockade (1940, Charles Frend)
Lights Out in Europe (1940, Herbert Kline)
Greek Testament (1942, Charles Hasse)
For Those in Peril (1944, Charles Crichton)
Dead of Night (1945, Alberto Cavalcanti and Charles Crichton)
Painted Boats (1945, Charles Crichton)
The Captive Heart (1946, Basil Dearden)
Hue and Cry (1947, Charles Crichton)
The Loves of Joanna Godden (1947, Charles Frend)
It Always Rains on Sunday (1947, Robert Hamer)
Saraband for Dead Lovers (1948, Basil Dearden; U.S. title *Saraband*)
Another Shore (1948, Charles Crichton)
Kind Hearts and Coronets (1949, Robert Hamer)
A Run for Your Money (1949, Charles Frend)
Dance Hall (1950, Charles Crichton)
Cage of Gold (1950, Basil Dearden)
The Lavender Hill Mob (1951, Charles Crichton)
The Man in the White Suit (1951, Alexander Mackendrick)
His Excellency (1952, Robert Hamer)
Mandy (1952, Alexander Mackendrick; U.S. title *Crash of Silence/ The Story of Mandy*)
The Titfield Thunderbolt (1953, Charles Crichton)
The Love Lottery (1954, Charles Crichton)
Lease of Life (1954, Charles Frend)
Touch and Go (1955, Michael Truman)
Sailor Beware (1956, Gordon Parry; U.S. title *Panic in the Parlor*)
The Man in the Sky (1957, Charles Crichton; U.S. title *Decision against Time*)
Heaven and Earth (1957, ITV Play of the Week, Peter Brook)
The Smallest Show on Earth (1957, Basil Dearden; U.S. title *Big Time Operators*)
Barnacle Bill (1957, Charles Frend; U.S. title *All at Sea*)
Davy (1958, Michael Relph)
Tread Softly Stranger (1958, Gordon Parry)
Circus of Horrors (1960, Sidney Hayers)
The Boy Who Stole a Million (1960, Charles Crichton)
Taste of Fear (1961, Seth Holt; U.S. title *Scream of Fear*)
The Young Ones (1961, Sidney J. Furie; U.S. title *Wonderful to Be Young*)
The L-Shaped Room (1962, Bryan Forbes)
Freud (1962, John Huston; U.S. title *Freud: The Secret Passion*)
The Servant (1963, Joseph Losey)

The Third Secret (1964, Charles Crichton)
Guns at Batasi (1964, John Guillermin)
A High Wind in Jamaica (1965, Alexander Mackendrick)
Promise Her Anything (1965, Arthur Hiller)
The Blue Max (1966, John Guillermin)
The Fearless Vampire Killers (1967, Roman Polanski)
Robbery (1967, Peter Yates)
Fathom (1967, Leslie H. Martinson)
Boom! (1968, Joseph Losey)
The Lion in Winter (1968, Anthony Harvey)
The Italian Job (1969, Peter Collinson)
The Buttercup Chain (1970, Robert Ellis Miller)
The Music Lovers (1970, Ken Russell)
Murphy's War (1971, Peter Yates)
Travels with My Aunt (1972, George Cukor)
The Return (1973, Sture Rydman)
Jesus Christ Superstar (1973, Norman Jewison)
The Great Gatsby (1974, Jack Clayton)
The Marseille Contract (1974, Robert Parrish)
Hedda (1975, Trevor Nunn)
Love among the Ruins (1975, George Cukor)
The Maids (1975, Christopher Miles)
Rollerball (1975, Norman Jewison)
The Lucky Touch (1975, Christopher Miles)
The Sailor Who Fell from Grace with the Sea (1976, Lewis John Carlino)
The Bawdy Adventures of Tom Jones (1976, Cliff Owen)
Nasty Habits (1977, Michael Lyndsey-Hogg)
Julia (1977, Fred Zinnemann)
Caravans (1978, James Fargo)
Lost and Found (1979, Melvin Frank)
The Lady Vanishes (1979, Anthony Page)
Nijinsky (1980, Herbert Ross)
Raiders of the Lost Ark (1981, Steven Spielberg)
The Pirates of Penzance (1983, Wilford Leach)
Never Say Never Again (1983, Irvin Kershner)
Indiana Jones and the Temple of Doom (1984, Steven Spielberg)
Water (1985, Dick Clement)
Lady Jane (1986, Trevor Nunn)
Indiana Jones and the Last Crusade (1989, Steven Spielberg)

Awards

The Servant (1963), British Academy of Film and Television Arts Best Cinematography Award

Guns at Batasi (1964), British Academy of Film and Television Arts nomination

The Blue Max (1966), British Academy of Film and Television Arts nomination

The Lion in Winter (1968), British Academy of Film and Television Arts nomination

Travels with My Aunt (1972), Oscar nomination and British Academy of Film and Television Arts nomination

Jesus Christ Superstar (1973), British Academy of Film and Television Arts nomination

The Great Gatsby (1974), British Academy of Film and Television Arts Best Cinematography Award

Rollerball (1975), British Academy of Film and Television Arts nomination

Julia (1977), British Academy of Film and Television Arts Best Cinematography Award and Oscar nomination

Raiders of the Lost Ark (1981), Oscar nomination and British Academy of Film and Television Arts nomination

Indiana Jones and the Temple of Doom (1984), British Academy of Film and Television Arts nomination

The Servant (1963), *The Lion in Winter* (1968), *Jesus Christ Superstar* (1973), *The Great Gatsby* (1974), *Indiana Jones and the Temple of Doom* (1984), 1995, British Society of Cinematographers Lifetime Achievement Award and five BSC awards

2002, American Society of Cinematographers International Achievement Award

CHAPTER 3

Nicolas Roeg, CBE, BSC

(1928–)

Nicolas Jack Roeg was born on August 15, 1928, and got hooked on films from an early age. As a child he would often go to the cinema with his sister to see the latest offerings, sometimes staying in to see the film twice.

Roeg started in the business making tea for a small documentary studio in Marylebone, London. He then moved to the cutting rooms at De Lane Lea in London's Wardour Street. He worked with Gladys Brimpts, whose husband had started the Association of Cinematograph Technicians. In those days Roeg worked on films that were dubbed from French to English.

With Brimpts's help he got a job at MGM Elstree in its camera department as a loader, where he met the great cinematographer Freddie Young [1902–1998]. He stayed there for around two years. Roeg said that he had no idea about photography when he joined the camera department. He was a focus puller on several early 1950s films, including *Cosh Boy* (1953). He went on to operate on a number of notable films as a camera operator: Ken Hughes's *The Trials of Oscar Wilde* (1960), starring Peter Finch, and Fred Zinnemann's *The Sundowners* (1960), to name two. He became a director of photography (DP) in 1960, working with DP Ted Moore on *Jazzboat*. He is quoted by the British newspaper *The Guardian* as saying, "It wasn't through a love of photography, but rather through my love of film, and the telling of stories through film. Later I couldn't think how anyone can become a director without learning the craft of Cinematography."

He pointed out that there was no proper training back then. Film schools didn't exist; you learned as you went along. Roeg said, "I'll never forget working for the late American cinematographer Joe Ruttenberg on *The Miniver Story* (1950). Ruttenberg had worked on *The Philadelphia Story* (1940) and *Gigi* (1958). He probably taught me the biggest lesson of all about photographing a movie. He said, 'Never forget, Nic: You're not trying to enter a photographic

society with your work; you are trying to illustrate the story. It's the scene that must be served. The movie is made through the cinematography.' It's quite a simple idea, but it was like a huge revelation to me."

He went through the ranks and became a DP, working on a number of memorable films, including *Lawrence of Arabia* (1962), where he shot the train explosion. Roeg won't take any credit for *Lawrence*, giving it instead to Freddie Young. Roeg was on the picture's second unit for around three months, and total shooting was around eighteen months.

Roeg became a director in 1968, codirecting with the late writer/director Donald Cammell on *Performance*, starring pop legend Mick Jagger. The film wasn't released until two years after it was made. Roeg went on to work on his first film as a solo director, *Walkabout*. Though he has made many notable films, the one that stands out for many is *Don't Look Now* (1973), starring Donald Sutherland and Julie Christie. It was shot in England and Venice, Italy. One critic said that Roeg's films shatter reality into a thousand pieces and are unpredictable, fascinating, cryptic, and liable to leave you wondering what the hell just happened.

He was awarded the commander of the order of the British Empire (CBE) for services to the film industry and has won several awards for his work, including the Golden Palme at Cannes for *Insignificance* (1985).

How old were you when you decided to work in the film business, and what got you interested in it?
I must have been around eighteen or twenty. The movies always appeared magical to me. I liked going to the cinema. It seemed so marvellously unusual; it had a reality to it. I would often go to the cinema with my sister when I was around twelve years of age. I think I have kept that feeling ever since: What is reality? It's such an extraordinary thing, the retention of the image. We take it so much for granted, but it affects every single attitude we have towards life, towards any sort of continuity of existence, the past and the future.

Why did you choose cameras? Were you interested in photography from an early age?
No, I started in a cutting room in London's Wardour Street, getting tea for the editors at De Lane Lea.

When did you start photographing?
I did second units and slid into it. I also did television. I worked on *Lawrence of Arabia* on the second unit. Freddie Young was on the main unit, and he was terrific. I got on very well with him.

Nicolas Roeg. *Courtesy of Nicolas Roeg*

Do you have any favourites you worked on?
No, they were all part of your life. Years ago they took much longer to make. That was a time when you could ponder film. The studios were like a film university. Gradually things speeded up because of advancing technology.

Why did you decide to move into directing from camera work? Did you feel you needed a change?
No, I didn't decide to go in as a cameraman. I didn't know what a cameraman was at the beginning. There weren't any film schools. You learnt as you went along. I was drawn to writing and all sorts of things, but it was a job that became fascinating and was part of a division of departments.

You directed *Don't Look Now* (1973). What was it like working with Donald Sutherland and Julie Christie?
They were great. They brought a certain truth to the piece. It was not a long shoot; it was quite confined. We did four or five days in England and then five or six weeks in Venice. Before we started to shoot, I went over to Venice. We wanted to keep the continuity of emotion going. We didn't want to get held up over rigs and things. It is very difficult in Venice because to move large equipment you have to go by canal and to get under the bridges you have to wait for the tide to come down. Logistically it was very difficult. I kept in continuity, and it worked out well. It was a swift shoot.

Do you think the films of today are as good as the old movies?
Yes, everything goes in phases. Things become original, then obvious, then normal and everyday. New filmmakers are bringing new thoughts and attitudes, and the old attitudes take time in going away. I think we are going through a swift process. The financing of movies is changing. Everything is changing: the ability, the availability, and the laboratory work.

What do you think of digital?
It is wonderful. My children's grandchildren will probably say, "Why was it ever called film?"

Are there any cinematographers today that you admire?
I think there are a lot. There is a long answer to that because there are so many I would hate to exclude. When I say so many, even when there are four or five, that is a lot, but there are more than that because of the amount of material being shot. There seems to be more films reviewed every week than ever before. The look of film today is wonderful.

Nicolas Roeg in costume on the set of *Far from the Madding Crowd* (1967). Roeg says it was just a funny snap of him posing as a Victorian photographer. *Courtesy of Nicolas Roeg*

Would you tell me a bit about working with the late Alex Thomson [1929–2007]?

Alex was a terrific filmmaker. I remember we were shooting in Elstree on the streets, and Alex got into an old pram to shoot some sequences. It was hilarious. He had the heart and soul of a cinematographer. We first met at a union meeting and became great friends. Alex was innovative and rule breaking in all kind of ways before steadicam.

Which film took the longest to shoot as a cinematographer?

The longest shoot was *Far from the Madding Crowd* (1967) because it went through the seasons. It was very interesting, and I enjoyed working with John Schlesinger very much.

Which film took the longest to shoot as a director?

I can't think which was the longest. It's a different thing. One doesn't think in terms of time; one thinks in terms of life. The film is with you for a long time before you start. Sometimes it takes a while to get the money for the project. Then the film takes six weeks, but it's not only that. There is the cutting of it and other things, so that is a very difficult question. Emotionally, getting over a film affects your life, putting your life in it.

When you were a cinematographer, did you do any effects in the camera?

Yes, I did some on the original *Casino Royale* (1966). I always tried to do it in the camera because if it went to a laboratory to have effects added, they didn't always work out how you intended them. With today's technology your intention can be created perfectly. Grading has become a completely different enterprise, too. They can now do it immediately, enabling the cinematographer to see the result straight away. There are no waiting days for it to come back and then finding it is not right.

Do you intend to retire in the near future?

I wouldn't know what to do. I've recently been working on a script.

Filmography

Jazz Boat (1960, Ken Hughes)
Information Received (1961, Robert Lynn)
Ghost Squad (1961, TV Series, Eric Price and William G. Stewart)
Just for Fun (1963, Gordon Flemyng)
The Caretaker (1963, Clive Donner)
Band of Thieves (1963, Peter Bezencenet)
Dr. Crippen (1964, Robert Lynn)

Nothing but the Best (1964, Clive Donner)
The Masque of the Red Death (1964, Roger Corman)
Victim Five (1964, Robert Lynn)
The System (1964, Michael Winner)
Every Day's a Holiday (1965, James Hill)
Doctor Zhivago (1965, David Lean)
Fahrenheit 451 (1966, François Truffaut)
A Funny Thing Happened on the Way to the Forum (1966, Richard Lester)
Far from the Madding Crowd (1967, John Schlesinger)
Petulia (1968, Richard Lester)
Performance (1970, Donald Cammell and Nicolas Roeg)
Walkabout (1971, Nicolas Roeg)
Glastonbury Fayre (1972, Peter Neal and Nicolas Roeg)

As Director

Performance (1970)
Walkabout (1971)
Glastonbury Fayre (1972)
Don't Look Now (1973)
The Man Who Fell to Earth (1976)
Bad Timing (1980)
Eureka (1983)
Insignificance (1985)
Castaway (1986)
Aria (segment "Un ballo in maschera," 1987)
Track 29 (1988)
Sweet Bird of Youth (1989)
The Witches (1990)
Cold Heaven (1991)
The Young Indiana Jones Chronicles (1993, TV Series)
Heart of Darkness (1993, TV Movie)
Hotel Paradise (1995)
Two Deaths (1995)
Full-Body Massage (1995, TV Movie)
Samson and Delilah (1996, TV Movie)
The Sound of Claudia Schiffer (2000)
Puffball (2007)
The Adventures of Young Indiana Jones: Demons of Deception (2007, Video)

Awards

Don't Look Now (1973), British Academy of Film and Television Arts nomination
Insignificance (1985), Golden Palme at Cannes

CHAPTER 4

John de Borman, BSC
(1954–)

John de Borman was born in Paris, France, in 1954. He went to the Chelsea School of Art (now College of Art and Design) and studied sculpture. He is the president of the British Society of Cinematographers (BSC), which he says is a great honour. He took over from cinematographer Sue Gibson, who had done her two-year stint. Borman would like to get older cinematographers to relate and record their stories of the old days when it was a different ball game with slower film and lots of lights, heavy cameras, and no steadicam or video assist.

What got you interested in the film business?
I did photography a lot when I was young, and I used to do a lot of home movies. My father was also into home movies, and I would borrow his super-8 camera. We bought editing equipment together, and I started editing all the holiday films. I also did a huge amount of photography. Unconventionally, I suppose, I went to art school rather than film school and studied as a sculptor. Taking photographs fascinated me. I was good at drawing, but I was better at photography, composing, and printing. I would do that a lot, and that is how I got started.

How did you get into the film business?
My first break came when I was thirty. A friend, Nigel Cole, who is now a director and who I have known since I was twenty, and I would go up and down Wardour Street, London, trying to work out ways of making films. Now it is a lot easier, but in those days it was a big number—it was a massive financial thing.

We managed to get an MTV series. We used to shoot rock videos, do interviews, and different projects every month. This got me into the business. I had a friend who had a company called Limelight. I started doing rock videos for them. I worked with Prince and Madonna, and the jobs got bigger, and

John de Borman. *Courtesy of John de Borman*

it allowed me to experiment. That's how I started, but my main interest was feature films.

How did you get into features?
It was at a time when the industry was very unionised. You couldn't get into making films until you had a union ticket (Association of Cinematograph and Television Technicians) and you couldn't get a union ticket until you got a job. It was a catch-22 situation. As I came from an art school background, I didn't know many people in the industry. A friend of mine wrote a little horror movie. He had twenty thousand pounds, and he said, "Let us do this." He got a few actors together, and it won the gold at a horror movie festival. From that we did another film, then another. They weren't great films, but they allowed me to experiment and to do feature films. I suppose my real break was when I did *Small Faces* (1996) for director Gillies MacKinnon, which was all shot on super 16mm. It won the gold at the Edinburgh Film Festival for the Best British Movie. It was a gangland story set in 1960s Glasgow. Director Peter Cattaneo gave me *The Full Monty* (1997) to shoot. I got better known, and things started coming in.

Did you start as an operator, or did you go straight in as a DP [director of photography]?

I was a very bad assistant. I wasn't very good. I was so interested in lighting that the majority of my time was asking DPs questions. I think there are different talents. To be a good focus puller, you have to have a certain mind-set. The technical aspect of being an assistant is a different one than being a cinematographer. You can be a very good focus puller without being a good cinematographer and vice versa. I realised my talent wasn't in assisting but more in operating, which I think is absolutely vital to good cinematography and hopefully lighting.

Do you do your own operating?

Virtually everything I've done I have operated on. In America, the unions were very strict about that, so I used to bring operators in. Even then I always tried to get a second camera out and would do a lot of the second camera work as well as the lighting.

Do you always use a light meter?

I do use them but less and less. Now that film has gone up to 500 ASA, you don't need to use one so much. Often what happens is I get the exposure for the key light, and from then on I do the rest by eye because the image is based between the highlights and the shadow areas, and once you have got basic exposure for the key, then the rest you can do by eye, especially with the stocks we have now.

What do you think of digital? Have you done much shooting on it?

Yes, I have done quite a bit of shooting on digital, but I have not done a feature film. I think the problem with digital is because we can have 800 ASA, it is more sensitive than your eye, therefore you look at something you have lit and it seems very dark. Then you look at the monitor and it looks overexposed. So at the moment it is best to light by monitor and not by eye. I have always lit by eye, so I think you slightly disassociate yourself from being the operator, close to the actor, making decisions there, because you are always reflecting back on to the monitor to make sure that the lighting is right. Digital has a latitude of eleven stops, and so it is getting very close to film.

Can you see that everything will be shot digitally in the near future?

Yes, but sometimes there is a strobing problem when you are panning fast and there are things that are not the same. It is a shame that digital doesn't have its own look. Digital is based on financial reasons rather than visual. That is a slight shame. You might as well say, "Why don't you shoot film if you're trying to make digital look like film?" I can understand that producers don't want

to spend so much money on stock, and of course you don't get any scratches. Film and grain is a bit more forgiving, and I think for people's close-ups, film is still much more sensual, and I think that is a big difference between digital and film. I think there is a certain sensuality about the negative, the grain, and doing portraiture, which you don't quite get on digital. It is quite harsh. Portraiture is something that is very important to me. I used to be a sculptor, so I understand people's faces. There is a certain harness with digital that you don't get on film, and I think for the moment that is the difference.

Is digital easier to edit?
It isn't really. It's just less expensive to get it to the editor. You have to format it. All the films I have done recently have all been digitally edited. The negative is made into a digital image, and then it's the same. Some films are shot using digital and film cameras. One of the reasons for doing that is because of small digital cameras that can be used in very small areas.

How long did it take to shoot *The Full Monty*, and what was it like to work on?
It was a very tough shoot with a six-day week and fourteen- to sixteen-hour days. It was shot on a low budget, and we had no idea how successful the film was going to be. The script hit a nerve. It just called everybody, universally all round the world. A lot of people at that time were out of work. Quite a lot of people have come up to me, including actor Sam Shepard, who said, "John, everybody in that film I recognise. They all live in my town." It showed situations that people everywhere could relate to.

Did you operate as well as being the DP on that?
I did a bit. I started, and then it all became very busy, so David Whally came to help out with operating.

Which cameras do you prefer?
I have always used Arri, apart from once when I shot *Death Machine* (1994). On that I used Panavision anamorphic. From then on I have used Arri with Cooke lenses.

Do you have a favourite movie you have worked on?
I loved *Hideous Kinky* (1998) and *Small Faces*, and I really enjoyed *An Education* (2009). I have enjoyed most films I've worked on. I have a team of people I use all the time, so it becomes like a family. I find working on movies very stimulating. I don't just stick to one genre. I like to do a bit of everything so I can change the style, and it makes it more interesting that way.

Are there any DPs today that you admire?
Yes, there are many. I always look at some of Chris Menges's films before I start. He has a great colour palette. He has a very sensitive way of shooting. He really knows how to use the lighting that is there, and often you don't notice where the light comes from in any of his movies, and that is very clever. He uses a lot of bounce light and a lot of wraparound light. I think he is the best in the world.

Do you have a favourite studio?
Not really. I think studios are studios, just bare rooms. Pinewood was great. They are all good. I think it doesn't matter where I am. The standard of proficiency with all the people that I work with is very high, so I think the studio is not in question really.

Are there any films you didn't like working on?
Occasionally you don't get on well with a director, and that makes it difficult. Sometimes there are reasons beyond your control or maybe the director is having a hard time with the studio so he puts it onto the crew, so that becomes difficult. I am not a great lover of directors that shout and scream on the set. I feel that filmmaking is a collaborative process. No one person makes a film. It is a collaboration between everyone. There have been a couple of films where the director seems to think that he was the only person that was important.

You produced *Murder on Line One* (1989). Did you not want to produce others?
No, because I'm not really a great producer. It was only a means to an end. My real love is telling stories and making feature films. I do commercials, and I do pop videos, which I enjoy doing, but my real love is telling stories. When I got *Small Faces*, which I think was one of my best films, I felt, "Now I can stop producing and let producers do their jobs, and I'll concentrate on the photography."

Have you ever considered becoming a director?
Yes. I have just not found the right script. I did write a script once, and I got very far into it. It took a year out of my cameraman life. The money was all in place, and suddenly there was a crash in the late '80s where the money got taken away from the project, and I thought, "I don't want to do this. I would much rather be in a position where by the time I got there the money's all in place, the script has been written, and I would just get on and do the job." The problem with being a director is you do one film every three years, if you're lucky. I like working all the time, so being a cameraman means I can do many varied jobs, and it's still very stimulating and creative. I think, on the whole, I am very happy being a cinematographer. However, if someone gave me a script, I would also be happy to be a

director. I do work with a lot of first-time directors, so to an extent I have a slight directorial role with them anyway. I help them, and I make sure that the scenes are covered. I also help in the style of the scene and how it's shot. On *An Education* the director didn't know about the late 1950s. I could help with the look of it. She was brilliant with the actors and their performances, but visually I did a lot of the work. We talked a lot, and I saw her for months before we started shooting, and we discussed how we would shoot it. As a cameraman you need to know everybody's job. I find it thrilling when you can involve yourself in other people's work.

Do you have an agent?
I have a British and an American agent, but mostly I am approached by producers and directors. The worst scenario is being offered two films and having to choose. You want to work on a film that does well and is well distributed as well as it being a good film; it's very difficult to know before you start. If I was to be honest, I didn't think *The Full Monty* was going to be as big as it was. I thought it was going straight to television. It caught peoples' imagination and was liked by so many people, but it was very difficult to tell before you started it.

Were you undecided about doing it?
No, it was still very early on in my career. I'd just done *Small Faces*. It was a good script and took around six weeks to shoot.

John de Borman with Richard Gere and Anita Gillette on the set of *Shall We Dance?* (2004). *Courtesy of John de Borman*

I see you shot five films with Gillies MacKinnon?

I met Gillies very early on. In a way, I feel the first film I did with him, *Small Faces*, was my break because it was a very well-written story, which he wrote with his brother, Billy MacKinnon. It was set in Glasgow and was semiautobiographical. It was my first proper film where I flexed my muscles and started planning things out. MacKinnon is a very talented man. He came from art school, the same as me. He used to draw scenes on the street and sometimes use them in the film. He had a very graphic and visual eye and also had a gentle way of telling stories, so we shot this film on super 16mm on a low budget. *Hideous Kinky* was another film I shot for MacKinnon, which is one of my favourites. We shot it in Morocco, and it starred Kate Winslet. She had just finished *Titanic* (1997), so she was the biggest star in the world at that point. Against her agent's recommendations, she wanted to do the film. She's such a brilliant actress, and it was a delight to work with her. The nice thing about Gillies is that he is a European director really. He has a very gentle and truthful approach to directing. He doesn't push anything onto the audience. He leaves things open. You either like or don't like that, but I think it's very nice.

I did *Tara Road* (2005) with Gillies, which wasn't a great script. I loved working with Gillies, and I would go with whatever he wanted to do. We got on great and had a good time filming. Nigel Cole is another good friend of mine. We wrote scripts together. We bought books and wrote scripts from the books. We bought the Kray brothers' book at one stage and very nearly did that, but that didn't come off. We were filmmakers from a very early age. Then suddenly he got a break, and he got me onto the shows with him. Then we did our first film together, *Saving Grace* (2000). From then on, sometimes he'd use me, sometimes he didn't. But we'd always go backwards and forwards and work together because we are such good friends.

Would you tell me about *Tsunami: The Aftermath* (2006)?

Tsunami: The Aftermath, directed by Bharat Nalluri, was a big job shot at a risky time of the year. The monsoons were happening at that time, so there could have been problems. We did two ninety-minute films in ten weeks, and we had five hundred extras. There was a lot of preparation. Bharat and I got on well, so we did *Miss Pettigrew* (2008) together, which was a period film and was fantastic to do. We had an excellent production designer, Sarah Greenwood, who did some beautiful, silvery sets. They were a great example of how the production designer can really help the cinematographer in his lighting by putting in lovely, glistening things that respond to film. That went very well, and then I did a pilot with her for ABC in New York because I'd worked a lot in America, and she wanted somebody who knew the American system.

Would you tell me a bit about *Made in Dagenham* (2010), directed by Nigel Cole?

It was set in 1969. Ken Loach's *Poor Cow* (1967) was used as a template for the feel and look of the film. Nigel and I decided to film it so all the characters could get up, lean over, and do things that weren't rehearsed while the action was happening in the centre of the factory. So we decided to use two cameras on tracks at ninety degrees of each other and just move round people whenever they got in the way. We created a very busy atmosphere, and sometimes people blocked the lens. We gave it a liveliness, which you couldn't get if it had been rehearsed. That actually taught me quite a lot by letting things go. By not rehearsing things, you can use certain things that happen in front of you as an accident, which is actually very beautiful. That is the way we did it, and we tried to make it look like *Poor Cow* as much as we could.

How did you get on with director Bill Forsyth on *Gregory's Two Girls* in 1999?

I got on very well with him. He was very clever and very funny. The film we did wasn't as good as the original.

Are there any directors you admire?

I have admired most of the directors I have worked with, including Gillies MacKinnon, Nigel Cole, and Bill Forsyth, who unfortunately isn't making films

John de Borman on the set of *Made in Dagenham* (2010). *Courtesy of John de Borman*

anymore. I admired Lone Scherfig for different reasons really. She had a very interesting way of placing the actors and getting them to speak their lines with a sort of Scandinavian rhythm, which was interesting.

Would you tell me about *Last Chance Harvey* (2008), starring Dustin Hoffman?

It is a romantic comedy set in London with Dustin Hoffman and Emma Thomson. I got to meet Dustin Hoffman, which was great. He's very funny, charming, nice, and very kind. He's a man that has made so many quintessential films, and it was fascinating to talk to him. We became very friendly, and he asked me to shoot a film he is directing in 2011 called *Quartet*. It will be starring Albert Finney, Tom Courtney, Maggie Smith, and a fourth person, who we don't know yet. So we have very well-known actors directed by Dustin Hoffman. It will be fascinating.

Would you tell me about *Seven Lives*?

That is a bit of a mistake, I don't know why it's on my IMDb. I was in the pub one day, and a student came up to me and said, "Would you help me? I need to get a pilot going to get the money to make this film." I read the script, and I thought it was very good. What he wanted to do originally was have seven DPs for the seven different lives and seven different looks, which I thought was a good idea. I spent a week for nothing shooting one of the lives. They cut it together, and fortunately they got the money for the rest of the film off that. So that is all I did. I only did the pilot to help them get the money together.

Out of all the films you have shot so far, do you have any particular favourites?

I think *Small Faces* and *An Education*.

What was your most difficult shoot and why?

They all have their own difficulties. I think the most difficult are ones with directors you don't get on with, the ones that shout and scream. That becomes very tiring, makes it very difficult and hard and uninspiring. On one film we had a director who was shouting at everyone, and that makes you feel, "I don't care. I don't want to do this job." I will never work with that director again.

Have you any industry heroes?

My hero in cinematography is Chris Menges. I had a French upbringing, so a lot of them are from France.

Could you tell me about some of the best moments?

Some of the best are when working in a tropical location. You finish work at five o'clock and jump in the sea. That is a fun way of ending the day's work.

Apart from sculpting, have you any hobbies?
I love watching rugby union. I have played it and broken my nose several times.

What is the best thing about being a director of photography?
The best thing about it is you are in a position that has a certain amount of power, and basically the camera is the centre of the film. Everybody on the film works for the camera.

Would you like to continue into old age like some other cinematographers?
Yes, I'd love to drop on the set while filming. I would just like to keep on going. There are still lots of things I would like to try out and do. I get a huge amount of excitement out of filmmaking, so I can't see that dwindling.

Do you start working early on the set?
Sometimes we start at four in the morning, which is incredibly early. The good thing is, after working hard for several months, you can take a month off. We can have more time off than most people.

Oswald Morris [1915–] told me that cinematographers work longer hours now. Why is this?
These days they cram it in. Most films now take around seven weeks to shoot. At one time that was the bare minimum to make a film, now it's the norm. The last two films I shot only took seven weeks. Sometimes you have to use three cameras to get through the day's work. They are trying to get as much as they can out of what little time they have got. I suppose that is understandable. What I think will happen is that you will get the really expensive films and then the low-budget ones. The middle range, the ones that I have been doing, are going to dwindle. The profits are not high enough, and they take too long to get them back, but there are exceptions of course. I recently saw a film called *Buried* (2010), which cost a million dollars to make and they made thirty million profit.

On a big scale, they may not be excited about making so much, but when it only costs one million, a profit of thirty million is very good. So if you can bring it down to small scale, small budget, and manage to make that sort of money, you're happy. People are going to be thinking about that much more with the technology that is coming out.

Do you think shooting time has been cut right down due to lighter and smaller cameras?
Oh, yes. It's not like the older DPs who had to emulate what the contrast between the light and the dark would be with only 50 ASA. They had to put so much light in there and make it look as natural as possible. Now you can literally

do it to the eye. Whatever you see basically the film records. Also the cameras are a lot lighter, a lot smaller, and the film stock has so little grain on it. Everything has been brought up to an incredible standard, so this is part of the reason films can be shot in less time.

Filmography

Unmasked Part 25 (1989, Anders Palm)
Murder on Line One (1989, Anders Palm)
Murder Blues (1991, Anders Palm)
Death Machine (1994, Stephen Norrington)
Crazy for a Kiss (1995, Chris Bould)
The Passion of Darkly Noon (1995, Philip Ridley)
Small Faces (1996, Gillies MacKinnon)
Trojan Eddie (1996, Gillies MacKinnon)
The Full Monty (1997, Peter Cattaneo)
Photographing Fairies (1997, Nick Willing)
The Mighty (1998, Peter Chelsom)
Hideous Kinky (1998, Gillies MacKinnon)
Gregory's Two Girls (1999, Bill Forsyth)
Saving Grace (2000, Nigel Cole)
Hamlet (2000, Michael Almereyda)
New Year's Day (2000, Suri Krishnamma)
There's Only One Jimmy Grimble (2000, John Hay)
Serendipity (2001, Peter Chelsom)
The Glow (2001, Marcus Dillstone)
The Guru (2002, Daisy Von Scherler Mayer)
Pure (2002, Gillies MacKinnon)
Ella Enchanted (2004, Tommy O'Haver)
Shall We Dance? (2004, Peter Chelsom)
A Lot Like Love (2005, Nigel Cole)
Tara Road (2005, Gillies MacKinnon)
Fade to Black (2006, Oliver Parker)
Tsunami: The Aftermath (2006, Bharat Nalluri)
Miss Pettigrew Lives for a Day (2008, Bharat Nalluri)
Last Chance Harvey (2008, Joel Hopkins)
An Education (2009, Lone Scherfig)
Cupid (2009, TV Series, Bharat Nalluri)
Made in Dagenham (2010, Nigel Cole)

Christopher Challis, BSC, RPS

(1919–)

Christopher Challis was born on March 18, 1919, in Kensington, London. His father was a motorcar designer, and Challis had a private education, attending King's College School in Wimbledon, London. He first started working for Gaumont British in their newsreel department. Later, he photographed fourteen features for writer Emeric Pressburger and director Michael Powell. They ran a company called The Archers.

Challis was a founding member of the British Society of Cinematographers (BSC) and is now an honorary member. He was president from 1962 to 1964. He is also a member of the Royal Photographic Society (RPS).

Were you interested in films as a child?
I was interested in photography, and it became my hobby when I was a schoolboy. I had an old box camera, and I would do the printing out. You didn't need a darkroom. I became interested because of that. Then later on my father had a very good American friend who used to come over every year. He was a motor racing enthusiast who used to shoot 16mm films of all the races that he went to. He gave me a 16mm Bell and Howell camera, and that was the start of me using a movie camera. I fiddled around with that a bit and photographed a newsreel of the events at my school.

How did you get into the film business?
I first came in the business because my father knew a gentleman called Castleton-Knight, who was the managing director of Gaumont British News. I was very keen to get into the film industry in any shape or form. My father had no doubt given Knight a glowing account of these wretched films I'd made at school. Knight said, "Send him up, and I'll take a look at them." So I went up to Film House in Wardour Street, London, where their newsreel was based,

with my projector and those wretched films and showed them to him. He was very noncommittal. He didn't say anything any way. He just had a look at them, and they all looked ridiculous. It was a small picture in the corner of a big screen. Anyway, I was lucky, I think, because the period coincided with the newsreels starting to record sound. Up until that time, they didn't. The newsreel cameramen had worked alone. They were more like press photographers. The cameras were comparatively simple. With the advent of sound and all of its equipment, they needed extra people. They had three sound units. My first job was going out with them and humping gear.

What year was that, and how old were you?
It was around 1936. I was eighteen and had just left school. I would get tea and bacon rolls for the cameramen from the Sudbury Dairy Café, which was next door to Film House. The camera staff would spend a day there when they were on call. I spent my first year virtually running errands. I would occasionally touch a camera and follow focus shots when they needed to have an extra person. I realised it wasn't what I wanted to do. I wanted to work on feature films. I enjoyed the newsreels because they were a tremendous experience, but I wanted to get into features. On the newsreels I went to about every event during the course of the year. I went to Ascot, the test match, and many other events. The newsreels were a big thing then. They had their own theatres, and apart from screening newsreels, they showed shorts and cartoons. There was a lot of competition in getting the news out first. They had all sorts of ways of spoiling the other people's chances. The rights to some big events were granted to one company.

What equipment was used?
For wild shooting (nonsound) there was the Debrie, Newman Sinclair, and Bell and Howell, which were clockwork driven. Some of the cameras were hand cranked. The sound system was British Acoustic, which belonged to Gaumont British. Vinton cameras were used for a lot of sound shooting. They were special cameras that recorded the sound on the same piece of film that was being shot. The cameramen hated it because the system was variable area (optical sound) and the processing had to be exactly right; it was all time and temperature. It was hated because they liked to go to the labs and say, "Give it another couple of minutes" or say, "I think it's underexposed because there wasn't much light." They couldn't do that anymore, so they all loathed it. It also meant a big crew because instead of the cameraman working on his own, like a press photographer, he was lumbered with a sound crew and a truck and all sorts of things.

Why did they use this system?
I think it was because they wouldn't need a separate sound camera. There were all sorts of problems with a separate sound camera.

How long did you work for Gaumont British?
I should think about a year or eighteen months. I somehow heard or read that
Technicolor, which was in its infancy, was coming to England to make a film
called *Wings of the Morning* (1937). I think up until then they had only made
about half a dozen films in America. The film was going to be made at Denham
Studios and on location in Ireland. I took my courage in my hands and went
down to Denham on my day off and asked for a job. It was an enormous cheek
really because I didn't know anything. I got a job as a loader. My visions of being
on the studio floor and mixing with the stars didn't happen. I ended up working
in the darkroom loading the three black-and-white negatives running side by
side in the camera. The magazines were enormous, great, heavy things because
to produce a thousand feet you had three thousand.

Yes, Alex Thomson and Jack Cardiff told me how cumbersome they were.
Jack Cardiff [1914–2009] worked for Denham as a camera operator. He
worked on *Wings of the Morning*. Everyone else on it was American. They
came over lock, stock, and barrel and brought the cameras with them. If you
made a Technicolor film, you had to use their cameras because they were de-
signed and built by them and they had to process the film. It was quite unlike
Eastmancolor. Technicolor had a huge staff and a big camera department.
The cameras went back to Technicolor every night, where they were serviced
and delivered back to the studio the next morning. At that time they liked
their own cameramen if possible because they were trained to light a certain
way. Colour needed an enormous amount of light. Anyway, I worked through
that film, mostly loading, not having a lot to do with the production side of
it. During the course of making that film, Technicolor decided to build a
laboratory in Europe, because the demand for colour was growing overnight,
so to speak. It made just as big an impact as sound. They decided to build a
laboratory in London, England. At the end of *Wings of the Morning*, they kept
me on. I went to Technicolor, where their building was just nearing comple-
tion. All the equipment, including cameras, was in place. The equipment and
technicians had come over from the States. I worked with them, going through
the whole process. I was the first Englishman employed by them. They never
employed Jack Cardiff; he was a camera operator who subsequently did a lot
of work for Technicolor as a cameraman/operator. I worked at the laboratory
setting up cameras, so I had a pretty good knowledge of the process. There
was a tremendous amount to learn. The Technicolor camera was a very good
camera, which was beautifully made. Definition was the thing that defeated
the three-strip Technicolor process. As bigger screens came in, the definition
wasn't as good as, for example, Eastmancolor.

Technicolor colours seemed to be vivid. Why was this?

They need not have been. Everything had been made in Hollywood, and they were used to bright sunlight and bright colours. They liked it that way. It could be very muted. In fact, you had enormous control, which you didn't have with Eastmancolor. You started off with three black-and-white negatives in the camera, each shot through a tricolour filter. Each one recorded one of the primary colours. When shooting in Technicolor, we used to view the rushes in black and white. It took too long, and it was too expensive to produce colour rushes. A black-and-white rush print was made of the action, and you had a coloured pilot. A pilot was a shot of every scene. This was a test strip. Usually we saw the pilots a couple of days after viewing the black-and-white rushes. They either looked all right, or they didn't. When you saw them cut together, they were wildly different. When they made the first answer (ungraded print), they used the data, which they had recorded from making these tests. The rushes were all in colour with Eastman but not three-strip.

In the early days, Eastman wasn't very successful because it was a negative/positive process. So it was a direct print, but the control wasn't very good. Technicolor processed some of the films. They made three separation negatives from the Eastmancolor film, but it suffered from the same problem of definition.

How long did you work for Technicolor?

Right up until the outbreak of war. I then went into the RAF as a cameraman.

Did you go straight back into a film studio after leaving the RAF?

Yes, I did. Jack Cardiff, who I had worked with before the war on travelogues called *World Windows* as a technician, was working on *A Matter of Life and Death* (1946), which was also called *Stairway to Heaven*, and they needed a second unit to photograph, among other things, the motorcycle accident and the death of the doctor; it was quite an involved sequence. Jack suggested to Michael Powell [1905–1990], the director, that I should do it. I had to go up and see Micky, rather dauntingly, because I wasn't really all that experienced. Anyway, I got the job. Then the camera operator on the main unit, Geoff Unsworth [1914–1978], was offered a film as a DP [director of photography]. He told Micky, and Micky said, "You should take it. It's a big break, and we are nearly through now." I took over from Geoff as the operator. I finished the film and then went to operate on *Black Narcissus* (1947). Jack Cardiff was the DP. I then went off to photograph my first film as DP, *End of the River* (1947), shot up the Amazon in Brazil, which was a difficult picture one way and another. Powell and Pressburger produced it, but they never had a very active part in it.

Christopher Challis (smoking pipe) working with child actors on *The End of the River* (1947). *Courtesy of Christopher Challis*

After I had finished that film, they were preparing to make *Red Shoes* (1948). I love ballet and wanted to work on the film. Jack Cardiff was the DP, and I persuaded them to let me come back as operator on the film. I did *Red Shoes* and wouldn't have missed it for the world. At the end of it, Micky asked me to be DP on *Small Back Room* (1949). From that moment on, I shot most of their pictures. I was offered *Peeping Tom* (1960), which I turned down because I didn't like the subject.

What were Michael Powell and Emeric Pressburger like to work for?

I loved it. Micky was a hard taskmaster. He could be very unkind. He was out to judge people, I think pretty quickly, and once he'd made a decision, he never altered it. If he didn't like you for one reason or another, it was best to leave. On the other hand, with the people he liked and respected, he was wonderful and was very loyal. He was one of those people who liked to be challenged. He liked people to stand up to him, and most people ran away. I got on great with Micky and Emeric.

I understand that Powell would run instead of walk round the set?

Yes, he did. He had a desk on the set with a secretary. Having lined a shot up, he left you to get on with it. He came back with a list of things he wanted to do. This was circulated so suggestions could be made.

What was it like working on Vistavision?

It was horrible. I hated it. My first contact with it was on *The Battle of the River Plate* (1956). It was originally going to be shot in Cinemascope, but Rank had a quarrel with them. John Davis [1906–1993] from Rank and Bert Easey, who was head of the camera department at Pinewood, went to the States to see a demonstration of Vistavision and signed up to shoot the film in it. Suddenly, the whole thing was changed to the new format. Vistavision required a special camera because the film ran horizontally. It took a frame similar to a Leica aspect ratio. It was called the Lazy 8 camera because it had eight perforations per frame and ran horizontally. The cameras were awful and badly designed. There were only a small number of cinemas that showed horizontal Vistavision. Most cinemas showed it in the normal way. This meant a normal 35mm negative (vertical projection) was struck from the horizontal version. The quality when screened horizontally was wonderful. The prints shown in ordinary 35mm weren't so good. I was glad to see the back of Vistavision; I thought it was poorly produced. And the camera was difficult to handle. I shot one more film in the process: *Ill Met by Moonlight* (1957). This was shot in black and white, and it was hard working in some of the locations, which involved mountain work. This was because of the camera, which was difficult and heavy.

At the same time as Vistavision, we had Cinemascope, of course. We also had various widescreen ratios, and they all required different headrooms, which was an absolute nightmare. If you were shooting in standard 35mm, you had to keep a clear area for the other various aspect ratios and keep microphones, mic shadows, and other things out of the frame. This meant all the lamps had to be higher in order to clear this area. This is one thing you don't want to do. The lower you get the lights, from a cameraman's point of view, the better.

So you were glad to get back to the Mitchell or the Panavision camera?

I was glad to get back to the Panavision camera, which was wonderful because it had all the good points of the Mitchell plus the direct look-through. It was designed in consultation with cameramen. I thought the Panavision equipment was excellent. Mechanically the Mitchell was excellent, but they didn't seem to liaise very much with the people that had to use them.

What was your most difficult film?

My most difficult film was *Saadia* (1953), shot in Morocco and directed by Albert Lewin. Al was a writer who had been head of the script department at

MGM. Once the script had been written and accepted, no deflection of any sort was permitted. Al went to Morocco to meet Francis D'Autheville, a Frenchman who had written a book, with the idea of turning it into a script. Al went around with D'Autheville and saw the places he had written about. Al came back with a script, and on the front page, it stated that all the locations were standing and waiting to be photographed.

I think this was the first Technicolor feature made entirely on location. They didn't want to bring it back to the studio at all. They didn't want any postsyncing. They wanted to get the right sound, and of course it was three-strip Technicolor, so we had this monstrous blimp. We had a mixed crew of Italian, French, and a few British. All locations, which Al had picked, were absolutely unsuitable. They were too small. He hadn't got the technical knowledge. One of the opening scenes was at a hospital in a doctor's office. The scene had eight or nine characters in it. The room Al had picked was too small. With the blimp and a couple of lamps, you couldn't get into the room. You could only get a waist figure of someone standing on the other side. There was no way we could shoot a group of people. We desperately tried to convince Al that you created a room by the way you shot it. You could shoot it on the set and have exactly the same effect.

One of the scenes required a white Arab stallion that could do tricks. We had to find a horse, and in my spare time, I went to look for one with Al. Nothing could be found that was right. Al would not make any compromises at all. It had to be a white stallion with a flowing white tail. Eventually they located one in Algeria, which belonged to a French army officer. The only person who could make it do anything was the groom. Al said, "Bring it here," but that was twelve hundred miles away. We brought over the horse and the groom, and we were all paraded in the morning. Al had a deaf aid. He couldn't hear anything. The production manager, Henry Henigson, was also stone deaf. We paraded at eight o'clock and produced this horse, which I thought was wonderful. Al tuned his deaf aid in, which was one of those old-fashioned ones with a box he wore around his neck, and said, "OK, let's see it do some tricks." The groom spoke to it, and it performed tricks, and everyone breathed a sigh of relief. There was a silence. Then Al said, "Someone hand me the script." He looked at it for a moment and then said to Henigson, "Henry, it ain't no good." Henry said, "What's wrong now Al?" He said, "It ain't got a long tail." They made several tails in England and the States, which were flown over. Because it was a mixed unit, there was an argument between makeup and props whose responsibility it was to put it on. In the end it was all sorted out.

Would you tell me a bit about working on 65mm?
Shooting on 65mm wasn't that much different to shooting on 35mm, except you needed more light because you had the same problem with depth of focus

as you had with Vistavision. You needed to stop down more in order to get the same depth of focus. I worked on 65mm Mitchell cameras and was DP on two 65mm productions. The first was *Those Magnificent Men in Their Flying Machines* (1965), followed by *Chitty Chitty Bang Bang* (1968). It was fun on both films. *Magnificent Men* was difficult because of the process work. We didn't have the sophisticated things they have now. We used a lot of travelling matte, which entailed a lot of problems, including depth of focus. The special effects were never easy in those days because we didn't have computers. You had to do it for real, so you always had problems with wires showing. Wires had to be painted to hide them. *Magnificent Men* entailed a lot of problems because the wire rigging on those old planes disappeared in the making of the matte, so we had to increase the diameter of it all. We had to make it much bigger so it worked on the blue backing. We then had the depth-of-focus problems because most of the shots were on a pilot in the cockpit and behind him was the rudder and the tail plane. We couldn't hold the depth of focus because the light level on the blue screen would only give us the maximum of about T4. We needed a lot more, so all the sets had to be redesigned so they would bring them into the depth of field. We had to learn as we went along.

Did a studio ever employ you?
For a short period, I was employed by Rank, which I absolutely hated. I always resented it. John Bryan [1911–1969], an art director who became a producer, whom I liked very much, did a picture called *The Spanish Gardener* (1956), which I photographed. John said, "Why don't you sign a contract with Rank? You will only work with me and photograph my pictures." I did that and went on to shoot several pictures, including *Windom's Way* (1957), directed by Ronald Neame [1911–2010]. John had a row with Rank and left. I was then left with the contract. I worked on a lot of rubbish because I had no option.

Would you tell me about working on the classic 1953 film *Genevieve*?
The whole film was typical of the British film industry. It was a wonderful script, and Henry Cornelius [1913–1958] was a jolly good director. I was asked to do it because George Gunn from Technicolor tried to persuade Henry to make the film in colour and Henry, while he would have liked to, said, "I haven't got the money." Gunn said, "I think I can find someone who will take the challenge." He roped me in and explained about the budget.

Henry said, "Most of it is on location. We are starting at the wrong time of the year for weather. I just cannot afford to wait endlessly to light. That is my situation. If there is enough light to shoot, we have to shoot. If you are willing to take it on under those conditions, I promise you that if there is anything that is absolutely frightful at the end and we have any spare money, we will reshoot it."

Everything apart from the Brighton locations was done in striking distance of the studio. The hilarious thing about it all, typical of Rank and their accountants, was they had spent a huge sum of money on what was called an independent frame. This device enabled us to shoot scenes against projected backgrounds, either still or moving. They had got the best back projection equipment available anywhere in the world. None of it was being used because it didn't work very well. It would have been a sitting duck for us. It was just what we wanted: two people sitting in a car and a simple screen behind projecting the road. It would have worked perfectly well. It would have been fine.

We couldn't use it because, although it was a Rank film, we hadn't got the money because of internal budgeting to rent the studios or rent the equipment. We had a low loader, which the camera crew mounted with a generator and a couple of lamps, so we shot it for real with a mock-up of the cars. It was better than back projection, but it's not good in terms of shooting for time. It took a long time to get everything on the road.

What was it like working for the great director Billy Wilder?
I worked with Billy Wilder [1906–2002] on *The Private Life of Sherlock Holmes* (1970). Wilder was very tough with the actors. He didn't allow any individual interpretation. What was in the script is what they had to say. He was a wonderful director. He shot long takes, and he didn't cover. He didn't shoot anything he didn't use.

Another one like Wilder was Carol Reed [1906–1976]. He was like a watchmaker: He knew exactly what he was going to use and how he was going to use it in the final cut, so you shot very little extra.

Did you have a favourite star you worked with?
My favourite star was Sophia Loren [1934–]. She was absolutely great, brilliant. She knew how to look her best, and she knew where the lights needed to be to make her look her best. She was great fun.

One actor I didn't get on too well with was Rex Harrison [1908–1990], whom I worked with on *Staircase* (1969). We had a big row at the beginning of the film. The film was shot in Paris but set in London. Rex wanted his entire wardrobe made in Italy. His wardrobe came to Paris, and director Stanley Donen [1924–] wanted to shoot a test. We did the shoot, and it looked what it was: Rex Harrison standing up against a white background. We ran it at the rushes, and Rex didn't like it. He said, "I have never been so badly photographed in my life. I refuse to be in a picture like that." I said, "Rex, I am working for Stanley Donen, not you. This is what he wanted." Rex stomped off the set and left Paris. He said he wouldn't return unless I apologised. Stanley Donen said, "You are not going to apologise, and if he doesn't come back, we will sue him."

Eventually he came back. He never apologised, and neither did I. So we weren't the greatest of buddies.

So there was a bit of tension while making the film?
Yes, there was a lot of other tension because of Richard Burton [1925–1984], who starred with Harrison. He was a nightmare, really, because we were working French hours. We started shooting at twelve o'clock and worked straight through without a break. Of course by the time we were ready to shoot something, Richard Burton was usually a little worse for wear because of drink. Rex was at loggerheads with him because of this, so one way and another, *Staircase* wasn't a very happy film.

You worked with Richard Burton on *Villain* (1971). What was he like on that?
All right. I always got on with him. If he wasn't ready to shoot, there was nothing I could do about it. Sometimes he couldn't remember his lines. It was a tragedy, really, because he was a wonderful actor. It didn't show on the screen because we had to shoot round it or not use him when he was in that sort of state.

What was Peter Sellers [1925–1980] like to work with?
Peter was a very funny man on screen but wasn't very funny off the set. Like a lot of comedians, he wasn't a very cheerful, happy man, but he was great to work with.

Out of all the films you have worked on, do you have a favourite?
I have more than one. Technically *Tales of Hoffman* (1951) was my favourite film. Not technically I would pick some of the films I did with Stanley Donen, such as *Arabesque* (1966) and *Two for the Road* (1967).

Which film took the longest?
The longest was *The Victors* (1963), which took around a year. We had problems finding locations, and the director/producer, Carl Foreman [1914–1984], wanted it exactly as he saw it and was prepared to take the time. It was a big film. There were locations in Sweden and Italy. Carl wanted me to find the locations. I went around with the art director, Geoff Drake. Sometimes Carl didn't like what we had found, and so we had to go back and try again. We spent a lot of time not shooting but working out how we were going to shoot. Carl, who was a writer by profession, didn't have a good visual sense. He found it very difficult to imagine anything until he actually saw it. He wasn't sure it would work until he saw it in rushes. He wasn't unique in that respect. One of the greatest directors of all time, Billy Wilder, was like that.

Christopher Challis lighting *The Victors* (1963). Romy Schneider in foreground.
Courtesy of Christopher Challis

What was your shortest film?

It was a film made for television called *In This House of Brede* (1975), directed and produced by George Schaefer [1920–1997]. George was absolutely great. I thought it was going to be awful. I almost regretted signing up for it. I knew it had an incredibly tight schedule and budget. It was shot in a convent in Mill Hill, London, and at another one in Ireland. I met the director, and he had it worked out exactly how he was going to do everything. He had rehearsed all the scenes with the actors before we got onto the shooting stage. When we arrived at the convent, the room we were to shoot in wasn't like what we had in our imagination. George would say to me, "Chris, I can change anything. What is going to make it easier?" I would say to George, "If we shot all this one way or out of context, it is going to save a lot of time because we have no room in here at all and it will make life a lot easier." George said, "OK, we will do it." Because he had prerehearsed everything, it went pretty well.

Did you have a favourite director?

I liked working with Stanley Donen and Michael Powell, not because they were the best directors. They were ardent filmmakers and fun to work with. They were very creative, and they both a very good visual sense, which made it very interesting from a cameraman's point of view.

Chistopher Challis, producer Lord Brabourne, and director Guy Hamilton on the set of *Evil under the Sun* (1982). *Courtesy of Christopher Challis*

Did you usually keep the same crew?
As much as I possibly could. We were all freelance, of course, so sometimes there were periods where you didn't have work. If your operator had a chance of another film, he had to take it, so you did lose people. I was very lucky. I managed to keep people for quite a long while. Freddie Francis [1917–2007] was my operator for quite a while and then the late Austin Dempster [1921–1975], who was a wonderful operator.

Filmography

The End of the River (1947, Derek N. Twist)
The Small Back Room (1949, Michael Powell)
Gone to Earth (1950, Michael Powell and Emeric Pressburger)
The Elusive Pimpernel (1950, Michael Powell and Emeric Pressburger)
The Tales of Hoffmann (1951, Michael Powell and Emeric Pressburger)
The Wild Heart (1951, Michael Powell and Emeric Pressburger)
Angels One Five (1952, George More O'Ferrall)
24 Hours of a Woman's Life (1952, Victor Saville)
The Story of Gilbert and Sullivan (1953, Sidney Gilliat)
Genevieve (1953, Henry Cornelius)
Twice upon a Time (1953, Emeric Pressburger)
Saadia (1953, Albert Lewin)
Flame and the Flesh (1954, Richard Brooks)
Malaga (1954, Richard Sale)
Raising a Riot (1955, Wendy Toye)
The Sorcerer's Apprentice (1955, Michael Powell)
Footsteps in the Fog (1955, Arthur Lubin)
Oh . . . Rosalinda!! (1955, Michael Powell and Emeric Pressburger)
The Adventures of Quentin Durward (1955, Richard Thorpe)
The Battle of the River Plate (1956, Michael Powell and Emeric Pressburger)
The Spanish Gardener (1956, Philip Leacock)
Ill Met by Moonlight (1956, Michael Powell and Emeric Pressburger)
Miracle in Soho (1957, Julian Amyes)
Windom's Way (1957, Ronald Neame)
Rooney (1958, George Pollock)
The Captain's Table (1959, Jack Lee)
Floods of Fear (1959, Charles Crichton)
Blind Date (1959, Joseph Losey)
Sink the Bismarck (1960, Lewis Gilbert)
Never Let Go (1960, John Guillermin)
Surprise Package (1960, Stanley Donen)
The Grass Is Greener (1960, Stanley Donen)
Five Golden Hours (1961, Mario Zampi)
Flame in the Streets (1961, Roy Ward Barker)

H.M.S. Defiant (1962, Lewis Gilbert)
An Evening with the Royal Ballet (1963, Anthony Asquith and Anthony Havelock-Allan)
The Victors (1963, Carl Foreman)
The Long Ships (1964, Jack Cardiff)
A Shot in the Dark (1964, Blake Edwards)
Those Magnificent Men in Their Flying Machines or How I Flew from London to Paris in 25 Hours 11 Minutes (1965, Ken Annakin)
Return from the Ashes (1965, J. Lee Thomson)
Arabesque (1966, Stanley Donen)
Kaleidoscope (1966, Jack Smight)
Two for the Road (1967, Stanley Donen)
A Dandy in Aspic (1968, Anthony Mann and Laurence Harvey)
Chitty Chitty Bang Bang (1968, Ken Hughes)
Staircase (1969, Stanley Donen)
The Private Life of Sherlock Holmes (1970, Billy Wilder)
Villain (1971, Michael Tuchner)
Keep Your Fingers Crossed (1971, Dick Clement)
Mary Queen of Scots (1971, Charles Jarrott)
Follow Me! (1972, Carol Reed)
The Boy Who Turned Yellow (1972, Michael Powell)
A War of Children (1972, TV Movie, George Schaefer)
The Little Prince (1974, Stanley Donen)
In This House of Brede (1975, George Schaefer)
The Old Curiosity Shop (1975, Michael Tuchner)
The Incredible Sarah (1976, Richard Fleischer)
The Deep (1977, Peter Yates)
Force 10 from Navarone (1978, Guy Hamilton)
The Riddle of the Sands (1979, Tony Maylam)
S.O.S. Titanic (1979, TV Movie, William Hale)
The Mirror Crack'd (1980, Guy Hamilton)
Evil under the Sun (1982, Guy Hamilton)
The Nativity (1982, Barry Chattington)
Secrets (1983, Gavin Miller)
Top Secret! (1984, Jim Abrahams, David Zucker, and Jerry Zucker)
Steaming (1985, Joseph Losey)

Awards

The Victors (1963), British Academy of Film and Television Arts nomination
Those Magnificent Men in Their Flying Machines or How I Flew from London to Paris in 25 Hours 11 Minutes (1965), British Academy of Film and Television Arts nomination
Arabesque (1966), British Academy of Film and Television Arts Best Cinematography Award
The Deep (1978), British Academy of Film and Television Arts nomination

CHAPTER 6

Peter Suschitzky

Peter Suschitzky was born in London and is the son of legendary photographer and cinematographer Wolfgang Suschitzky [1912–]. Suschitzky's first passion was with music, but he decided to work with film. He went to the Femis Film School in Paris, France, and the cinematographer-in-residence, Jean-Pierre Mundviller, showed him a hand-cranked camera and demonstrated it by singing a marching song to keep a steady eighteen frames per second. Suschitzky has shot a number of films for David Cronenberg [1943–]and prefers to operate himself. He says he could tell an operator how to start and finish but would have no control in between.

What got you interested in the film business? Was it because your father was in it?
It was because my father was a photographer that I became aware of images from a very young age. I saw him disappearing into the darkroom. I wanted to know what happened in that darkroom. I would knock on the door from the age I could walk up the stairs. He would let me in for a short while. I would then get bored, but I became very interested in the magical process of transforming reality into photographic images.

Did you go and watch your father at work on the film sets?
I did but very rarely. I saw him more with his still camera, and I started taking photographs and processing them. Sometime in the 1940s, I went to Dover to watch him shoot a documentary. I went to see him on the set of *The Bespoke Overcoat* (1956).

Peter Suschitzky. *Courtesy of Peter Suschitzky*

So you were influenced by your father?

Yes. He used to come home with little test strips from his movie making called Cinex strips. They were strips of twenty images, which went from very light to very dark. The director of photography picked the density as he wanted the print to be made at. He gave me some of those strips, and I made a little homemade cinema and put them into the screen area. When I say a homemade cinema, it wasn't a functioning one. I just dreamt myself into it being a picture palace.

So you were very interested in the cinema?

I was just fascinated by the construction of movies. The first time I think I saw a film was on my birthday when a colleague of my father brought round a 9.5mm projector and showed Charlie Chaplin films. Or it could have been when I was taken to see *Dumbo* (1941) around 1948. I can't remember which came first.

How did you get to work in cinematography?

As a child I took up photography as a hobby, and I became more and more involved with it. My first passion, however, was music, and I said to my father when I left school that I wanted to become a musician. He said, "Keep that for pleasure." I went to the Femis Film School in Paris, France, but because I was impatient, I only stayed there a year.

At nineteen I became clapper boy in a commercial studio based in London. Still impatient, I got bored with that and asked to be transferred to their documentary division. The company was called World Wide Films. They made documentaries as well as commercials. I wanted to work in documentaries because I knew they had small crews and I'd be a focus puller as well as a loader. I was obviously a very impatient young man.

What was your first job as a clapper boy?

It was a commercial. After a few months on the documentaries, a director asked me if I would like to go to the United States as an assistant on a series of documentaries for a German TV documentary film crew out in the States. Then the producer of that company saw some of my stills. He said, "Would you like to work as a cameraman in Latin America?" I jumped at the opportunity. I was then twenty-one.

Did you go straight in as a DP [director of photography]?

I went straight in as a DP. I spent a year in Latin America, shooting in 16mm black and white, photographing political and sociological subjects.

How long were you at that before going into features?

I spent a year in Latin America. I could have stayed on. They didn't ask me to leave, but being as impatient as ever, I thought, "Really what I lack is experience in drama." I had had enough of reality. I wanted to create fiction and get experience in studios and so on. I came back to London with a lot of stills I had taken in Latin America and showed them to Kevin Brownlow [1938–]. Brownlow had been an editor and was going to make a film on weekends and asked if I'd like to be the cinematographer. So it was really through my stills that I got my first two important jobs as a cinematographer in documentaries and features. I photographed Kevin Brownlow's film *It Happened Here* (1965) at the age of

twenty-two, and it gave me a kind of visiting card. I could say I'd made a feature film. It was bought by United Artists and had a screening in the West End, even though it was only at one cinema. It was a fantastic break.

What did you do after that?
After working with Kevin Brownlow, I did some more documentaries, including one about Francis Bacon. I also did commercials and short films. Then I was asked to shoot *Privilege* (1965), directed by Peter Watkins [1935–]. That was my first real professional feature film in colour.

It is reported that you also helped to shoot the Peter Watkins film _The War Game_ (1965).
This is an error. I didn't work on that film. I shot *The Peace Game* (1969), also known as the *Gladiatorerna* with Watkins, after shooting *Privilege* (1967).

Which film took the longest to shoot, and which was the shortest?
The longest was *The Empire Strikes Back* (1980) and probably one of Ken Russell's [1927–] films that went over schedule. The shortest, I don't know. I think *The Rocky Horror Picture Show* (1975), which took six weeks, was one of the shortest.

Do you have a favourite camera?
I want a camera that has a good look-through and a good finder. I preferred on the whole to work with Panavision cameras up until three years ago. I recently worked with Arri cameras. The camera does not matter, and I will be shooting digital in two weeks' time on a movie called *Cosmopolis*, directed by David Cronenberg.

Did you work on the Mitchell camera?
Yes, I shot many movies with a Mitchell rack over. It was a terrific camera. It had an offset finder, which meant that what you saw in the finder was not what went onto the film precisely. It was the parallax. It needed a lot of experience to successfully shoot with it. In those days I worked with operators. I haven't for a long time. I have operated myself for many years, and I prefer that. In fact, I resent the British term *lighting cameraman*, the only country that uses it. It is an apt description for what they did to DPs in this country. They sidelined them into lighting only. The operators would muscle in and choose the setups with the director. In America they consider, quite rationally, that if somebody becomes a cinematographer after a number of years it's because they merit it and have opinions, not only about the lighting but where to put the camera and which lenses to use. If a director wants to decide all that by himself, fair enough,

but a lot of directors want input from the cinematographer, so I don't want to work with operators that want to dominate that part of it and I don't want to be called a lighting cameraman either.

A lot of cinematographers now do their own operating, don't they?

Well of course you must understand that probably some producers love it because it's cheaper for them. However, on very expensive films, I work with an operator. The higher the budget, the more pressure there is, and if the production falls behind schedule, they may point to the director of photography. I have never fallen behind with any of the films I have done both jobs on.

How many do you have on your crew?

We have a focus puller and a loader. Sometimes we have two loaders. We also have a grip.

Don't you find it a lot harder doing both jobs?

I find it better. Because there is no separate operator, there are no disagreements where to put the camera, unless it's with a director, of course.

Do you have a favourite film you have shot?

A Dangerous Method was most enjoyable to work on. I have enjoyed working on nearly all of them.

Are there any DPs you admire?

I am reluctant to name names. I look at films primarily as a member of the audience, and I wish to be sucked into the narrative and the characters on the screen. I don't primarily look out for the photography. Inevitably I do take notice of it, especially if the film is bad. One of the films I keep going back to for visuals is *Sunrise* (1927).

Where in the world have you worked?

I have worked in a lot of countries. I haven't done so much work in Asia. I have worked in Australia, all over Europe, the United States and Canada, and South America.

Have you done a lot of studio work, and do you have a favourite?

I have done an enormous amount of studio work. I don't have a favourite. I get drawn into the project, and I forget where I am when I'm working. It may sound quite banal, but I like to have a decently cooked lunch, I like the toilets to be clean, and some studios have neither.

Have you won many awards, and would you like to win an Oscar?
I haven't won that many awards. I don't expect to get an Oscar because the films I'm drawn to are not the kind of films that get Oscars. On the whole to get an Oscar it helps if you shoot something in an exotic location or in period costume or, if they are neither of those, it is if your film does extremely well commercially. I've missed a couple of chances. For personal reasons I didn't do two films that were offered to me, both of which won Oscars for cinematography.

What was your most demanding film from a technical point of view?
I'm sure my early films were more difficult because I was not as confident. All films are difficult. They all make tremendous demands, not just physically, but also on the imagination.

What advice would you give a new cinematographer?
My advice is to develop your hobbies. You are bound to have gaps between your films. It may sound like a lighthearted thing to say, but it's serious. It is not an easy career to have.

Do you prefer a particular film stock, for example Kodak and Fugi?
I've tried varies stocks. I test quite rigorously before each film. I've worked with Kodak on my last few films, but I have shot films on Fugi stock. I'm very thankful they have to compete with each other; it's given us a lot of choices. For many years we didn't have a choice at all. There was one stock available for a long time, which was slow and hard to use. Because of competition we have a lot of choices, and now I am afraid they are on their way out. Film stock is threatened by digital.

You will be shooting digitally on *Cosmopolis*. Have you shot digitally before?
I have done digital shoots on commercials and the odd documentary.

Do you see features being shot totally digital in the not-too-distant future?
Yes, I do. I think in around a year's time most productions will be shot digitally. There is a tremendous investment in projectors, cameras, and all the transfer equipment, so there is commercial pressure for us to move into the digital area. I shall miss film, and I feel I have had a relationship with film all my life, and it's not quite finished yet, and my relationship is going to be cut off before I am ready for it. I love film for many reasons. I'm not entirely sad to shoot digitally for several reasons. Now when we finish a film, we almost always digitise the film. It looks terrific when we view it on a big screen in the digital suite, in the digital format, from the film to the digital file. When we print it, we lose a lot

of quality, so I would rather stay digital once we have gone from film to digital. I don't really mind how I shoot as long as it looks as good as film or better. The demands on the imagination are the same.

You can put the film look into digital, can't you?
You can do all of that, and you can get over the problem of scratching and dirt.

What do you make of filmmaking today?
There are fewer films being made. I am very sad that independent cinemas are closing down all over the place. People in many countries don't seem to be very interested in the smaller films. There are more people looking for less work. It is a problem.

Do you always use a light meter?
I use my eyes first and just before we shoot I check things up on the light meter.

Did you consider becoming a director?
I've thought about it from time to time. As long as I can find interesting projects to work on as a cinematographer, I shan't feel that I'm a frustrated director. I wouldn't want to do just anything as a director. It's such a personal commitment. I would want to do a personal type of film, and they are becoming harder to finance.

Was *It Happened Here* (1965) photographed in 16mm or 35mm?
I believe it started out on 16mm before I joined them. When I joined it was 35mm. We had short ends from Stanley Kubrik's *Doctor Strangelove* (1964).

Do you often have a second unit on your films?
Not often. I have had a second unit on large-budget action films like *The Empire Strikes Back* and *Krull* (1983). Usually there is no need for a second unit because I do more intimate films.

Do you get involved in the special effects photography?
It depends which process is being used. These days there is a lot of green screen work, which I get involved in. I've done blue screen, front projection, back projection, and some which are not used anymore.

Do you have a favourite David Cronenberg film you have worked on?
I think my two favourites are *Naked Lunch* (1991) and *Dead Ringer* (1988).

What was it like working on *The Rocky Horror Picture Show* with Jim Sharman [1945–]?

Peter Suschitzky on the set of *Naked Lunch* (1991). *Courtesy of Peter Suschitzky*

We only had six weeks to shoot it, so everything had to go very quickly. We had one advantage, which was that the cast was the same that had played it on the stage. That helped us to move along quickly.

Do you usually shoot in continuity?

No, we don't usually shoot in continuity because there are many demands. There is the availability of actors who may not be on the film all the time but only come in for their parts. It is very rare that we can shoot in continuity. It is good for the actors and the director to shoot early scenes in the film first. This allows the actors to build up their characters slowly rather than plunge into the middle or the end of it.

You did two films with Waris Hussein [1938–] and two with Ken Russell. Could you tell me a bit about them?

They are very different. The two Ken Russell films are from the middle of his career when we were able to get reasonably big budgets, which were generously spent on production values. The first I worked on with Hussein was *A Touch of Love* (1969). Hussein was a good director, especially with actors. A lot of it was shot in the studio. This was my first studio film, and I had to learn quickly how

to cope with the sound boom, which in those days was a large piece of machinery on which the microphone was placed. It was called a fisher, and I quickly had to learn how to avoid casting shadows on the set. Another film with Hussein was *Melody* (1971). It was an Alan Parker script written before he went into directing and was shot around the Hammersmith area in London.

What was it like working for Ken Russell?
I was lucky to work on his films because the production values were large and generous. In other words we had big sets to play with. Ken always put a strong emphasis on the visual side of the films he directed, so I have worked on good films with Russell.

Did *Litzomania* (1975) take long to shoot?
I think it was quite a long shoot and that we may have gone over schedule. On the first day of shooting, a young actor playing Wagner had to fly. The wire broke, and he fell and broke his leg, so we had to reschedule a lot of the shooting.

Would you tell me a bit about working on the other Russell film, *Valentino* (1977)?
Again, very interesting to shoot. We had an unusual star in the shape of Rudolf Nureyev, whom I got to know a bit and liked a lot. I think both of Russell's films were an adventure for me in those days. Nureyev was annoyed one day, I remember. Ken tried to provoke him by asking an actress to push her breasts into his face. He felt insulted by it and walked off for half a day. That was the only time that he was upset, and I understood why. Ken just wanted to be provocative.

Are there any other films that stand out?
I shot a film with Albert Finney called *Charlie Bubbles* (1967). The atmosphere on it was just lovely. Filmmaking has become more of a factory process than it was then. Having said that, I had a delightful time on my last film, *A Dangerous Method* (2011). It was just wonderful working with David Cronenberg, who knows just how he's going to use the material. He doesn't do many takes or angles. He used to do a lot of coverage but doesn't now. He is very confident. Part of the pleasure in filmmaking comes from the people around me. I try to choose my part of the crew, in other words the lighting technicians, the camera technicians, and the grip [a person that sets up camera and tracks]. I try to choose people that are good at their jobs and are nice to be with. You're always working under stress no matter what you do.

Do you have an agent?
I have an agent in Los Angeles. Sometimes he puts films forward, but usually the films are offered by the directors, and the agent deals with fine print.

You did two pictures with director Claude Whatham [1927–2008], *That'll Be the Day* (1973) and *All Creatures Great and Small* (1975). What were they like to work on?

That'll Be the Day was shot on the Isle of Wight and was great fun to work on. *All Creatures Great and Small* starred a young Anthony Hopkins [1937–]. The first scene we did with him was with a dog he was putting to sleep. No one had told the owner of the dog that the dog should not be fed for a number of hours before the shoot. The dog defecated in this very small room, and we were all gagging from the smell. Being the professional that he is, Hopkins carried on with the scene.

Your passion is music. What kind of music do you like, and can you play any instruments?

I love classical music, and I play the flute for my own amusement. I once played at the Hollywood Bowl but not professionally. One day we were working there, and we stopped for lunch, and I discovered that one of the actors also played, so we did a duet on stage. My favourite composer is Bach. I also like some of the pop music from the '60s, but I don't seek it out.

Cinematographers can't make or break a film. What I think is essential for a good film is a good script, and sometimes I don't mind a badly photographed, well-scripted, well-acted film. We as cinematographers can contribute a lot. We can enhance the atmosphere and the feeling of the film through what we bring to the framing and the lighting, so our job is a very important one.

Filmography

The Meeting (1964, Mamoun Hassan)
Trinidad & Tobago (1964, Documentary, Geoffrey Jones)
It Happened Here (1965, Kevin Brownlow and Andrew Mollo)
Road to St. Tropez (1966, Michael Sarne)
Privilege (1967, Peter Watkins)
Charlie Bubbles (1967, Albert Finney)
A Midsummer Night's Dream (1968, Peter Hall)
Lock Up Your Daughters! (1969, Peter Coe)
Gladiatorerna (1969, Peter Watkins)
A Touch of Love (1969, Waris Hussein)
Leo the Last (1970, John Boorman)
Figures in a Landscape (1970, Joseph Losey)
Melody (1971, Waris Hussein)
Henry VIII and His Six Wives (1972, Waris Hussein)
The Piped Piper (1972, Jacques Demy)
That'll Be the Day (1973, Claude Whatham)

Hallmark Hall of Fame (1975, TV Series, David Greene and Clive Donner)
All Creatures Great and Small (1975, TV Movie, Claude Whatham)
The Rocky Horror Picture Show (1975, Jim Sharman)
Lisztomania (1975, Ken Russell)
Valentino (1977, Ken Russell)
Star Wars: Episode V: The Empire Strikes Back (1980, Irvin Kershner)
Krull (1983, Peter Yates)
Falling in Love (1984, Ulu Grosbard)
In Extremis (1988, Olivier Lorsac)
Dead Ringers (1988, David Cronenberg)
Where the Heart Is (1990, John Boorman)
Un homme et deux femmes (1991, Valerie Stroh)
Naked Lunch (1991, David Cronenberg)
The Public Eye (1992, Howard Franklin)
The Vanishing (1993, George Sluizer)
Fallen Angels (1993, TV Series, Tom Cruise)
M. Butterfly (1993, David Cronenberg)
Immortal Beloved (1994, Bernard Rose)
Crash (1996, David Cronenberg)
Mars Attacks! (1996, Tim Burton)
The Man in the Iron Mask (1998, Randall Wallace)
EXistenZ (1999, David Cronenberg)
Red Planet (2000, Anthony Hoffman)
Spider (2002, David Cronenberg)
The History of Violence (2005, David Cronenberg)
Shopgirl (2005, Anand Tucker)
The Stone Council (2006, Guillaume Nicloux)
Eastern Promises (2007, David Cronenberg)
A Dangerous Method (2011, David Cronenberg)
Cosmopolis (2012, Preproduction, David Cronenberg)

Awards

Valentino (1977), British Society of Cinematographers nomination (1977) and British Academy of Film and Television Arts nomination (1978)
Dead Ringers (1989), Genie Award for Cinematography
Where the Heart Is (1990), National Society of Film Critics Cinematography Award
Crash (1996), Genie Award for Cinematography
Eastern Promises (2007), Genie Award for Cinematography
International Cinematographers Film Festival Manaki Brothers' Life Achievement Award (2009)

CHAPTER 7

Gilbert Taylor

(1914–)

Gilbert Taylor was born on the April 12, 1914, in Bushey Heath, Hertfordshire. He was the son of a successful builder, and it was taken for granted that he would join the family business. At fifteen he was studying to be an architect but really didn't want to be one. His heart was in films, and when he was given by a neighbour the opportunity to become a camera assistant, it was his mother who persuaded his father that he should go for it.

He joined the film business in 1929 as an assistant to cinematographer William Shenton. Taylor said that he and Shenton shot the last two silent pictures to be made at Gainsborough's studios in Islington, North London. His first job was to hand crank a wooden Williamson camera and to make sure it was loaded with film. He also appeared in a few of these films. He went to Paris with Shenton to shoot several boxing movies. After that it was back to Gainsborough to make his first talkie, *Third Time Lucky* (1931), directed by Walter Forde [1896–1984]. Eight months later he was working with legendary cinematographer Freddie Young [1902–1998] at Elstree.

He picked up a lot from people like Franz (Fritz) Planer [1894–1963] and Günther Krampf [1899–1950]. They let him cover second unit work when they were required elsewhere. By 1934 he was operating. During the war he was an officer and cameraman in the RAF. After hostilities ceased he returned to operating.

Taylor operated on a number of memorable films, including *Brighton Rock* (1947), photographed by Harry Waxman [1912–1984] and starring a young Richard Attenborough [1923–]. He went on to become a director of photography (DP), working on a great number of films, including *Star Wars: Episode IV: A New Hope* (1977) with George Lucas [1944–].

Gilbert Taylor. *Courtesy of Gilbert Taylor*

How did you first get interested in films?
I had an uncle who was a newsreel cameraman, and when I was twelve, I was cleaning the brass on his Williamson camera. In 1929 I was training to be an architect. Then I got a call. Mother said "Yes," and Dad said "No." Mother won, and I went to drive for cinematographer Bill Shenton, going to and from Isleworth, London. He was fond of his drink so needed someone to drive him around. He took me to Paris, where I worked on two silent movies. I came back and went to Gainsborough and then British International Pictures. I then worked with Alfred Hitchcock [1899–1980] as second camera assistant on *Number 17* (1932).

You were not a clapper boy for very long?
I went to Germany on *Escape Me Never* (1935) with Freddie Young and two German cameramen, Sepp Allgeier [1895–1968] and Georges Périnal [1897–1965]. A huge film it was, directed by Paul Czinner [1890–1972] and edited by David Lean [1908–1991]. I think I was sixteen and was very keen. I went on to work at British and Dominions in London and worked in booths with the cameras when sound came in. Sometimes there were four cameras at one time, and when you are loading film for that lot, you were going through around fourteen thousand feet of film a day.

Do you have a favourite that you worked on?
My favourites are *Repulsion* (1965), *Cul-de-sac* (1966), and *Dr. Strangelove* (1964).

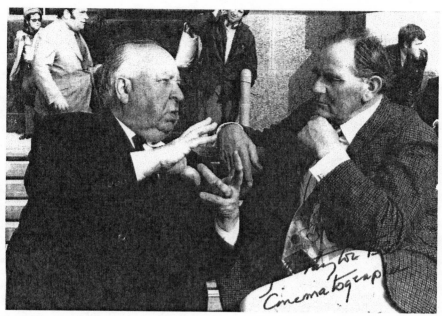

Alfred Hitchcock in discussion with Gilbert Taylor. *Courtesy of Gilbert Taylor*

Did you have a favourite director?

Not really. I loved working with Roman Polanski [1933–] and Alfred Hitchcock. Hitchcock was a gentleman. He treated you like someone special, looked after you, and paid you well. When I first worked with him, I was called Gillpots. He was a great man to work for. In 1939 I went into the RAF, and I was demobbed in 1945.

What was it like working with the Beatles on *A Hard Day's Night* (1964)?

It was great fun. I had worked with the director Dick Lester [1932–] before on *It's Trad, Dad!* (1962) and got on well with him. We had a script, but a lot of it was invented on a daily basis. Walter Shenson [1919–2000], the producer, was a marvellous bloke, so it was a very happy experience. The Beatles couldn't remember their dialogue. We had to put microphones under their seats when they were talking.

I had five of the best operators in the world, and everyone had a 10-to-1 zoom. They worked under instructions, but they were free to use their artistic ability.

One day we were working at an airfield, and the boys were playing cricket, when a helicopter landed. Dick Lester said, "Could you get a shot from up there?" so I jumped on the helicopter with my operator, Derek Browne [1927–2010]. The battery was going down on the camera, so I altered the stop to compensate for the slower speed. Lester saw it in rushes and said, "That looks marvellous.

Will you go up there again?" So we did, and this is the way the film was made. It was always with invention. It took about six weeks to shoot. The thing was, they had marvellous melody, marvellous crowds, and everyone went absolutely mad, and you couldn't hear anything. Lester asked me to do *Help!* (1965), but I was working on *The Bedford Incident* (1965), so David Watkin [1925–2008] did it. I didn't want to do it anyway. Fortunately when I was working, I had lots of freedom because I always had two or three movies to choose from. I turned a Bond film down for a Polanski film.

Which film took the longest?
I don't know, but it may have been *Dr. Strangelove*. Nothing took more than twelve weeks. On *Strangelove*, Peter Sellers [1925–1980] was playing the part of the pilot, but it just wasn't working. I had a picture of Slim Pickens [1919–1983], which I put on Stanley Kubrick's [1928–1999] desk. Within twenty-four hours he was working on the film.

What was it like working with Tony Hancock [1924–1968] on *The Rebel* (1960) and *The Punch and Judy Man* (1962)?
I loved Tony. He was always socially friendly. He had bad moments when he was trying to play Hamlet. The trouble with those films: They were made on the cheap. They were always trying to do things for nothing.

What was Stanley Kubrick like to work with on *Dr. Strangelove*?
He was very talented, and I learned a lot through him because he kept me at it. I had to keep a book of tables in my pocket because he kept asking questions. He would then have some expert down in his office, talk to him, and then ask me how I would do it. He was that sort of person. I didn't mind his interference. He wanted me to do his next movie, but I couldn't do it.

Did you keep the same crew?
I had the same crew for twelve years. I had marvellous gaffers. People would ring me up and ask when I was doing my next movie. I had a choice of cameras, and I used Cooke lenses.

Where did you enjoy shooting?
I enjoyed the South of France and Ireland, which is a wonderful place.

Did you have a favourite studio?
My favourite studio was Shepperton because it was full of different people all the time. I also loved Elstree, Denham, and Pinewood. I wasn't keen on Gainsborough.

Did you ever consider directing?

Yes, I did. I directed a film for Monty Berman [1905–2006] called *The Man from "X"* (1969), and he offered me another one straight after. He said I was one of his best. I did it one day short of everyone else, nine days instead of ten. I also taught a cameraman to light on it. I didn't take up the second offer. In my work as a DP, I would make suggestions to directors. Maybe I should have changed and become a director.

Would you tell me a bit more about *A Hard Day's Night*?

The budget was so small. They were moaning about it the whole time. Anything that you wanted extra you couldn't have because it wasn't in the budget. We made it on the cheap. It was a very close, tight unit compared to most films. I had about eight electricians, where normally I would have about two dozen. Everything was cut down by Denis O'Dell, our Irish production manager. After the premiere I was in Scotland, and I got a cheque from the producer for £1,000 to say "You're great." That was the first I'd had off anyone since making movies.

What hours were worked on it?

We started shooting around half past seven in the morning, and we carried on until we finished what we were doing. We didn't have any trouble with the Beatles. They weren't on any special assignment during that period. They didn't have any money then. John wanted a secondhand Bristol motorcar costing £1,700, and he couldn't afford that, so he told me. They didn't have any spare money.

Who were the operators that worked on it with you?

They include Derek Browne [1927–2010], Paul Wilson [1925–], and Val Stewart [1914–1975].

What was Freddie Young like to work with?

I worked with Young at British and Dominions loading film. He had a test on everything he did before turning over. If you didn't have a print on the floor within nine minutes, you were in trouble and you had to go in Saturday morning and polish the floor. You then had to stay there until twelve. Freddie Young would then walk through with a pair of very muddy Wellington boots and say it is still dirty.

Was *Star Wars* shot on 35 or 65mm?

The film was shot on 35mm and blown up to 70mm for some theatres. I didn't have much contact with the director, George Lucas, so I was left to make my own decisions on how it was to be photographed. I did some experimenting

Gilbert Taylor and George Lucas on the set of *Star Wars* (1977). *Courtesy of Gilbert Taylor*

before going on location to Tunisia. *Star Wars* was a challenge, and I am still in touch with fans all over the world.

You did a number of films with the Boulting brothers [John, 1913–1985; Roy, 1913–2001]. What were they like to work with?
Wonderful. They were gentlemen. I made several films with them, including *Brighton Rock.*

You worked with Tommy Steele [1936–] on *Tommy the Toreador* (1959). What was he like to work with?
I loved him. I thought he was a real, true Danny Kaye. At the end of the film, he bought me a gold pencil. He has great style and is a good actor, singer, and dancer.

What was director John Paddy Carstairs [1910–1970] like to work with?
He was a gentleman. As a director he didn't have any great talent. He was the sort of chap who would put the toast out with jam on it to the wasps and then get a great big sting on his finger. I met his brother Raymond during the war years. He was in the army film unit. The films I made with Paddy Carstairs were all low budget.

Did you have a favourite camera?
Yes, it was the Mitchell camera.

You did eight films with director J. Lee Thompson [1914–2002]. What was he like to work with?
He was fantastic. I was on his first movie when he came out of the script department. It was called *The Yellow Balloon* (1953). I was sorry that he went to America because if he hadn't I would have continued working with him. I didn't want to go to America.

You also did some TV work, didn't you?
I did a bit of work for Monty Berman. I directed *The Man from "X"* for him. He had twenty-two electricians on the payroll, and the budgets were so small. I introduced him to my bounce light and got him down to eight electricians, saving him money. I was being paid a lot more than the directors.

When did you get interested in painting?
I got interested in art when I was young. When I retired and moved to the Isle of Wight, I went on a few courses.

What type of subjects do you paint, and do you paint in watercolours or oils?
I like oils; I've gone over to acrylic because you can paint quicker. It dries quicker, but you have to persevere to get depth and transparency.

I love painting landscapes and shire horses. I have also done a few portraits.

Do you still keep in touch with people you have worked with in the business?
Well, there aren't many left. I'm in my nineties, so a number of people I have worked with have now gone.

As well as cinematography, you enjoyed farming, didn't you?
I really enjoyed farming. Farming was in my heart. If I had the money, I would buy a farm tomorrow.

Filmography

The Guinea Pig (1948, Roy Boulting)
Seven Days to Noon (1950, John Boulting and Roy Boulting)
Circle of Danger (1951, Jacques Tourneur)
High Treason (1951, Roy Boulting)

The Yellow Balloon (1953, J. Lee Thompson)
Single-Handed (1953, Roy Boulting)
Front-Page Story (1954, Gordon Parry)
The Weak and the Wicked (1954, J. Lee Thomson)
Trouble in the Glen (1954, Herbert Wilcock)
Seagulls over Sorrento (1954, John Boulting and Roy Boulting)
As Long as They're Happy (1955, J. Lee Thompson)
Josephine and Men (1955, Roy Boulting)
Yield to the Night (1956, J. Lee Thompson)
The Silken Affair (1956, Roy Kellino)
My Wife's Family (1956, Gilbert Gunn)
It's Great to Be Young! (1956, Cyril Frankel)
The Good Companions (1957, J. Lee Thompson)
Woman in a Dressing Gown (1957, J. Lee Thompson)
No Time for Tears (1957, Cyril Frankel)
Ice-Cold in Alex (1958, J. Lee Thompson)
She Didn't Say No! (1958, Cyril Frankel)
No Trees in the Street (1959, J. Lee Thompson)
Operation Bullshine (1959, Gilbert Gunn)
Tommy the Toreador (1959, John Paddy Carstairs)
Bottoms Up (1960, Mario Zampi)
Sands of the Desert (1960, John Paddy Carstairs)
The Full Treatment (1960, Val Guest)
The Rebel (1961, Robert Day)
Petticoat Pirates (1961, David MacDonald)
It's Trad, Dad! (1962, Richard Lester)
A Prize of Arms (1962, Cliff Owen)
The Punch and Judy Man (1963, Jeremy Summers)
Dr. Strangelove or: How I Learned to Stop Worrying and Love the Bomb (1964, Stanley
 Kubrick)
Hide and Seek (1964, Cy Endfield)
Alive and Kicking (1964, Cyril Frankel)
A Hard Day's Night (1964, Richard Lester)
Ferry Cross the Mersey (1965, Jeremy Summers)
Repulsion (1965, Roman Polanski)
The Bedford Incident (1965, James B. Harris)
Cul-de-sac (1966, Roman Polanski)
The Baron (1966–1967, TV Series)
Theatre of Death (1967, Samuel Gallu)
The Man Outside (1967, Samuel Gallu)
Work Is a 4-Letter Word (1968, Peter Hall)
The Avengers (1966–1969, TV Series)
Before Winter Comes (1969, J. Lee Thompson)
Randell & Hopkirk (Deceased) (1969, TV Series, Cyril Frankel)
A Nice Girl Like Me (1969, Desmond Davies)

Quackser Fortune Has a Cousin in the Bronx (1970, Waris Hussein)
The Tragedy of Macbeth (1971, Roman Polanski)
A Day at the Beach (1972, Simon Hesera)
Frenzy (1972, Alfred Hitchcock)
The New-Fangled Wandering Minstrel Show (1973, Buddy Bergman)
The Pathfinders (1972–1973, TV Series)
Soft Beds, Hard Battles (1974, Roy Boulting)
The Omen (1976, Richard Donner)
Star Wars: Episode IV: A New Hope (1977, George Lucas)
Braking Up (1978, TV Movie, Delbert Mann)
Escape to Athena (1979, George P. Cosmatos)
Meetings with Remarkable Men (1979, Peter Brook)
Dracula (1979, John Badham)
Flash Gordon (1980, Mike Hodges)
Green Ice (1981, Ernest Day)
Venom (1981, Piers Haggard and Tobe Hooper)
Losin' It (1983, Curtis Hanson)
Voyage of the Rock Aliens (1984, James Fargo)
Lassiter (1984, Roger Young)
The Bedroom Window (1987, Curtis Hanson)
Don't Get Me Started (1994, Arthur Ellis)

Robin Vidgeon, BSC

(1939–)

Robin Vidgeon was born on August 12, 1939. Not choosing to do anything else, he joined the film industry in 1956. In 1959 he decided to freelance because the studios went four-waller, meaning such people as camera crews were no longer employed but were brought on as freelancers when required. Vidgeon worked for many years with notable cinematographer Douglas Slocombe [1913–] and camera operator Bernard Frederick (Chic or Chick) Waterson [1924–1997]. He said Waterson was never called Bernard; he was always known as Chic.

The first film that Vidgeon worked on with Slocombe and Waterson was *Circus of Horrors* (1960), a low-budget colour film directed by Sidney Hayers [1921–2000]. Vidgeon worked with Steven Spielberg [1946–] on a sequence of *Close Encounters of the Third Kind* (1977) and two *Indiana Jones* movies (*Raiders of the Lost Ark*, 1981, and *Indiana Jones and the Temple of Doom*, 1984). He went on to become a director of photography (DP). He says his first film as a DP was *The Penitent* (1988), not *Hellraiser* (1987), as stated in filmographies. He has also done a lot of television work.

Today he teaches cinematography and has no intentions of calling it a wrap just yet. He loves the business and will keep himself involved for as long as possible.

What got you interested in films?
When I was around nine, I was taken to see the *Bells of St Mary's* (1945) by my father, and I was just blown away. Over the next four or five years, I gradually built a cinema at home, which was a total fire risk. They were 9.5mm films I hired from a library in Shepherds Bush, London, which were shown once a month. I had a motorised screen, coloured lights, and a wind-up gramophone. They would sit and sweat for an hour and a half.

How did you get into the film studios?

I was very lucky. In 1955 the union called the Association of Cinematograph Technicians (ACT) were holding interviews in the Highlander public house in London's Soho. I applied for an interview, and I was accepted. I went there on a rainy November night and went into this smoked-filled room full of ACT members; many of them worse for wear with drink. There were only three of us up for interviews. One guy wanted to get into editing; the other, sound. I wanted to work with cameras. After the interview I had to wait a couple of months to see if there was a place in any of the studios. That was a few years before studios started to go four-waller, meaning people were taken on a freelance basis rather than being employed. In January I was told there was a place in the camera department at Pinewood Studios under Bert Easey [1901–1973], head of the camera department. So I went there for two years, first making tea. In my last year there, I was working on special effects down the bottom end of Pinewood. I worked with visual effects man Bert Marshall on *Reach for the Sky* (1956). I also worked on *Battle of the River Plate* (1956). Then I had an offer to go and do a picture with camera operator Dudley Lovell [1915–1998] and cinematographer Wilkie Cooper [1911–2001] in the Canary Islands. The film was called *S.O.S. Pacific* (1959), directed by former cinematographer Guy Green [1913–2005]. When I came back, I saw an advertisement in one of the trade papers for a loader at Beaconsfield Studios on a film called *Circus of Horrors* (1960). I met the cinematographer Douglas Slocombe and his operator, Bernard (Chic) Waterson, in my trilby hat, rolled umbrella, and mackintosh. They thought, "He looks mad enough." I stayed with them for twenty-seven years.

Did you have a favourite film and director?

As a focus puller, I worked on *The Servant* (1963) with Joseph Losey [1909–1984], and that was an amazing experience. We also did *King and Country* (1964) after that. Joe Losey is one of my favourite directors. We did *Julia* (1977) with Fred Zinnemann [1907–2007], which was also amazing. Then we got taken out to India to shoot a sequence with Steven Spielberg for *Close Encounters of the Third Kind*. It was a sequence they had overlooked. On the way to India, we never stopped talking. Steven said he'd been told in the States never to work in Britain because they were lazy and only drank tea. We shot out in India with three cameras and one crew. Spielberg said, "I've never seen people work like you guys; I'm going to make pictures in the UK." Later he came up with *Raiders of the Lost Ark*. After the second picture, *Indiana Jones and the Temple of Doom*, I left to take up the meter, which I always wanted to do anyway. I have been lucky. I left to operate and also did some lighting. When I was doing a picture in the States, I got a message from someone I knew that said, "When the Americans knew I was going to do a picture over there, they said, 'That's the guy that never

operated.'" I worked for twenty-seven years with one of the greatest operators ever, Chic Waterson. I learned a lot from him.

How long did it take to shoot *Raiders of the Lost Ark*?
It was a long project, around twelve to fourteen weeks. It was a very complicated film. Spielberg was wonderful. He was so enthusiastic. We have kept in touch ever since. I have a great letter he wrote to me. When I did *Neverending Story 3* (1994), directed by Peter MacDonald, I went to Germany to pick up the cameras for the shoot. We were going to shoot with Arri cameras, and while I was at Arri in Munich, a guy came in with two camera bodies and dumped them on the table. They were covered in dirt, and whoever sent them back from a shoot should be ashamed of themselves. I said to the guy in the workshop, "Where on earth have these camera bodies come from?" He said they had just done a film called *Schindler's List* (1993) with Steven Spielberg. I said, "I'll have those two then, thank you very much."

Would you tell me about some of the features you shot as a DP, and did you have a particular favourite?
The first feature I shot was *The Penitent*, shot in Mexico over eight weeks, but I had been doing commercial, promos, and a couple of TV dramas before that. I then shot *Hellraiser, Hellbound* (1988), and *Nightbreed* (1990), directed by Clive Barker [1952–].

What were they like to work on?
Clive had never been on a film set before. Clive is an author, and while we were filming, his book agent came on set and signed a cheque for $10 million for his next three books.

 Hellraiser was difficult to make because there was no studio work apart from two days at Samuelson Studios at Cricklewood, which are not there anymore. It was all done on location in a house in Cricklewood, North London, that had been empty for two years. Obviously you cannot move walls like you can in a studio setup.

Was there any blue or green screens used?
There was no blue or green screen used in *Hellraiser*. We did some on either *Nightbreed* or *Hellbound*, but they were based at Pinewood.

You worked with Ken Russell [1927–] on the TV series *Lady Chatterley* (1993). What was Russell like to work with, and how long did it take to shoot one episode?

It was made as a 35mm feature. I had done a lot of work with Ken, shooting around five of his music videos. He has an amazing gift of putting classical music to his imagery. Before those, I worked as a focus puller for him on his first feature, *French Dressing* (1964), and later *The Music Lovers* (1970), photographed by Douglas Slocombe.

How did you get into TV work?
The BBC and ITV were starting to do more feature dramas shot by freelancers. They wanted people who had shot features. I was one of the early ones who had a foot in both camps. I was working nonstop between features and TV.

Do you enjoy TV as much as feature work?
There is no difference. When I walk onto a film set, I don't care what I've got behind me. I do the same job. I forget what is on the dolly behind me; I look at a set and light it. There is no difference between TV drama and features. The budget is different in TV. On the *Frost* series (1992–), we were doing twenty-five and thirty setups a day. The days seem to go quickly. You're tired, but you come away satisfied.

What film did you enjoy working on the most?
It was *August* (1996), with Anthony Hopkins [1937–]. It was Hopkins's first film as a director. He was like Clive Barker, such enthusiasm and a great sense of humour. I first worked with him as a focus puller on *The Lion in Winter* (1968). When he interviewed me for *August*, he said, "Would you like to hear some music?" We walked into this room that housed a grand piano. Hopkins sits down and plays like a concert pianist. All the music for *August* was composed by him. I went along to a recording session with the London Symphony Orchestra (LSO) after the film was finished. He was there and did all the orchestrations. All the music you hear in the film is played by him. He is very talented. He was very tired at the end of it because we were up in North Wales for eight weeks, where he was also rehearsing and acting in the stage version at Theatre Clwyd.

They put an editing truck in the car park. He edited all morning, rehearsed all afternoon, and acted in the evening.

Do you have any industry heroes?
Douglas Slocombe and Steven Spielberg, whom I did three jobs with. He enthuses everyone on the set. I also admire Anthony Hopkins and the late Joe Losey. I think Hopkins is extraordinary; I've loved all his work. Losey had a great eye for composition. He was a very quiet man. He never raised his voice on the set but inspired everyone around him.

Is a focus puller's job just as hard today as it was in the past?

It is much harder today. Film cameras like the Panaflex and the Arricams have incorporated a lot more electrical gadgets into them, so it is not just a film camera pulling film through a gate. You can run a camera backwards, high speed, low speed, stop frame. You can do dissolves and automatic iris stops. As you go through a shot, you can program it into the hand computer. As the camera tracks forward, the focus puller doesn't have to alter the stop. It's done through a software program. A film camera is now extremely complicated. Another thing is, I go onto some sets, and not one lamp is pointing to an actor. It's all bounced-off light. I can't do that. I've been brought up to point the lamps and create depth. I try to create depth by modelling the set and actors. I can light a set in twenty minutes with soft light but then spend two hours trying to stop the soft light going where I don't want it to go. So focus pullers are working at wider apertures on the lens than we ever did. Big pictures now have two or three cameras on every shot. Because you have a wide, medium, and ultra-closeup for every shot, the sound boys can't put a mic in anywhere. Today a lot of work is done with radio mics, which the sound people hate because the sound quality is not so good. On some shots booms can't be used because of new techniques. So radio mics are hidden in various places.

As a focus puller, how did you keep accurate focus?

Every film and digital camera has got a four-inch monitor screen on board. Students tend to look at the monitor instead of the actors, and you can't pull focus like that. You take the measurements and put marks down. Some American actors don't like marks; they feel they want to wander all over the place, so you have to be spot on to the inch, and that comes with experience. If they don't like marks, you have to look where a chair is, where a corner of a table is, and other things. Your eyes are flicking around to see where their feet are. Focus pulling can be a nerve-racking job.

Dirk Bogarde [1921–1999], who I did a lot of work with, was one of the best technical actors I have ever worked with. If he didn't know what lens I was using, he would come and ask. He would know how to adjust his performance to the lens. He was always spot on on marks. Good actors and actresses understand the camera. If they don't understand the camera, it makes it really hard for the crew.

Did you have a favourite TV series you worked on?

I think the *Frost* series with David Jason [1940–]. I did about six or seven of them. We worked from 8 a.m. to 7 p.m., five days a week. Each episode took six weeks to make, which included preparation. They were great fun to make, and David Jason has got a great sense of humour. Everyone on the series was wonderful.

Which was your longest shoot?

One of the longest shoots I did was on *Neverending Story 3*. I got ten weeks' preparation on that, sitting in an office at Shepperton. There was no recce, and the art department was in Germany because it was made by a German company. We went on location to Vancouver, which I knew really well after shooting *Fly II* (1989). It was weeks before I saw any set drawings. The director, Peter MacDonald, kept saying, "How would I light it?" I said, "I don't know. Show me some drawings, and show me some sets."

What do you think of digital cinematography?

I don't care what is behind me; my lighting technique is the same. A lot of productions are now going digital, and when film eventually goes, I will miss it. At the moment they have not got digital to look as good as film.

What do you think of cinemas going over to digital projection?

It doesn't matter. The projectors are so good, and of course you don't get scratching, dirt, weave, and sprocket damage. If it's a small release and it's two or three thousand pounds a print, you're saving a fortune. It doesn't matter how much you screen it; the quality remains the same. Digital projection is fantastic.

Are the 3D movies shot digitally?

It all depends. If it's shot on a 3D rig with 2 cameras, yes, that is digital. Any 35mm film can now be converted to 3D.

Who gave you the opportunity to shoot *The Penitent*?

It was the producer, Mike Fitzgerald. He had seen things I had done and gave me the break, though I don't quite know how it happened. Also the director, Cliff Osmond [1937–], was an American scriptwriter who had never directed before. That is why I think it happened.

Robin Vidgeon on 3D shoot for the film *Concerto for the Earth* (1991). It was a five-month shoot around the world using 65mm equipment. *Courtesy of Robin Vidgeon*

You were an additional unit director on *Event Horizon* (1997). How did that come about?

There was a problem with the second unit, and I got a call to take over. I hate taking over because you don't know what the politics are. I had eight to ten weeks on that. I replaced the whole crew apart from the DP, bringing my own people in.

How did you find directing compared to cinematography?

I have worked on so many pictures with first-time directors that you have to get involved with the directing side of it. I have worked with people, such as Fred Zinnemann, Norman Jewison [1926–], George Cukor [1899–1983], and Steven Spielberg. If you don't learn something from them, you'd be stupid. On a set I am watching actors all the time, not just for lighting, but also for moves so camera work goes just as we rehearsed. Not with performance, that is the director's job. But if I spot something I think he or she has missed, I would have a quiet word in their ear. It would be as help, not a criticism, because we are all there to help each other. Filmmaking is a collaborative effort.

Were there special effects in *Hellraiser*?

There was no CGI work. It was all done for real. As it was shot in a house, I had to try to make it look different all the time, like day, dusk, night, and early morning. We had to black things out. You can't move walls like you can in a studio. There were around thirty people working on *Hellraiser*. It was a success, so more money was put into the followup *Helllbound*. On that we had a bigger special effects team. When it came to *Nightbreed*, it took fifteen weeks and was directed by Clive Barker, director of the first one. *Hellraiser* is now on Blu-ray DVD and looks excellent. All films are now transferred to DVD. I took some of my students to a restoration plant. One of the plant's projects is restoring seven films that Alfred Hitchcock made in the U.K. Within five years almost all film that has survived will be archived on Blu-ray.

Are a lot of TV productions still shot on 16mm?

Recently the BBC announced that all drama for us would be commissioned on HD, no more 16mm, which is sad.

How is the 16mm negative cut now?

The negative is developed, transferred to a hard drive, and then the hard drive is taken to the editing suite. HD is still not as good as 16mm; it is not quite there yet.

Would you tell me about *Fly II*? Was there CGI work on it?

A bit. Not too much. There was a lot of on-set effects, which took a bit of time. They were a great team to work with, and we had a first-time director, Chris Walas (1955–). We had a tight schedule, but we had more time than you would get on a one-hour TV drama. The film was shot using a mechanical fly with about eight operators.

What is your favourite part of the world to shoot in?

Vancouver, Canada, where we shot *Fly II* and *Neverending Story 3*. The first time I worked in Canada was on *Lost and Found* (1979), shot in Toronto. Vancouver is the most beautiful place, and we only did five days a week.

Do you prefer a particular film stock?

They are both as good as each other now. I was always a Fuji fan to start with because I felt it was good that Kodak had some competition, but over the years Fuji have come on a par with Kodak. Agfa went down just after *The Mission* (1986) that I did with Chris Menges [1940–]. Just before that they brought out a new 250 tungsten negative, which everyone said was fantastic, so we used the stock for jungle shots because it was very good with greens. Shortly after, Agfa decided to stop producing motion picture negative. Today many people will have you believe that film is finished, which isn't so. Panavision have got eleven or twelve movies on the go, and nine or ten of those are on film.

You worked with Sidney Hayers on *The Professionals* [1999, TV Series]. Was that the first time you'd seen him since *Circus of Horrors* back in 1960?

Yes, it was, and he was a very funny brilliant editor/director, mainly editor, having worked at Ealing in that capacity. He had a very good sense of humour, and

Robin Vidgeon on the set of *King David* (1968) in Italy. *Courtesy of Robin Vidgeon*

I was very lucky to work with him. He'd aged well, like a good wine, and it was great fun talking about the old days.

What was it like working on *The Professionals* with Martin Shaw [1945–] and Lewis Collins [1946–]?
Martin and Lewis were fine. We went at quite a pace on that. It was hard work. The studios were at Teddington. Hayers, who we called Sid, wasn't in the best of health, so we decided to shoot in a radius of two miles, which would save a huge amount of time. Previously location work was further afield, the travelling taking up a lot of time.

Going back to your first film with Hayers, on *Circus of Horrors*, what was it like to work on, and was some of it shot abroad?
No, it was all shot in England. It was shot at Beaconsfield Studios, and the circus sequences were shot at Billy Smart's circus on Clapham Common, London. The film took around eight or nine weeks to shoot. On occasions we were held up by very foggy weather. We did a lot of all-night filming. Anton Diffring [1918–1999] was a lovely man to work with. I worked with him quite a lot. He was also in *The Blue Max* (1966) as a German officer. I've got a copy of *Circus of Horrors* on DVD, and it is very funny to see it now.

What other jobs did you consider apart from the film business?
I never considered working in anything else. When I was a kid, I had my own darkroom, and when I was around ten, I had a 9.5 projector. I was hooked very early. I got a magazine called *Amateur Cine World* every month and would look at all the formats but didn't know what they were then. It was just the shape of screen. I remember going into my local Odeon and visiting the projection room, watching the projectionists changing reels, and watching changeovers.

It's a very responsible job being a DP, getting the lighting right. Did you ever find it nerve-racking?
Students often ask me, "How do I light a set?" I tell them, "I can't tell you that. I've got to walk on a set, and the set speaks to you." The only reason you're standing there is because the director has seen something you did before and wants you to do it again. That's all it is. Fortunately I have never found it nerve-racking.

What was the hardest thing you have had to light or frame?
I think *Hellraiser* for the reason I told you. It was shot in an old Edwardian house, which had narrow stairs, narrow corridors upstairs, fairly small rooms and entrance hall. To light that for eight weeks and try and keep every scene

Robin Vidgeon with Derek Jacobi on the set of *Breaking the Code* (1996). *Courtesy of Robin Vidgeon*

fresh and a bit different was a challenge. Because we didn't want to make it a static film, just closeups and wide shots, we laid tracks to track with people. We didn't have steadicam then. It was around but was very expensive, so few people used it. We had to make the house in daylight look night by blacking out. That had to be low key. To put lights where they couldn't be seen was really tricky. Everywhere else I had worked had space, but that film was really restrictive.

Filmography

Hellraiser (1987, Clive Barker)
Mr. Corbett's Ghost (1987, Danny Huston)
The Penitent (1988, Cliff Osmond)
Mr. North (1988, Danny Huston)
Hellbound: Hellraiser II (1988, Tony Randel)
Work Experience (1989, James Hendrie)
Parents (1989, Bob Balaban)
The Fly II (1989, Chris Walas)
The Strange Affliction of Anton Bruckner (1990, Ken Russell)
Nightbreed (1990, Clive Barker)

The Fool (1990, Christine Edzard)
The Crucifer of Blood (1991, Fraser Clarke Heston)
Highway to Hell (1991, Ate de Jong)
As You Like It (1992, Christine Edzard)
The Secret Life of Arnold Bax (1992, Ken Russell)
Lady Chatterley (1993, TV Series, Ken Russell)
Comics (1993, TV Movie, Diarmuid Lawrence)
Neverending Story III: Return to Fantasia (1994, Peter MacDonald)
Seaforth (1994, TV Series, Stuart Burge)
My Good Friend (1995, TV Series, Martin Dennis)
Class Act (1994–1995, TV Series, No Director Listed)
August (1996, Anthony Hopkins)
Die Eisprinzessin (1996, TV Movie, Danny Huston)
Tales from the Crypt (1996, TV Series, No Director Listed)
Breaking the Code (1996, TV Movie, Herbert Wise)
Colour Blind (1998, TV Series, Alan Grint)
Dead on Time (1999, James Larkin)
The Round Tower (1999, TV Movie, Alan Grint)
Tilly Trotter (1999, TV Series, Alan Grint)
CI5: The New Professionals (1999, TV Series, Sydney Mayer, Ken Grieve, and John Davies)
The Thing about Vince (2000, TV Series, Christopher King)
The Cazalets (2001, TV Series, Suri Krishnamma)
Rockface (2002, TV Series, Terry Windsor)
Nine Lives (2002, Andrew Green)
A Is for Acid (2002, TV Movie, Harry Bradbeer)
Solid Geometry (2002, TV Short, Denis Lawson)
Octane (2003, Marcus Adams)
LD 50 Lethal Dose (2003, Simon De Selva)
The Brides in the Bath (2003, Harry Bradbeer)
City Lights (2007, TV Series, No Director Listed)
Diamond Geezer (2007, TV Series, Paul Harrison)
Broken Planes (2007, Richard Perry)
A Touch of Frost (2008, TV Series, "Mind Games" and "In the Public Interest," Paul Harrison)
A Touch of Frost (2008, TV Series, "Dead End," Roger Bamford)
The Fairweather Girl (2010, Adam Coop)
Following Footsteps (2010, Richard Perry)
A Touch of Frost (2010, TV Series, "If Dogs Run Free," Paul Harrison)

CHAPTER 9

Jack Cardiff, OBE, BSC, ASC

(1914–2009)

Jack Cardiff was born on September 18, 1914, in Yarmouth. His real name was John G. J. Gran. He had it changed to his father's stage name of Cardiff. Cardiff's parents filled in with film work between stage shows. He performed in several silent films and once played a character called Billy Rose.

He became a clapper boy for Claude Friese-Greene [1898–1943], son of film pioneer William Friese-Greene [1855–1921]. Cardiff went on to operate cameras for cinematographer Hal Rosson [1895–1988]. Later, Rosson's work included *The Wizard of Oz* (1939). Cardiff went on to become a Technicolor consultant, a director of photography (DP), and director.

Cardiff died on April 22, 2009, at age 94. He shot many memorable films, including *The Red Shoes* (1948) and *The African Queen* (1951). He says that John Huston [1906–1987] and Humphrey Bogart [1899–1957] drank whisky while on the film in Africa so they didn't get ill, unlike others who worked on it. He went on to direct and says his favourite in that role was *Sons and Lovers* (1960). His first feature as a director was *The Story of William Tell* (1953), starring Errol Flynn [1909–1959]. Unfortunately it wasn't finished. A few years later, he directed *Intent to Kill* (1958). Other offerings as a director included *Scent of Mystery* (1960), released in 70mm, and *The Long Ships* (1963). He worked with some of the biggest names in film, including Sophia Loren [1934–], Robert Donat [1905–1958], and the legendary Marilyn Monroe [1926–1962]. Great directors he has collaborated with include Henry Hathaway [1898–1985], Laurence Olivier [1907–1989], King Vidor [1894–1982], and the master of suspense, Alfred Hitchcock [1899–1980]. His autobiography, *Magic Hour*, was published in 1996 by Faber.

Where were you born?

My parents were on the stage, and I was born on tour. They played all over England, and I was born in Yarmouth because they were there that particular week and that's how it was. My mum and dad were never in the big money, but when the show finished, they filled in with film work, usually as extras. It was a happy, filling-in thing to get a bit of extra money.

You appeared in some of the films. Did you enjoy it?

Well, yes, I remember appearing in a film called *Billy Rose* when I was around four. My parents, I think, were paid a guinea a day. Being brought up in the theatre, I was present at most of the rehearsals, and I would watch how things were arranged. I always made chums with the art director, so that was a fascinating side issue. When they were working at night, I had to be taken home.

Acting wasn't something you wanted to carry on with?

No, I became interested in the drapes and the colours. The art director was also my big friend. I would watch how he designed the set. I was fundamentally interested in the design, and then I realised the photography in films was very important.

Do the films you were in still exist?

I would doubt it very much. I often think about that because, as you probably know, a lot of films are buried somewhere in an attic or cellar that may turn up one day.

What got you interested in cameras? Was it watching the cameramen at work?

Yes, I did a lot of that. It was fascinating for me. The cameraman would turn the handle, and I managed to get in with him. I was interested in watching the way the camera was used, changing lenses, and so on. Sometimes they would say, "Sonny, please go and bring that case over here," and they let me pull focus. They would put pencil marks on the lens and say, "When I tap you, move the lens from one side to the other." I didn't know what I was doing. I said, "What did I do?" They said, "You followed focus son." The silent Debrie camera had a wonderful focus attachment across the top of the camera from infinity to one foot in a fraction of a second, so that was wonderful. I would follow focus with these cameras, so I got a very early start.

When did you start operating?

It was in 1931 working on British Quota films. Then in 1932 I operated on *Brewster's Millions*.

I understand you have an interest in paintings?
I was very lucky. I don't know how it happened, but I did become interested in looking at paintings in museums without going into it and analysing it. The fact was I loved paintings. I don't know exactly how it happened, but I did very soon develop a love for them. The luck I had was that we would be in a place for one week only, and one of the first things I did was get someone who worked with us and lived in that town to take me to the museum. So I went to a museum, not every week, but every few weeks. I soon developed an admiration for the impressionists. I realised even at that early age that the paintings that contained light and shade were almost like film lighting. So I had a very long education in paintings when I was very young.

When did you become a DP?
In 1937 I was working at Technicolor, and one day a very expensive car turned up with a gentleman by the name of Count Von Keller with his wife. They said to Technicolor that they had travelled all over the world with a 16mm camera and they felt they would like to do it again with a 35mm Technicolor camera. They were supplied with a camera, and I set off with them. My big break as a DP was given to me by Michael Powell [1905–1990]. He saw me working one day. I was shooting stuffed animal heads for *The Life and Death of Colonel Blimp* (1943). I then went on to photograph *A Matter of Life and Death* (1946) for Powell.

Which films were your favourite?
It was *Sons and Lovers* as a director and *Black Narcissus* (1947) as a cinematographer.

Which film proved to be the most difficult?
Well, they were all difficult. I can't remember any that stood out particularly. Michael Powell was a great director, and he was my favourite. He was very enthusiastic and gave you the same enthusiasm. He made everybody think and work hard. We had a very good art director by the name of Alfred Junge [1886–1964], who was very despotic. He would say, "I am the art director, this is my set, and I want you to light it this way." I said, "I'm sorry, but I want to put the light the other side," and he said, "No, no. It is my set." We often had a lot of arguments, but I usually got it my way. But he was a very good man to work with. Michael was marvellous. He would say, "Let's go, let's do this, let's do that." He was keeping people very busy. He would run instead of walk on the set. Alfred Junge would often come on the set and say, "I want it doing like this," but I always ignored him.

Operator Christopher Challis on the set of Cardiff's *The Red Shoes* (1948). *Courtesy of Nikki Cardiff*

You directed and photographed *Girl on a Motorcycle* (1968). Was it difficult to do both jobs?

Of course it was difficult, but on the other hand it was a fascinating opportunity to do a film with a motorbike. Marianne Faithfull [1946–] and Alain Delon [1935–] were great to work with. It was not easy, and it was made on a low budget. Sometimes I had to try and work out a way that wouldn't cost so much.

Did it take long to shoot?

I forget how long it took to shoot. It wasn't done like films today where you start on January 1 and carry on until the film is finished. We would work a bit on it, then have a break because of the lack of finances. We didn't have many actors that we had to keep continuity with. In between I would work on another film.

I understand that parts of *The African Queen* were shot in England?

Yes, it was the back water of the Thames. It was obviously difficult to get anything like the African look. Most of the film was set in Africa. We tried to match everything as close as possible to the African river, and it worked very well.

What were Humphrey Bogart and Katharine Hepburn [1907–2003] like to work with?

Bogart (Bogie) and Hepburn were both professionals. Bogie was a tough guy, saying things like "What the hell is this? OK, what are we doing?" He was great

Alfred Hitchcock and Jack Cardiff on the set of *Under Capricorn* (1949). *Courtesy of Nikki Cardiff*

Jack Cardiff on the set of *A Matter of Life and Death* (1946). Also pictured is director Michael Powell, with hands behind his back. *Courtesy of Nikki Cardiff*

fun to work with. Hepburn and Bogie were completely different personalities. Bogie would say, "OK, let's do this." She would say, "Now wait a minute. I don't see why."

John Huston, the director, was magnificent. I respected him very much as a director. He had a very good way of handling the actors. He never shouted and screamed, "I'm the bloody director." There was none of that stuff. He and I got on very well. I would do anything for him. Sometimes he would ask me to light something that was very difficult. Some cameramen would say, "That is impossible," but I tried my best to make it work.

I understand that you started to direct *William Tell* in 1953, but the production ran out of money before the completion. Does the footage still exist?
The footage is kept in Boston. Only a third of the picture was shot.

Which year did you receive your OBE [Order of the British Empire]?
I received it in 1998 for services to the film industry.

Filmography

The Last Days of Pompeii (1935, Ernest B. Schoedsack and Merian C. Cooper)
La Caccia Alla Volpe Nella Campagna Romana (1938, Alessandro Blasetti)

A Road in India (1938, Hans Nieter)
Paris on Parade: A Fitzpatrick Traveltalk (1938, James A. Fitzpatrick)
World Window (1939, Count Von Keller)
Main Street of Paris (1939, Jean-Claude Bernard)
Peasant Island (1940, Ralph Keene)
Green Girdle (1941, Ralph Keene)
Plastic Surgery in Wartime (1941, Frank Sainsbury)
Western Isles (1941, Terry Bishop)
Queen Cotton (1941, Cecil Musk)
Border Weave (1942, John Lewis Curthoys)
Colour in Clay (1942, Darrell Catling)
This Is Colour (1942, Jack Ellit)
Out of the Box (1942, Terry Bishop)
The Great Mr. Handel (1942, Norman Walker)
Scottish Mazurka (1943, Eugeniusz Cekalski)
Western Approaches (1945, Pat Jackson)
Caesar and Cleopatra (1945, Gabriel Pascal)
A Matter of Life and Death (1946, Michael Powell and Emeric Pressburger)
Black Narcissus (1947, Michael Powell and Emeric Pressburger)
The Red Shoes (1948, Michael Powell and Emeric Pressburger)
Arabian Bazaar (1948, John Hanau and Hans Nieter)
Scott of the Antarctic (1948, Charles Frend)
Under Capricorn (1949, Alfred Hitchcock)
Peintres et Artistes Montmartrois (1950, Jean Claude Bernard)
The Black Rose (1950, Henry Hathaway)
Paris (1951, Jean-Claude Bernard)
Pandora and the Flying Dutchman (1951, Albert Lewin)
The African Queen (1951, John Huston)
The Magic Box (1952, John Boulting)
It Started in Paradise (1952, Compton Bennett)
The Story of William Tell (1953, Jack Cardiff)
The Master of Ballantrae (1953, William Keighley)
Montmartre Nocturne (1954, Jean Claude Bernard)
Il Maestro di Don Giovanni (1954, Milton Krims and Vottorio Vassarotti)
The Barefoot Contessa (1954, Joseph L. Mankiewicz)
War and Peace (1956, King Vidor)
The Brave One (1956, Irving Rapper)
The Prince and the Showgirl (1957, Laurence Olivier)
Legend of the Lost (1957, Henry Hathaway)
The Big Money (1958, John Paddy Carstairs)
The Vikings (1958, Richard Fleischer)
Fanny (1961, Joshua Logan)
The Mercenaries (1968, Jack Cardiff)
The Girl on a Motorcycle (1968, Jack Cardiff)
Scalawag (1973, Kirk Douglas and Zoran Calic)
Ride a Wild Pony (1975, Don Chaffey)

The Prince and the Pauper (1977, Richard Fleischer)
Death on the Nile (1978, John Guillermin)
The Fifth Musketeer (1979, Ken Annakin)
Avalanche Express (1979, Mark Robinson and Monty Hellman)
A Man, a Woman and a Bank (1979, Noel Black)
The Awakening (1980, Mike Newell)
The Dogs of War (1980, John Irvin)
Ghost Story (1981, John Irvin)
The Wicked Lady (1983, Michael Winner)
The Far Pavilions (1984, TV Miniseries, Peter Duffell)
Scandalous (1984, Rob Cohen)
The Last Days of Pompeii (1984, TV Miniseries, Peter R. Hunt)
Conan the Destroyer (1984, Richard Fleischer)
Cat's Eye (1985, Lewis Teague)
Rambo: First Blood, Part II (1985, George P. Cosmatos)
Tai-pan (1986, Daryl Duke)
Million Dollar Mystery (1987, Richard Fleischer)
Call from Space (1989, Richard Fleischer)
The Magic Balloon (1990, Ronald Neame)
Vivaldi's Four Seasons (1991, Jack Cardiff)
The Dance of Shiva (1998, Jamie Payne)
The Suicidal Dog (2000, Paul Merton)
The Tell-Tale Heart (2004, Stephanie Sinclaire)
Lights 2 (2005, Marcus Dillistone)
The Other Side of the Screen (2007, Stanley A. Long)

As Director

The Story of William Tell (1953)
Intent to Kill (1958)
Beyond This Place (1959)
Holiday in Spain (1960)
Sons and Lovers (1960)
The Geisha (1962)
The Lion (1962)
The Long Ships (1964)
Young Cassidy (1965)
The Liquidator (1965)
The Mercenaries (1968)
The Girl on a Motorcycle (1968)
Follyfoot (1972–1973, TV Series)
The Mutations (1974)
Penny Gold (1974)

Awards

Black Narcissus (1947), Oscar Award Best Cinematography (1947) and Golden Globe
 Award Best Cinematography (1948)
War and Peace (1956), British Society of Cinematographers Award and Oscar nomination
Fanny (1961), Oscar nomination
The Far Pavilions (1985), British Academy of Film and Television Arts TV Award
 nomination
British Society of Cinematographers Lifetime Achievement Award (1994)
American Society of Cinematographers International Achievement Award (1994)
Honorary Oscar (2000)

Awards as Director

Sons and Lovers (1960), New York Film Critics Circle Award Best Picture and Best Di-
 rector (1960), Golden Globe Award (1961), Directors Guild of America nomination
 (1960), and Oscar nomination (1960)

CHAPTER 10

Freddie Francis, BSC

(1917–2007)

Freddie Francis was born on December 22, 1917, as Frederick William Francis in Islington, North London, England. For a short while, he studied engineering. At technical college he wrote an essay on film and was given the opportunity to visit Lime Grove Studios in Shepherds Bush, London. Before joining the film industry, he worked for a stills photographer by the name of Louis Prothero. He remained with Prothero for around six months, during which time he did some work at Ealing Studios on Stanley Lupino [1893–1942] pictures. Later, through his father's business, he got a job at British and International Pictures as a clapper boy. He says his first picture was *The Marriage of Corbal* (1936), photographed by Otto Kanturek [1897–1941]. During the war he was in the Army Kinematograph Service based at Wembley. When he was there, he worked on *The New Lot* (1943), photographed by John Wilcox [1905–1979] and later remade as *The Way Ahead* (1944). He says he did a bit of everything, including editing and being a jack-of-all-trades. After the war he went on to operate and worked with Oswald Morris [1915–] on several pictures, including *Moulin Rouge* (1952) and *Moby Dick* (1956). He first met Morris in 1936 at Pinewood Studios.

Describing Francis, Morris said,

> He was a wonderful operator, very experienced. On *Moulin Rouge* we were expected to do all sorts of strange things with the camera. Freddie was throwing the very heavy three-strip Technicolor camera around very well, and it was a great help to me because I was occupied lighting it. Our characters worked wonderfully well. Our interests were the same, and there was great banter between us.

Francis then went on to become a director of photography (DP). His first picture in that role was *A Hill in Korea* (1956). He worked with his second

wife, Pamela Mann Francis [1927–] on *Saturday Night and Sunday Morning* (1960). She was a continuity person. He says one of his favourite films was *The Innocents*, released in 1961. It was directed by Jack Clayton [1921–1995] and was photographed in Cinemascope and black and white. Francis says Clayton didn't want it in scope, but he had to relent. Francis created an effect that at times gave a nonscope look that worked very well. He said it was the best film he had ever photographed. He won Oscars for *Sons and Lovers* (1960), made in black and white, and for *Glory* (1989), shot in colour. After working several years as a DP, Francis decided to go into directing. His first outing was *Two and Two Make Six* (1962); his camera operator was Ronnie Taylor, credited as Ron Taylor [1924].

He went on to direct in the horror genre, and according to his wife, he hated them. His first horror offering was *Paranoiac* (1963) for Hammer Films. In a filmed interview, Francis said, "The Hammer organisation for a certain period was a great success, but it was set up on business lines rather than artistic lines. If any of us could get any artistic points in we would, but the overall operation was a business, financial situation." Francis went on to shoot horror for Amicus, based at Shepperton Studios, and for Tyburn Pictures. He never regarded himself as technical. Operator Gordon Hayman [1939–] said he had a good eye for cinematography and directing. Francis said, "I read the script and see how it should be shot in my mind. I then go and reproduce it on the screen."

He said it was a lot of fun being a cameraman, but obviously directing was more interesting. He loved making films and didn't care where he was filming, either as director or cameraman. Francis was an honorary member of the British Society of Cinematographers and was president from 1998 to 2000.

He decided to go back to lighting, and his first film on his return was *The Elephant Man* (1980), directed by David Lynch [1946–]. He went back to directing and then back for the last time as DP. His final film was *The Straight Story* (1999) at the age of eighty-two. Francis didn't go to film school. He learned as he went along. This did not prevent him from shooting great movies. Francis died on March 17, 2007. There is a bench that is dedicated to him in the Rhododendron Walk at Pinewood Studios.

How old were you were you when you started in the film industry, and what got you started?

When I was at technical school, I wrote an article on film and managed to get a visit to the Gaumont British Studios in Shepherds Bush, London. I just got very interested and wanted to go into it. Through my father's business, I knew the chief carpenter at the British International Pictures (BIP). I got a job as a clapper boy.

Were you fully trained there?

Well, there was no training. You just went straight into it. You became a clapper boy and picked things up as you went along. I'd been slightly interested in photography at school so it was a bit of a help. To be a clapper boy, you don't have to know a lot about photography, but of course if you are interested in the subject, you can then pick up cinematography.

How long were you a clapper boy?

It wasn't very long. The first feature I was a clapper boy on was *The Marriage of Corbal*, photographed by Otto Kanturek and directed by Karl Grune [1890–1962] and Frederic Brunn [1903–1955]. This was Brunn's only film as a director, and he was uncredited on the film. From BIP I went to British and Dominions. Later B and D moved over to Pinewood, and I became a camera assistant and eventually went on to operating. But if I remember rightly, I had just started operating when war broke out. I then went into the Army Kinematograph Service Film Unit. I operated and became a director of photography [DP]. It took a war to do it, but one got a lot of training.

Did you shoot on 16mm?

No, I've never shot on 16mm. It's always been 35mm.

When you came out of the army, did you go straight back into the studios?

I went straight back into the studios as an operator.

Which was your first film as director of photography?

The first feature I became a DP on was *A Hill in Korea*.

What make of camera did you first work with?

It was a Debrie Super Parvo. After that I went on to the Mitchell camera, which was really the only camera, a first-class piece of engineering.

You went into directing. What was your first film as a director?

It was a film called *Two and Two Makes Six*.

Can you recall your most enjoyable film?

I enjoyed working on them all. I just love making films. I suppose it's because I can't do anything else. I have had a wonderful time doing it and have enjoyed every moment.

Did you get on with most of the directors, and did you have a favourite?

I enjoyed working with most of them, but one of my favourites was Robert Mulligan [1925–2008], who I shot two pictures with.

Where in the world have you been on location, and have you any favourites?
I didn't mind working anywhere. I've been most places around the world. When I was filming, I didn't care where we were. It was the job I enjoyed.

Did you usually have the same crew?
One got the same crew if you could. For instance I made a great point of trying to get the same operator and the same chief electrician. If you could get those two, you were home and dry. It only took a few days to get used to new people, provided you made sure they were right for the job. If you have worked before with them, it saves time because they know your methods.

Were there any difficult actors/actresses?
Not really. You took them as part of the job and tried to establish that you were in charge of what you were doing.

Did you find it hard changing from cinematography to directing?
Not really because as a feature film cameraman I worked closely with the director, so one got to know the director's job.

What was it like working on the Hammer films? It was a small studio, wasn't it?

John Huston and Freddie Francis. *Courtesy of Freddie Francis*

It was only small, but it was a self-contained studio, and they made so many horror films that they knew how to go ahead in that genre. As far as horror films were concerned, they were bang on the ball.

How long did it take to shoot the Hammer films?
They usually took around six weeks to shoot. We usually worked five days a week from eight in the morning until six at night. It was only on the rare occasions that we worked past six.

Did the director sometimes leave it up to you where to place the camera?
On a properly made film, it's usually cooperation between the cameraman and director. You discuss the film with the director before you start shooting, and you keep discussing it as you go along and lining up the shots together.

How did you get on with Martin Scorsese [1942–] on *Cape Fear* (1991), and were there any difficulties?
I enjoyed working with Martin very much, and we got on very well. I found that when a film was over and I looked back, it seemed free from difficulties. Obviously there were, but providing the film worked out OK, you forgot that there were any.

Freddie Francis. *Courtesy of Freddie Francis*

Would you tell me a bit about working on television material?
It's no good asking me about my TV work because I've forgotten what I did for TV. I've probably forgotten not because I'm at the age I forget everything; I just wasn't interested in television. I found it very dull.

How long did it take to shoot *Room at the Top* (1959) with Jack Clayton?
I would say the shooting took about eight weeks. I think I was officially on the film two weeks before shooting started. When Jack was editing, I would sometimes sit in and watch. Jack was a very good friend of mine.

Did you have hobbies, for example, gardening?
I don't think I did. Filmmaking is such a full-time job, and the hours were long. I leave my wife to the gardening, as she is better at it than me.

Filmography

A Hill in Korea (1956, Julian Amyes)
Time without Pity (1957, Joseph Losey)
The Scamp (1957, Wolf Rilla)
Next to No Time (1958, Henry Cornelius)
Room at the Top (1959, Jack Clayton)
Virgin Island (1959, Pat Jackson)
The Battle of the Sexes (1959, Charles Crichton)
Never Take Sweets from a Stranger (1960, Cyril Frankel)
Sons and Lovers (1960, Jack Cardiff)
Saturday Night and Sunday Morning (1960, Karel Reisz)
Disneyland (1961, TV Series, William Fairchild)
The Innocents (1961, Jack Clayton)
Night Must Fall (1964, Karel Reisz)
The Elephant Man (1980, David Lynch)
The French Lieutenant's Woman (1980, Karel Reisz)
The Executioner's Song (1982, Lawrence Schiller)
Memed My Hawk (1984, Peter Ustinov)
The Jigsaw Man (1984, Terence Young)
Dune (1984, David Lynch)
Return to Oz (1985, Walter Murch)
Code Name: Emerald (1985, Jonathan Sanger)
Clara's Heart (1988, Robert Mulligan)
Her Alibi (1989, Bruce Beresford)
Brenda Starr (1989, Robert Ellis Miller)
Peter Cushing: A One-Way Ticket to Hollywood (1989, Alan Bell)
Glory (1989, Edward Zwick)

The Plot to Kill Hitler (1990, Lawrence Schiller)
The Man in the Moon (1991, Robert Mulligan)
Cape Fear (1991, Martin Scorsese)
School Ties (1992, Robert Mandel)
A Life in the Theater (1993, TV Movie, Gregory Mosher)
Princess Caraboo (1994, Michael Austin)
Rainbow (1995, Bob Hoskins)
The Straight Story (1999, David Lynch)

As Director

Two and Two Make Six (1962)
The Day of the Triffids (1962)
The Brain (1962)
Paranoiac (1963)
Nightmare (1964)
The Evil of Frankenstein (1964)
Das Verratertor (1964)
Dr. Terror's House of Horror (1965)
Hysteria (1965)
The Skull (1965)
The Psychopath (1966)
The Deadly Bees (1967)
They Came from Beyond Space (1967)
Torture Garden (1967)
The Intrepid Mr. Twigg (1968)
Man in a Suitcase (1967–1968, TV Series)
Dracula Has Risen from the Grave (1968)
The Champions (1969, TV Series)
The Saint (1967–1969, TV Series)
Mumsy, Nanny, Sonny and Girly (1970)
Trog (1970)
Gebissen wird nur nachts (1971)
Tales from the Crypt (1972)
The Creeping Flesh (1973)
Tales That Witness Madness (1973)
The Adventures of Black Beauty (1974, TV Series)
Son of Dracula (1974)
Craze (1974)
CBS Children's Film Festival (1974, TV Series)
The Ghoul (1975)
Legend of the Werewolf (1975)
Star Maidens (1976, TV Series)

Golden Rendezvous (1977)
Sherlock Holmes and Doctor Watson (1980, TV Series)
The Doctor and the Devils (1985)
Dark Tower (1989)
Tales from the Crypt (1996, TV Series)

Awards

Sons and Lovers (1960), British Society of Cinematographers Award and an Oscar Award
 Best Cinematography
The Elephant Man (1980), British Society of Cinematographers Award and British Academy of Film and Television Arts nomination
The French Lieutenant's Woman (1982), British Academy of Film and Television Arts nomination
Glory (1989), Oscar Award Best Cinematography, British Society of Cinematographers Award, and British Academy of Film and Television Arts nomination
Cape Fear (1991), British Academy of Film and Television Arts nomination
British Society of Cinematographers Lifetime Achievement Award (1997)
American Society of Cinematographers International Award (1998)
New York Film Critics Circle Award (1999)
The Straight Story (1999), Camerimage Golden Frog nomination
Manaki Brothers International Cinematographers' Film Festival, Golden Camera 300 for Lifetime Achievement (2000)
Evening Standard British Film Awards Special Award for Lifetime Achievement (2000)
Camerimage Lifetime Achievement Award (2002)

Gordon Hayman on Freddie Francis

Gordon Hayman was born on March 7, 1939, and joined the film industry in 1957. He was very keen on photography, and one day his next-door neighbour, cinematographer Gilbert Taylor, asked him if he would like to go to Libya to work on a film because the person who should have gone couldn't because of an accident. The job Hayman was offered was as a loader on *Ice-Cold in Alex* (1958). His job was to load film and print and develop tests. From then on he says he was hooked on the film business. He was training to be a quantity surveyor but was drawn to the world of cinema.

 Hayman went on to become a focus puller and camera operator, working on features. He was employed by ABPC studios at Elstree, England, which was known as the porridge mine because Scottish people ran it. He decided to freelance, went on to shoot commercials, and was the camera operator on a number

of notable features, including *The Man Who Fell to Earth* (1976), directed by Nicolas Roeg [1928–].

Hayman was the DP on *The Dark Tower* (1989), which was directed by Freddie Francis and Ken Wiederhorn. Hayman says he and Francis shared the photography. The film suffered from bad special effects, and Francis decided to take his name off it.

When did you first meet Freddie, and what was the first film you worked on together?
I had just finished a film with Mike Hodges [1932–] directing. Director Karel Reisz [1926–2002] was in touch with Hodges looking for operators. I didn't know it at the time, but Reisz worked very closely with the operator. I then had an interview with Reisz for *The French Lieutenant's Woman* (1981). A couple of days later, Freddie called me. He said, "We have never met. I don't know you. We have got two or three days to finish off on *Elephant Man*. Are you available?" I said, "Yes, indeed." Freddie said jokingly, "I'd like you to do the three days because we might hate the sight of each other," which is Freddie's humour. I did the three days and at the end of the first day, David Lynch, the director, said, "I wish we'd had you on the whole picture." I then worked with him on *The French Lieutenant's Woman* and that was the start of a long connection.

What other films did you work with him on?
There were quite a lot. Two of the memorable ones were *Cape Fear* and *Glory*. Freddie was instrumental in getting me a work permit to work in the States. Finally I ended up with a green card and doing a lot more work out there, not always with Freddie.

How would you describe Freddie as a person?
He had a great sense of humour. Sometimes people could take him the wrong way. On one occasion he had someone in tears and said, "You'd be in tears if I hated you." He was very funny and a wonderful cameraman.

The Elephant Man was David Lynch's second picture after *Eraserhead* (1977), and I think the producers wanted somebody experienced in black-and-white photography. Freddie's first Oscar was for black and white on *Sons and Lovers* (1960), directed by Jack Cardiff [1914–2009]. I thought he should have got it for *The Innocents* (1961), which I thought was better. Freddie didn't have one style. He would light according to the schedule and the film. The first time we went to America, we shot a film for TV called *The Executioner's Song* (1982). There was a lot of filming, and we had to work pretty fast. We shot it in nine weeks, and we couldn't believe it. He was very fast and very adaptable.

He had a wonderful eye and was a great one for homework, whether he was directing or photographing. He was open to new techniques, providing they didn't cost a lot of money and they enhanced the story.

Can you remember the films you shot in the States with Freddie?
They included *Cape Fear, Glory,* and *Man in the Moon* (1991), with director Robert Mulligan [1925–2008], which we shot in eight weeks. Mulligan was such a disciplinarian, a good technician, and wonderful with the actors. He wanted to shoot it on schedule, and at one point we were a week ahead. Three producers all named Bill said to Mulligan, "At this rate we are going to finish two weeks early." Mulligan said, "Back off. You have given me eight weeks to shoot this film. I have difficult things coming up with teenagers, and we haven't had any bad weather yet. Get off my back." Mulligan and Freddie had a similar attitude. We all got on well together.

What was Martin Scorsese like to work with on *Cape Fear?*
Wonderful. He liked watching old black-and-white movies in his motor home. Gregory Peck [1916–2003] and Robert Mitchum [1917–1997] also had parts in the film. They played in the original 1962 version and were wonderful players.

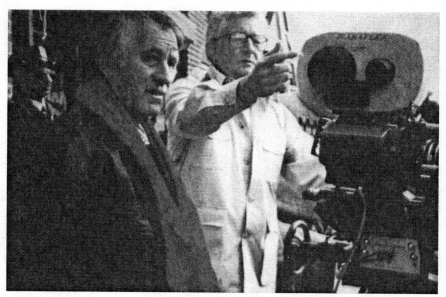

Freddie Francis and Robert Mulligan on the set of *Clara's Heart* (1988). *Courtesy of Freddie Francis*

Robert Mitchum was an anglophile and would stick with Freddie and I. The moment we finished filming, he would come and chat to us. Gregory Peck and Robert Mitchum were made up and in wardrobe and ready on set in time. Mitchum had a very long scene, which he delivered word perfect. It was quite a long shoot. De Niro [1943–] went at his own pace. He went off to his motor home, only coming out when he was ready. He would have the whole studio waiting!

Was De Niro friendly?

He was. He was very shy and didn't stay on the set chatting. The complete opposite of that was Nick Nolte [1941–]. There were four of us that would go and play golf on Sundays. There was Nick Nolte, the prop man, myself, and Nick Nolte's stunt double. On the set Nolte would jump in the water, do his scene, and come out and talk about where we were going to play golf. There was no side to him at all. De Niro would be two hours working up into the part and came out when he was ready.

Filmography

The Wrong Box (1966, Bryan Forbes)
The Man Who Fell to Earth (1976, Nicolas Roeg)
The Eagle Has Landed (1976, John Sturges)
The Greek Tycoon (1978, J. Lee Thompson)
Superman (1978, Richard Donner)
The First Great Train Robbery (1979, Michael Crichton)
Love and Bullets (1979, Stuart Rosenberg and John Huston [uncredited])
Bad Timing (1980, Nicolas Roeg)
Flash Gordon (1980, Mike Hodges)
The French Lieutenant's Woman (1981, Karel Reisz)
Yentl (1983, Barbra Streisand)
The Jigsaw Man (1984, Terence Young)
Dune (1984, David Lynch)
Return to Oz (1985, Walter Murch)
Code Name: Emerald (1985, Jonathan Sanger)
The Doctor and the Devils (1985, Freddie Francis)
Revolution (1985, Hugh Hudson)
Harem (1986, TV Movie, William Hale)
Half Moon Street (1986, Bob Swaim)
Castaway (1986, Nicolas Roeg)
A Prayer for the Dying (1987, Mike Hodges)
Track 29 (1988, Nicolas Roeg)
Black Rainbow (1989, Mike Hodges)

A Connecticut Yankee in King Arthur's Court (1989, TV Movie, Mel Damski)
A Plot to Kill Hitler (1990, Lawrence Schiller)
The Witches (1990, Nicolas Roeg)
Air America (1990, Roger Spottiswoode)
The Man in the Moon (1991, Robert Mulligan)
Cape Fear (1991, Martin Scorsese)
Diana: Her True Story (1993, TV Movie, Kevin Connor)
Princess Caraboo (1994, Michael Austin)
Frankenstein (1994, Kenneth Branagh)
First Knight (1995, Jerry Zucher)
Mission: Impossible (1996, Brian de Palma)
Croupier (1998, Mike Hodges)
Snake Eyes (1998, Brian de Palma)
Heart (1999, Charles McDougall)
The Straight Story (1999, David Lynch)
The Haunting (1999, Jan de Bont)
Taggart (1999, TV Series, Alan MacMillan)
Mission to Mars (2000, Brian de Palma)
Best (2000, Mary McGuckian)
Unbreakable (2000, M. Night Shyamalan)
The Gathering Storm (2002, TV Movie, Richard Loncraine)
Possession (2002, Neil Labute)
My House in Umbria (2003, TV Movie, Richard Loncraine)
I'll Sleep When I'm Dead (2003, Mike Hodges)
Ladies in Lavender (2004, Charles Dance)

As Cinematographer

Dark Tower (1989, Freddie Francis and Ken Wiederhorn)

Pamela Mann Francis on Freddie Francis

Pamela Mann was born in 1927 and worked for David Lean [1908–1991] as his secretary before moving into continuity work.

Did Freddie have a short spell in engineering before working for Louis Prothero?
He studied engineering for a while at the North West Polytechnic and then got a break with photographer Louis Prothero. He worked at Ealing Studios with Prothero. I can remember him talking about moving the large plate camera around.

How did you meet Freddie?

We met on a premier called *Next to No Time* (1958), which starred Kenneth More [1914–1982]. We then worked together on *Saturday Night and Sunday Morning*, which was Karel Reisz's first feature. Karel wanted the picture photographed in a documentary style.

How many films did you work on with Freddie?

I can't remember them all. We worked together on *Saturday Night and Sunday Morning* and *The Innocents*, when Freddie was a DP. The first film we did together when he was a director was *Two and Two Make Six*.

Did you have a favourite film of Freddie's?

It was *The Innocents*. The picture didn't get any nominations, but Freddie always said it was the best film he ever photographed. He said it doesn't matter if films are black and white or colour. He always said he photographed by eye and was not technical.

Did you often go and watch Freddie work?

Yes, I did. I went to America with him. David Lynch asked me to do continuity on *The Straight Story*. I turned it down, but I did go out there with him. It was Freddie's last picture, and he was in his eighties when he called it a day.

Did Freddie enjoy directing as much as cinematography?

I think he loved directing. I don't think it was as successful as cinematography, but I think it was a question of the breaks. He had very good reviews for the pictures he directed. He didn't get the breaks as a director and got pigeonholed in the horror genre, which he hated.

Why did he do horror movies if he wasn't keen?

It was what he was offered. He felt as a cameraman he was well known, but as a director he wasn't, so therefore he felt he should do a lot of films before being accepted as a director. I think that was a mistake. He always acknowledged that it was.

Why did Freddie leave directing and go back to cinematography?

I think to a certain extent because he was pigeonholed. He was due to do a picture in the States, but the producer, Ronald J. Kahn, died, and the picture fell through. It was a film called *The Children Are Watching* (2006), which was made later. After that he decided to go back to cinematography. He went on to shoot *The Elephant Man*, directed by David Lynch. A coin was tossed to decide who would shoot the movie. Freddie lost the toss but won the picture.

Did Freddie have a favourite operator he worked with?

He enjoyed working with Gordon Hayman. When Freddie won the Oscar for *Glory*, he credited Gordon and said, "Thanks to my wonderful operator, Gordon Hayman." Gordon had been accidentally left off the credits, so Freddie credited him when he got the Oscar. We had a private viewing of *Glory*, and I sat next to Gordon. As the credits rolled, I said to him, "Where is your credit?" It has never been rectified, and Freddie felt he should have a mention.

Did Freddie express any views on the coming of digital cinema, and what did he think of modern films?

Because he was not technical, he never embraced the coming of digital. Regarding modern films he either liked or disliked them. He didn't have any particular views. To me the twentieth century was the era of cinema. You knew what you were looking at. Freddie didn't like cheating in films. What was there he photographed. I don't want to put words in his mouth because that would be unfair, but I think in a way he felt some films are a bit of a cheat using CGI. When the bridge collapsed in *Bridge on the River Kwai* (1957) (I'm quoting my own picture), it was a real bridge and a real train that collapsed using controlled explosions. In the old days, what you saw on the screen was more or less what happened on the set.

Freddie worked on *The New Lot* in 1943. This was made by Army Kinematography Services (AKS), wasn't it?

Yes, Freddie was in the AKS, based at Wembley, and worked on *The New Lot*. In 1944 the picture was remade as *The Way Ahead*, directed by Carol Reed [1906–1976].

Did he work much in America?

He did quite a few. He started with *The Executioner Song* (1982). He worked with and became great friends with American director Robert Mulligan. Freddie made *Man in the Moon* and *Clara's Heart* (1988) with Mulligan. His last film, *The Straight Story*, was shot in the States.

Did Freddie have a favourite film?

Yes, it was *The Innocents*. He loved working for the director Jack Clayton. He and Jack got on very well.

Freddie worked for Amicus Productions. Where were they based, and how were Paramount involved?

They were based at Shepperton Studios. I think they were the smaller stages. I don't know if they are still there. I have been to Shepperton recently, but it is

unrecognisable. The main big stages were A, B, C, and D. Regarding the Paramount connection, Max Rosenberg [1914–2004], a producer, worked mainly in New York and Los Angeles. I can remember him saying at one point they were going with Paramount.

Freddie went from cinematography to directing, then back to cinematography, back to directing, and finally back to cinematography, didn't he?
Yes, he went back to directing on *The Doctor and the Devils* (1985). He always said, "I love making films." I think quite honestly he could have been a great director. Possibly he didn't choose his films very well. I didn't see all of Freddie's films, but in the horror movies he directed, he liked teasing the audience.

He directed *The Dark Tower* under the name Ken Barnet. Why was that?
The film was set in a skyscraper, which was supposed to be on the twenty-third floor. It was shot in Barcelona on the fifth floor, so every time you looked out of the window, you saw windows. Also they had a really, really terrible special effects team who came over from Los Angeles. The producer said to Freddie, "We are getting rid of these people and will redo the special effects." There were several other problems: The skyscraper was too low, and acting roles were recast. The special effects people were fired, and we were told that the effects would be done in Los Angeles, but this never happened. I remember seeing the picture, which was terrible. Freddie said, "I'm taking my name off it." He took his name off, and the producer replaced it with Ken Barnet. Freddie and I had no idea where the name came from. He felt let down on that film.

Freddie said he didn't care for TV work generally, but was there any that he liked, and did he only direct?
I think he only directed for TV. He directed Donald Sutherland in *The Saint* (1967–1969). He also did *Man in a Suitcase* (1967–1968) and a lot of the *Black Beauty* series (1974) He didn't like TV much. He always preferred feature films. I think he enjoyed working on *Black Beauty.* Some TV work was only done for the money.

How did Freddie get into directing?
I think he was offered it. The chance came up, and he grabbed it.

Freddie's last film was *The Straight Story* in 1999. Did he find it hard working on it, given his age?
He didn't seem to. The film was shot entirely on location. He said to David Lynch, the director, "I can't shoot more than a ten-hour day." David said he was only going to shoot that anyway.

I believe there is a bench dedicated to Freddie at Pinewood Studios.
Yes, it is situated in the Rhododendron Walk at Pinewood. Freddie would often joke that one man rode a horse, the other rhododendron, and he used to think that was very funny. So when it came to where the bench should go, I chose that.

What does it say on the bench?
It says "Freddie Francis, director and cinematographer, 1917–2007."

Oswald Morris, OBE, BSC

(1915–)

Oswald Norman Morris was born on November 22, 1915, in London. He was interested in the cinema at a young age and decided at sixteen that he wanted to work in the film business. After writing to several companies, he was offered an unpaid job at Wembley Studios working on quota quickies, films that were made in one or two weeks to meet the British quota. His first film as a clapper boy was *Born Lucky* (1933), photographed by Geoffrey Faithfull [1893–1979] and directed by Michael Powell [1905–1990]. This film is now missing and believed lost. He was only there for six months, and the studio closed. After a short break, he got a job as a clapper boy on *Blossom Time* (1934), made at Elstree's British International Pictures (BIP) Studios. He moved on to become a second camera assistant on *Mister Cinders* (1934). His last film at Elstree before moving back to Wembley, which became Fox British, was *Abdul the Damned* (1935). On this he was a camera assistant. Later in the year, he started to operate as well as assist. He and a man by the name of Frank Mills would take turns assisting and operating so it wouldn't become monotonous.

During the war Morris became a pilot in the RAF. After the war he went back into the film industry at Pinewood as operator on the film *Green for Danger* (1946), directed by Sidney Gilliat [1908–1994]. It was then on to *Captain Boycott* (1947). Later, he went to work on the three-strip Technicolor camera on the film *Blanche Fury* (1948). It was to be originally shot by Ernest Steward [1914–1990], who unfortunately had an accident on set. Morris said that four times more light was required for Technicolor, and because of the heat, sets had to be air conditioned to keep the actors cool.

Morris carried on operating until Ronald Neame [1911–2010] asked him to photograph *Golden Salamander* (1950). He worked with some of the finest directors, including John Huston [1906–1987] and Carol Reed [1906–1976], whom he made several films with, including *Oliver!*, released in 1968. Morris

Oswald Morris. *Courtesy of Oswald Morris*

said, when he worked with Reed on *The Key* (1958), a sea film involving a submarine, Reed would always call it a "sumbarine." Morris said filming at sea for *The Key* proved to be the most difficult.

In 1997 the queen presented him with the Order of the British Empire (OBE) for services to cinematography and the film industry. Also in 1997 he became doctor of humanities at Brunel University. Morris's last film was *The Dark Crystal*, which he shot in 1981. He published his autobiography, *Huston, We Have a Problem*, in 2006. It is in the Filmmakers Series by Scarecrow Press.

Morris says he often sits and watches his movies on DVD, thinking, "Could I have done it better?" His brother, Reginald Herbert Morris, was also a cinematographer.

How old were you when you decided you wanted to work in the film industry?

I was sixteen when I decided I wanted to do something in the film industry. I didn't know how I would get into it. My father suggested I write to four or five of the major studios, which I did. I got a letter back from the first one, I'll never forget it, saying "Dear Mr. Morris, Thank you for your enquiry. We haven't got a job for you at the moment, but we will keep you in mind." I thought, "Wonderful, I am recognised." Then I got a second, a third, and even a fourth letter, written in the same way, and I then realised I was being fobbed off, so depression set in.

My father then suggested that I write to the smaller studios. So I did that and got a letter from the chief engineer at Wembley Studios, London, asking if I would go and see him because he may have something for me. He said, "I've got a form of apprenticeship for you, but I can't offer you any money. We work very late at night on quota quickies. If you work after supper, we will pay you one shilling and three pence (six new pence) for your supper money." Well, I thought that was wonderful. He said, "Go home and ask your parents." So I did that, and they said, "OK." I started on the Monday and wasn't allowed to touch any film or camera equipment. All I did was put the board in and get the crew their cheese or ham rolls and their tea and coffee, and I was invariably out of pocket paying for those. The picture, a Westminster production, was called *Born Lucky*. It was Michael Powell's third picture as a director. He used to be a stills man at the Rex Ingram studios in France, and he decided he wanted to be a film director. Ingram was born in 1892 and died in 1950.

We worked late every night. The pictures took two weeks, and on the last Friday, they normally went on working through the night and all day Saturday because they didn't want to work on Sunday because it would be too expensive.

The camera assistant, a man called Jeff Talbot, said, "You can't work all night. I'll arrange for you to be put up in a little café opposite the studio." They did, and I can remember I didn't get any sleep because of the noise of moving trucks in the goods siding near the station. Anyway, I didn't care. I went in on Saturday morning, and they were still at it. They finished the film at four o'clock on Saturday afternoon. That is how the quickies were made. A new one would start the following Monday. There was a lot of pressure, but it was a good training ground.

When did you become a full assistant?

Wembley carried on for about nine months, and then they closed, and I was out of work again. One thing I'd learned while I was there, talking to the various technicians, was go over to Elstree to the British International Picture (BIP) Studios and see the head of the camera department, a man called Bill Haggett. They said, "He'll insult you and talk down to you, but just sit there. After about an hour, come out because he won't offer you anything. Do that once a week and you'll eventually get a job." That is what I did. My father let me have the car to go from Ruislip in West London, where we lived, to go over to Elstree. I would sit in the office and again was told there was nothing for me. At the third visit, Haggett once again said, "I have nothing for you." He went out of the office, came back a few minutes later, and said, "I think I've got something for you: clapper boy on a film called *Blossom Time* (1934) on two pounds a week." I thought this was a wonderful picture, directed by a Hungarian called Paul Stein [1892–1951]. It was photographed by Otto Kanturek [1897–1941], who was later killed in a plane crash. It starred the operatic tenor singer Richard Tauber

[1891–1948]. It was absolutely wonderful. I was really in then. I was getting two pounds a week, most of which went on fares, but I didn't care. I did another film called *Mister Cinder* with the Western Brothers. Then a third film came along called *Abdul the Damned*. It was a big German film directed by a man called Karl Grune [1890–1962]. This was my first job as a camera assistant.

About ten days after that had started, I got a phone call from Wembley Studios, which were reopening under Fox British Picture Corporation. They offered me a job at five pounds a week as a camera assistant. I was only getting two pounds ten shillings (two pounds fifty pence) at Elstree, so I gave my notice, much to the disgust of the studios, and went back to Wembley. From then on I was a camera assistant, and I alternated with another man and became a camera operator. That would be from 1935 or '36 until 1938. It was during that period I became a fully fledged assistant. I was going to be that on *Abdul the Damned*, but I only did a week on that.

Because the quota quickies, which were still being made at Wembley, were extended to three weeks, the hours weren't quite as long as they had been. They were still pretty long, and because of this I alternated between assisting and operating. I worked with a man called Frank Mills. He would operate on one picture, and I would assist, and on the next film, we changed roles, allowing me to operate. They did it to try and break it up so that it wasn't so monotonous for us.

In 1938 came the Munich crisis and the threat of war. All the British studios closed except Denham. At that time it was terribly difficult to get work. They were doing a lot of army training films at Aldershot, and we would go down there and get daily work. It was pretty grim, but most of us were single at that time, so it didn't matter. Finally, war was declared, and in 1940 I was conscripted into the RAF. I didn't touch a camera for six years and was demobbed in 1946.

What did you do in the RAF?
I was a pilot. You didn't have much option about that. They used to say it was voluntary, but it really wasn't. You did what they said, or you sat in a chair until you made your mind up.

I was in bomber command, which was pretty horrible. Later, I was moved into transport command, which was better. I stayed there and did pretty well for myself, I must say.

After the war I went to Pinewood Studios. Four of us were put under contract as camera operators, which we were all doing before the war. During the war the studio had stored sugar and aircraft.

Can you remember your first picture following the war?
The first picture was called *Green for Danger*. Sidney Gilliat directed it, and it starred Alastair Sim [1900–1976]. The cameraman was Wilkie Cooper

[1911–2001]. After that I did *Captain Boycott*, which was made in Ireland and was directed by Frank Launder [1906–1997] and starred Stewart Granger [1913–1993].

After that I operated for cinematographer Guy Green [1913–2005] on David Lean's [1908–1991] *Oliver Twist* (1948), which was the pinnacle of my operating career. Lean was a perfectionist and quizzed me a lot at the beginning, which was wonderful training for me.

What was your first film as a director of photography [DP]?
It was *Golden Salamander*, directed by the late Ronald Neame. I'd known him before the war. I operated for him a lot at Wembley and also knew him when he was at Elstree. He offered me my first job as a DP, which I took with open arms. The location was in Tunisia, and I was told I wouldn't be seeing the rushes. Being the first film, I would have liked to have seen them. They cabled me from London, telling me what they looked like.

What cameras did you work on in the early days?
The camera I operated on before the war was the Debrie Model T Parvo. Later, Debrie brought out a sophisticated soundproof camera called a Super Parvo.

After the war I am thrown into a Mitchell camera with a viewfinder that is eighteen inches off the axis, and I've got to learn about parallax. That is jolly difficult when you have group shots. I had a very fast cameraman by the name of Wilkie Cooper, who would put kicker lights near the edge of my frame, and it drove me up the wall. There was a time then that I wished I were back in the RAF.

I stuck to my guns, and when I went with David Lean, things quieted down, and I got used to it. After that I was thrust onto a three-strip Technicolor film because the operator had had a bad accident. I was under contract, so I had to go on the stage. I'd never worked on a Technicolor camera. They were enormous, with a huge blimp. After that I operated for Guy Green on *Blanche Fury* (1948).

What were the hours you worked?
Before the war [World War II] they were terrible hours. We started at eight in the morning on the quota quickies, and we worked through until we went for the last train, which was midnight. After the war the hours were reasonable. In those days most of the films were made in the studio. There wasn't much location work. The hours then were eight in the morning until six-thirty at night on Monday, Tuesday, and Thursday and eight in the morning until six in the evening on Wednesday and Friday. On Saturday we worked from eight until four. So they were very reasonable and enjoyable hours. That remained for a long time. I believe the industry has slipped back into terrible hours now. They work all hours of the day and night.

How were you offered films? Was it the director or the film company that decided who would shoot the film?

Normally it was the director. There is a close relationship between the director and the cinematographer. The cinematographer in my day was number 2 on the unit. The director is the chief, and I was like the first officer. The link between the director and cinematographer is very important.

Did you turn down films that you felt weren't right for you?

Well, in my early days, you couldn't afford to turn a film down. You had to earn a living and took what came along. Generally speaking that applied for two thirds of my career. Towards the end I did pick and choose a bit, as I was more established. Only on one occasion two films came up that clashed, and it was very embarrassing for me, so that is where an agent comes in. I asked the agent to sort it out. I told him which film I preferred, and he sorted it out. Otherwise it leaves sour grapes with the director you don't choose.

How much rest did you get between films, and how did you fit holidays in?

I would never take a film that started immediately after a previous one finished. You can't work that way. You have to do preparation on the following film, so when a film finished I'd take a break. I had to fit holidays in when I could. You could never say, "I'm going to be on holiday the first two weeks in August." It was a busy time in the film industry during the summer. There was a lot of location work done then because of the longer hours of daylight. I just fitted holidays in according to the film schedule. I didn't get many holidays, but having young children, we did struggle to get away. It was usually on the spur of the moment. I would say, "Right. The film is finished. Let's go away somewhere."

How much preparation was there before a shoot, and did this take some time?

Well, the answer is yes, there is preparation before a shoot, and if you are going to do it properly, it does take time. You have to tour the locations, give budgets for the lights and cameras you want, and talk with the director, so preparation is very very important. Usually in my contract, there was a deal made for me to be available, say a month before the film started, on a reduced fee, which gave me some spare time.

Who decided if a film was to be in colour, black and white, or scope?

The distributors usually had a contract with a production company for a film before I joined it. They would have decided if it was going to be in black and white or colour with the director. The distributors also had a say in the matter. As for scope it was usually between the director, the production company, and maybe myself. It's mainly between the production company and director. If I felt

it should be in scope, I would say to the director, "Don't you think we should have it in scope?" If he agreed we got it changed.

Is it the director's decision which order the film is to be shot in?
Up to a point, it is the director's decision. He has a very powerful input. Sometimes the logistics mean that he has to shoot out of continuity. If you have four different locations and location A covers the first and last part of the story and then you have locations B, C, and D to follow, we would have to do the first and last scenes at location A while we are there. We would have to because it would be too expensive to go back again. Whenever possible, a director will bust a gut to shoot in order because it helps him and it helps the actors.

Were there many difficulties on your first film as a DP?
The first film you photograph is unbelievably difficult. You are just floundering. You have never tried it before but have watched other cinematographers when operating. The first time is pretty nerve-racking. The first is the most difficult. It progressively gets easier. It takes about ten films before you can feel settled in and you don't quite have so much neurosis going on in your system.

Which film took the longest to shoot?
That was the musical *Oliver!*, which was a monumental film. Musicals always take longer because of the sheer logistics. The music, choreography, and dancing took time. Often a musical is split into two units. The choreographer will sometimes be allowed (with the director's permission) to supervise, with a second unit cameraman that I approve, some of the musical numbers, but only the musical numbers that don't have the principle actors. If the principles are in the musical number, it's absolute law that the director goes out with me and we take over that unit to do those pieces. Having done those we will move back into the studio with the principles and let the choreographer and second unit cameraman go on filming. Even then it takes ages. *Oliver!* must have taken about twenty-six weeks. Logistically it was a massive project. The song "Consider Yourself" took around four weeks to shoot.

The entire film, except for about four shots, was filmed on the back lot and in the studio at Shepperton.

What was it like working with three-strip Technicolor?
It was a whole different ball game and very difficult. The light level was very high. It was eight-hundred-foot candles at a stop of T1.3, and it had to be all daylight because of the nature of the system. It had a beam splitter system in, and it was always geared to split daylight, which is a different colour to incandescent light. That meant that all the sets in the studio had to have several large

Oswald Morris on the enormous set of *Oliver!* (1968) at Shepperton studios. *Courtesy of Oswald Morris*

arc lights on them. That was a monumental job because carbon arc lights had to be trimmed every so often. They were fed manually in the early days. Later, they became automatically fed, which helped a lot. It was a terrible problem, and it was a double problem for me in my early days because film A was in black and white and film B was three-strip Technicolor. It was very awkward getting used to the two levels. One was two-hundred-foot candles, and the other was T4 black and white. The colour was eight-hundred-foot candles at T1.3. You could stop down if you wanted to, but the light would then have to be increased. With the arcs there would be a lot of carbon dust. The heat was tremendous, and the risk of fire was always there.

You worked several times with Freddie Francis [1917–2007]. Would you describe Freddie, and where did you first meet?

We first met in 1936, the first year that Pinewood Studios opened. I was the camera operator for Ronald Neame on a quota quickie. In those, after a thousand-foot roll, the cameraman (Neame) would ask for a ten-foot test. That was torn off before the roll went to the laboratory. It was processed in a darkroom at Pinewood Studios, and Freddie Francis was there doing the tests. I can remember him coming onto the floor with a print to show the cinematographer, and that's where I first met Freddie. I was working at Wembley at the time but was at Pinewood because there wasn't enough room at Wembley to shoot the picture.

After the war I was put under contract to Pinewood Studios with three other operators that had worked prewar. It was part of the resettlement that the government insisted that we got work to get the industry going again.

By the late '40s, Ronald Neame, who was directing, offered me my first film as DP called *Golden Salamander.* I needed an operator, so I asked Freddie, and he agreed to operate for me on my first picture. I then went on to *Moulin Rouge* (1952), directed by John Huston. I asked Freddie if he would operate again for me. We then stayed together on several pictures.

Our last film together was *Moby Dick* (1956). On that he asked me if I could do the second unit work. I gave it to him with pleasure.

Ronnie Neame, who gave me my break, said, "I'll give you a chance to photograph this film, but for goodness sake get an experienced operator." Usually when a chap starts as a cinematographer, no experienced operator wants to know him because they think he's going to be a right pain in the neck. Freddie was very good, and he agreed to come with me.

We were great friends, and we'd rib each other. There was a lot of banter. Freddie was a wonderful operator, very experienced. On *Moulin Rouge* we were expected to do all sorts of strange things with the camera. He was throwing the cumbersome Technicolor camera around wonderfully well. It was a great help to me because I was occupied lighting it. At first Technicolor weren't happy with the look of the film colourwise. They tried to get rid of me. When the film was

completed and it got great reviews, they congratulated me for creating a wonderful new colour system.

A cinematographer and an operator have to get on with each other. If they don't it is a disaster. Freddie was great. He didn't mind if I looked through the camera and said, "I don't think this is right. Why don't you move it over there a bit?" He'd move it over and say, "Come and have a look now." I'd look through and say, "That's better," things like that. He got on very well with directors, and so did I. The camera crew have to hit it off with the director. If we think he is doing something wrong, we would try diplomatically to get him to change his mind. Freddie and I always agreed on everything we did. He never said to me, "I think that is a load of rubbish." We just hit it off. He became a very good DP. There was never any jealousy between us. If he'd seen something I'd done, he'd praise or criticise it, and I would do the same.

As a DP did you advise the director on camera angles? Did you say to the director, for example, "That would look good in long shot"?
There were three types of director I worked with. There was the perfect one, who was very good at scripts, very good at handling actors, and knows exactly the camera angles he wants. Now, all I have to do is stand by him and give him the viewfinder at the end of each take. He then gives me the next setup, tells me what he wants, and we do it.

Director 2 is the one that is brilliant with scripts and actors but hasn't a clue where to put the camera. What he would normally do is rehearse the scene with the actors and actresses. He would then quietly turn to me, and we'd have a conversation. He would ask me how I think we should shoot it. I would then give an input into it. I would not shout it out; I'd say it very quietly. He would then ask for the viewfinder and say, "Right. We'll do this." The unit and the actors/actresses think that he's got the setup, but I have told him. I didn't mind that. All I'm interested in is making a decent film.

Director number 3 is the worst of all. They reckon they know it all. They are not good with actors. They take a script—they never query it—they just ask for the viewfinder and stick the camera somewhere and just turn it out without any imagination at all, so you avoid those like the plague.

You always try and get with good directors you respect. They know their stuff, they are the captain of the ship, they are in control, do their homework, and know what they want. They are a dream to work with and handle actors and actresses very well. Occasionally you get a director who does it just for the money.

Which film do you regard as your most difficult?
I think the most difficult was a film I did in New York called *The Wiz* (1978). It was the biggest logistically that I done in my life. It was the logistics of dancing,

coping with weather, and doing things outside in New York during the autumn. All these sort of things don't affect me, but they do affect the look of the picture, and I have responsibility to help the director with the look of the film; it's my job. For example, when we started on *The Wiz*, it was the first of October, and it gets pretty cold in New York in October, and there was a strong wind. We were doing a scene with dancers, and I thought, "We won't be able to put the dancers out there with their flimsy dresses. They won't be able to stand up." I said to Sidney [1924–2011], "What are we going to do about the dancers?" He said, "I've got mobile dressing rooms to keep them warm. Let us make the wind help us. Let us put the dancers out there and see what they do. It might look magical." It did; it looked absolutely magical, their costumes blowing in the wind. It gave the whole thing freshness, a reality, and a life, which we hadn't thought of. The film required a lot of equipment, and the director, Sidney Lumet, said, "Whatever you need, you can have."

One of the difficulties was a dance sequence. Sidney wanted to shoot it at night by the Twin Towers. It was to be shot at the back of the towers in a wide-open space. It was difficult to light at night, particularly when I am going back when the film was much slower, and we had antiquated equipment. Sidney said, "I would like to shoot a big musical number here. Do you think you can do it?" I thought, "I can't believe this." I said, "Sidney, give me twelve hours, and I'll let you know." I went back to my apartment and said to my wife, "I'm going to sit on the settee and stare into space. Don't talk to me." I thought, "How am I going to do this?" Lighting space is difficult. You can't get the lamps into the middle bit; they are too far away. I suddenly thought, "There is a sunken well in the middle with an illuminated floor." I thought that would take care of all the middle bits. I could use lamps on the outside. There was just the bit between the outside and the middle that needed taken care of. I spoke to the production designer, Tony Walton [1934–], and said, Could he possibly put me something there in his décor that allows me to put lights there? He said, "No problem." I went and told Sidney we could do it, and he was over the moon. He then said, "Now I've got another problem. I want it done in three colours. The first sequence is green, the second is red, and the third gold."

I said, "We'll do it, but you have got to finish a colour at the end of the night so you can give us all the next day to change the colour, which was gelatine." He promised that, and that's what we did. We started on the Monday night in October, and they were the first scenes in the picture. Sidney always believed in starting the most difficult things in a picture first. Most directors give it two or three weeks for the unit to get to know each other. He said, "I guarantee you will finish a colour a night." At the end of the first night, we finished the green. We go home, and they get everything ready for the red. I go in the next night, and all my sparks (electricians) are there, ready, and the red is set up.

Finally, we did the gold, which was the longest sequence. There were seventeen one-thousand-amp generators lined up on the road around the Trade Centre. Fourteen were always in use. The spark said, "You must have three standing by to cover possible breakdowns." On the Friday night, we were in Coney Island shooting other scenes.

Would you tell me a bit about *Our Man in Havana* (1959)?

Our Man in Havana, which was shot in black and white, starred Alec Guinness [1914–2000], Maureen O'Hara [1920–], and Noel Coward [1899–1973]. It was written by Graham Greene [1904–1991] and was shot in Cuba just after the Castro regime took over. The director, Carol Reed, wanted a sequence shot by a swimming pool on the roof of one of the big tower blocks. He asked me, What time of the day did I want to shoot it? I thought, "I didn't want it in flat light; it would look interesting with a backlight." I didn't go up to look at it, and that was a mistake. We go up there one morning, which took a long time with all the equipment. I look at the backlight, which I had chosen, and because of the bad atmosphere in Havana, which I'd completely forgotten about, it flared badly; you could hardly look at it. If we had shot it, it would have been a waste of time because the background would have flared out. I apologised for my mistake and went back up another day. You can't afford to make too many mistakes because a lot of money is involved.

Were there any actors or actresses you preferred working with?

No. A cinematographers' job is to light and make the actors and actresses look as good as possible. Directors are responsible for their performance. The cinematographer is responsible for their appearance on screen. Directors don't want to know about performers looking good; they can't be bothered with all that. All they are concerned with is their performance. The cast were usually very nervous because most, if not all, hadn't worked with the director or myself before. I asked them if they have any hang-ups with their looks or something. I would have a signalling system with them so they would be photographed in the best possible way.

What was it like working with the great Humphrey Bogart [1899–1957] on *Beat the Devil* (1953)?

He was as good as gold, no problem at all. You could sit and talk to him. Call him Bogie—we all called him Bogie, even the camera crew. He loved it. The operator would say, "Bogie, can you move a bit to the right or left? Bogie, when you sit down, can you sit a bit slower so I can follow you? It's a bit sharp." He loved all that. Bogie always joked about people being made up. On the first day of shooting on *Beat the Devil*, he came up to me and said, "How do I look?" I

Oswald Morris filming a scene from *Beat the Devil* (1953). *Courtesy of Oswald Morris*

said, "Bogie, you look fine." He said, "I put a little bit of tan on just to give me a bit of colour. You don't mind that do you?" I said, "No, it's fine." He told me he used makeup and everyone else thought he didn't. It was a confidential thing between the cinematographer and the actor. He and John Huston liked their tipple in the evening and were also great poker players. I kept well out of all that.

Did most actors and actresses get it right the first time?

They are all different. Some actors and actresses might say, "I have a lot of dialogue, and I am having great trouble with it. Will you tell your camera crew, if I get through it without stumbling over the furniture or fluffing my lines, I'm only going to do it once?" That is fair comment. I could understand that. So I would tell the crew, "Whatever he or she is doing, follow them, even if they haven't rehearsed it that way." There are others who could do it several times, exactly the same. They vary. This is the magic of the film industry. There are no two people alike in it. Some of them are very disciplined with their movements, particularly American-trained actors. European performers are much more carefree. They may say, "What did you put that chalk mark on the floor for?" I'd say, "We are hoping you're going to hit somewhere near." Some said, "I'll never get near there." I said, "It's there if you need it, and it gives us an idea. Just spare a thought for us trying to follow you." You joke about it, and in the end they do hit the mark.

Did you find the job difficult at times?

I photographed fifty-eight feature films. The first third of those was a struggle because every film is different. I have got to cope with style, exterior, and interior problems. In those days we were switching from black and white to colour, so the first third were a sweat. Things settled down in the middle third because I knew the basic things about lighting. But you have got to do more than that eventually. It's like advancing toward the enemy, then digging in before the next advance. The last third were the best. By then I felt free to do anything I wanted. I experimented and took chances. That is when it became very exciting.

When you started a new film, did you have to work with a different crew?

No, I tried to keep my own crew. It's very important you do, and I generally did keep them. I used six operators during my career as a DP. That is about nine films each. The operators included Freddie Francis, who was my first. He became a very distinguished director of photography, winning two Oscars. The next was Arthur Ibbetson [1922–1997], who also became a very distinguished cinematographer. Then came Denys Coop [1920–1981] and then Brian West [1928–], who made a good name in America.

My crew would go to the rental houses and would check the cameras and the lenses, particularly with cinemascope [wide format]. In the early days, we had the hypergonar on the front of the camera, which was the original design of a professor, Henri Chretien [1879–1956]. The optics of the hypergonar weren't very good. We checked the lenses by putting a board up with a big circle in the middle and a small circle on the four corners of the board. We would photograph these in the anamorphic format. If they were happy with these circles, I was happy.

Was it up to you if you wanted to use filters?
I would tell the director what I'm going to do, and if he said, "Don't do that," I'd say, "Are you sure?" and explain why I wanted it. Sometimes I won the argument; sometimes I didn't.

Did you work with multiple cameras?
In my day all the top directors hated a second camera. They all wanted only one camera. This was because they believed, and rightly so in those days, that there was only one spot to put the camera for a particular scene. Nowadays it's all changed. It is multicamera, and they are floating around on very sophisticated rigs. Of course, there is video assist now, and the cameras are a lot smaller. You wouldn't believe the old antique things we had to work with. They now have lights I would have given my right arm for.

Did you ever want to become a director?
I never wanted to. I couldn't have handled the fads and fancies of some of the actors and actresses. I could handle their looks because they know I'm trying to make them look good. I wouldn't have dared handle some of the big names unless I'd directed ten or twelve pictures. They have got to respect you; otherwise they would tear you apart. I've seen directors destroyed by actors and actresses who ask so many silly questions and got the director completely bewildered.

What year did you receive your OBE?
December 1997, so that would be the 1998 New Year's honours list. The citation was for services to cinematography and the film industry. It was given to me by the queen.

Were you sorry to give up cinematography?
Not really. It was a considered decision by me. I felt I was getting scripts that I'd done before. I felt I would be stale if I photographed them. I felt I wouldn't give them any input that I hadn't done before, and I felt my reputation would go downhill, so I cut off at the top. I was happy with what I had done.

When did you first meet Guy Green and Ronald Neame?
I first met Ronald Neame in 1934 at Elstree Studios. Neame was a camera operator for Claude Friese-Green [1898–1943], the son of film pioneer William [1855–1921]. A year or so later, I met Guy Green. I became a camera assistant at Elstree and then decided to move back to Wembley.

Do you know when they started in the business?
Ronnie started in Alfred Hitchcock's [1899–1980] day. I think Guy Green started at Elstree.

How would you describe them?
Guy was very quiet. He never shouted when he was working. Ronnie was much more buoyant in his work. He was a born leader, and they were different in nature. I think I was more like Ronnie.

Do you know how Guy Green got into directing?
I don't know why. He was such a good cinematographer. That is one of the mysteries. I don't think his wife, Josephine, knew why he wanted to go into directing.

Ronnie became a producer for Cineguild. Even though he was one of the company's directors, he photographed the first two pictures. J. Arthur Rank [1888–1972] insisted that Noel Coward, who was in the first film, directed it because that way J. Arthur Rank would get money because of Coward's name. After photographing the first two, Ronnie wanted to direct. Cineguild was formed during the war by Noel Coward, David Lean, Ronnie Neame, and Anthony Havelock-Allan [1904–2003], who was the moneyman. He was Arthur Rank's representative in the group. Cineguild was very successful. After the war I operated for Cineguild, working with Guy Green. He wasn't called up during the war because the film industry became a reserved occupation.

Did you learn a lot about cinematography from Guy Green and Ronald Neame?
Oh yes. I watched them both very carefully, observing their techniques, and wanted to have a go myself. In the end I got the offer from Ronnie to photograph *Golden Salamander*. It was great having an ex-cinematographer as a director because he saw the picture from the camera point of view and would give me interesting setups to light. A director who had come from a writing background, like a lot of them did, including Michael Powell, just saw it as a script. They didn't appreciate the problems of getting it into a form we could photograph. That would have been difficult on my first picture as a DP. Fortunately I avoided that with Ronnie.

What was it like working with director Carol Reed?

Carol Reed could be very obstinate. He used to say "yes" to everybody and everything. He did that with the actors as well. The actors never knew what was going on. They would just do the bit from the script they had got. An actor would say to Carol, "Where is so and so when I come in the door, and where do I look?" Carol would wave his hands saying, "Over there, over there somewhere." Of course the actor or actress didn't know any more than he or she did before he'd asked the question. It was Carol's way of controlling the actor, and he was brilliant at doing that. I knew half the time when he said "yes" he meant "no."

John Huston was one of your favourites, wasn't he?

Yes, he was the most laid-back man of all time. He spent most of his time in the production chair, chatting away. He had an aura and a quality about him. The actors loved him. He could tame anybody, he really could.

The actor Orson Welles [1915–1985] could be very difficult. I did a couple of films with Welles and Huston. Orson could be a dominant actor. He would come onto the set singing like mad, and everyone knew he'd arrived. He had very definite ideas how he wanted to play a scene. He would often want to alter the script. I thought, "How is Huston going to manage this?" Huston said to Orson, "Let us do your version first." Orson would do it, and Huston would say, "That's fine." Huston would then say, "Now let us do the script version so we can see how much better your version is." So they would do it again. When you see the film, it is the Huston version. So many directors would argue with Welles about what is right, and there would be a terrible atmosphere. Getting Welles to do it twice and getting him to do his version first, he thought that would be in the picture, so keeping Welles happy. An inexperienced director couldn't have handled that.

Quota quickies were made in a week when you joined the industry. Did it show on screen?

The films were made very simply; they just hadn't got the equipment. They tried to avoid tracking shots because they took time. Directors were asked to avoid those shots as much as possible. As far as possible, we only shot one take. There were no elaborate sets. Mainly it was just dialogue in houses created in the studio. There was very little location work because it was expensive and time consuming to take the cumbersome equipment out. It was amazing how they managed to do it. The camera was usually just panned and tilted.

Filmography

The Golden Salamander (1950, Ronald Neame)
Cairo Road (1950, David MacDonald)

The Adventurers (1951, David MacDonald)
Circle of Danger (1951, Jacques Tourneur)
Saturday Island (1952, Stuart Heisler)
The Card (1952, Ronald Neame)
Moulin Rouge (1952, John Huston)
Stazione Termini (1952, Vittorio De Sica)
So Little Time (1953, Compton Bennet)
South of Algiers (1953, Jack Lee)
Beat the Devil (1953, John Huston)
Knave of Hearts (1954, Rene Clement)
Beau Brummell (1954, Curtis Bernhardt)
Moby Dick (1956, John Huston)
The Man Who Never Was (1956, Ronald Neame)
Heaven Knows, Mr. Alison (1957, John Huston)
A Farewell to Arms (1957, Charles Vidor)
The Key (1958, Carol Reed)
The Roots of Heaven (1958, John Huston)
Look Back in Anger (1959, Tony Richardson)
Our Man in Havana (1959, Carol Reed)
The Entertainer (1960, Tony Richardson)
The Guns of Navarone (1961, J. Lee Thompson)
Lolita (1962, Stanley Kubrick)
The Devil Never Sleeps (1962, Leo McCarey)
Term of Trial (1962, Peter Glenville)
Come Fly with Me (1963, Henry Levin)
The Ceremony (1963, Laurence Harvey)
Of Human Bondage (1964, Henry Hathaway and Ken Hughes)
The Pumpkin Eater (1964, Jack Clayton)
Mister Moses (1965, Ronald Neame)
Affair at the Villa Fiorita (1965, Delmer Daves)
The Hill (1965, Sidney Lumet)
Life at the Top (1965, Ted Kotcheff)
The Spy Who Came In from the Cold (1965, Martin Ritt)
Stop the World, I Want to Get Off (1966, Philip Saville)
The Taming of the Shrew (1967, Franco Zeffirelli)
The Winter's Tale (1967, Frank Dunlop)
Reflections in a Golden Eye (1967, John Huston)
Great Catherine (1968, Gordon Fleming)
Oliver! (1968, Carol Reed)
Goodbye, Mr. Chips (1969, Herbert Ross)
Fragment of Fear (1970, Richard Sarafian)
Scrooge (1970, Ronald Neame)
Fiddler on the Roof (1971, Norman Jewison)
Sleuth (1972, Joseph Mankiewicz)
Lady Caroline Lamb (1973, Robert Bolt)
The Mackintosh Man (1973, John Huston)

Dracula (1974, Dan Curtis)
The Odessa File (1974, Ronald Neame)
The Man with the Golden Gun (1974, Studio, Guy Hamilton)
The Man Who Would Be King (1975, John Huston)
The Seven Per Cent Solution (1976, Herbert Ross)
Equus (1977, Sidney Lumet)
The Wiz (1978, Sidney Lumet)
Just Tell Me What You Want (1980, Sidney Lumet)
The Great Muppet Caper (1981, Jim Henson)
The Dark Crystal (1982, Jim Henson and Frank Oz)

Awards

Distinguished Flying Cross (1943, RAF)
Air Force Cross (1946, RAF)
Moulin Rouge (1953), British Society of Cinematographers Silver Tankard
Moby Dick (1956), British Society of Cinematographers nomination
The Pumpkin Eater (1964), British Academy of Film and Television Arts Best Cinematography: Black and White
The Hill (1965), British Academy of Film and Television Arts Best Cinematography: Black and White
The Spy Who Came In from the Cold (1966), British Academy of Film and Television Arts Best Cinematography: Black and White and British Society of Cinematographers Golden Camera
The Taming of the Shrew (1967), British Society of Cinematographers Golden Camera
Oliver! (1968), Oscar nomination
Fiddler on the Roof (1971), Oscar Award Best Cinematography, British Society of Cinematographers Golden Camera, and British Academy of Film and Television Arts nomination
Sleuth (1973), British Academy of Film and Television Arts nomination
The Man Who Would Be King (1975), British Academy of Film and Television Arts nomination
The Wiz (1978), Oscar nomination
Brisith Society of Cinematographers John Alcott Arriflex Award (1992), Outstanding Contribution to British Cinema
American Society of Cinematographers Lifetime Achievement Award (1999)
British Society of Cinematographers Lifetime Achievement Award (2003)
British Academy of Film and Television Arts fellowship
Royal Photographic Society fellowship
National Film and Television School fellowship
Institute of Bournmouth honorary fellowship
British Kinematograph Sound and Television Society honorary fellowship

CHAPTER 12

Alex Thomson

(1929–2007)

Alex Thomson was born on January 12, 1929. He entered the film industry in 1947 after trying for almost two years and was given a job by Bert Easey [1902–1973], head of the camera department at Denham and Pinewood. Thomson first worked on *So Well Remembered* (1947) as a clapper boy. He started at Denham Studios, moving onto Pinewood. Later, he went to work for Technicolor, where he stayed for four years. During his time there, he worked with the great Oswald Morris [1915–] on *Moulin Rouge* (1952). He worked with many other greats, including Freddie Young [1902–1998], Otto Heller [1896–1970], and Robert Krasker [1913–1981], who photographed *The Third Man* (1949).

He went on to become a freelance camera operator, working on several films with Nicolas Roeg [1928–], who was then a director of photography (DP). Films they worked on together include *Lawrence of Arabia* (1962) on the second unit, *Nothing but the Best* (1964), and François Truffaut's [1932–1984] *Fahrenheit 451* (1966). Thomson's first feature as DP was *Ervinka* (1967), followed by *Here We Go Round the Mulberry Bush* (1968), which was his first colour feature as DP. He collaborated again with Nicolas Roeg when Roeg became a director. Thomson and Roeg became the best of friends. Thomson was special effects operator on *Inchon* (1981). He appeared in three documentaries, *Creating a Myth . . . The Memories of "Legend"* (2002), directed by J. M. Kenny [1965–]; *The Making of "Alien³"* (2003), directed by Charles de Lauzirika; and *The Making of "Casino Royale"* (2008), directed by Steve Mitchell. Thomson was the camera operator on the stunt unit with DP Nicolas Roeg.

On *Year of the Dragon* (1985), directed by Michael Cimino [1939–], Thomson was asked if he would operate as well as be the DP. He went on to do both jobs on several pictures. He mainly used Arri and Panavision equipment. His favourite studio after Denham was Cinecitta in Rome, where part of Sylvester Stallone's [1946–] *Cliffhanger* (1993) was shot.

He was on the board of governors of the British Society of Cinematographers (BSC) for twenty-six years and was president from 1981 to 1982. After Thomson's death, Oscar-winning cinematographer Billy Williams [1929–] said, "Alex was a remarkable member of the society. He contributed an enormous amount of his time and talent to the well-being of the society. He was one of the leading lights in moving us to North Lodge. He did a great deal for the BSC, was a very talented cinematographer, and did some wonderful work. He was also a very good friend."

Thomson also worked with Kenneth Branagh [1960–] on *Love's Labour's Lost* (2000) and a short film, *Listening* (2003). Thomson shot *Hamlet* (1996) in 65mm. Director Kenneth Branagh wanted it shot in the large format because he had seen how good *Lawrence of Arabia* (1962) had looked. *Hamlet* was shot in nine weeks using Panavision equipment. A large part of the film's budget was spent on the large main hall. Thomson said that *Hamlet* was a difficult shoot because of the complex camera movements. Following Thomson's death Branagh said,

> Alex was always good humoured on set. He gave you the feeling of having seen it all before but was still highly amused about the ever-surprising shannanigans of filmmaking. He had his own very dry, very wry sense of fun in response. It made him very good company when the going was rough. He was a very glamorous figure. Tall, slim, and with a fine head of hair. He once showed me a production still from *Fahrenheit 451*. In the picture was the handsome French-man and the young, breathtaking Julie Christie [1941–]. Both, however, were eclipsed by the figure at the side of the shot. Collar up, dark hair, movie-star handsome. The camera loved him. Was it the male lead? No, it was the camera operator: one Alex Thomson.
>
> It was also, of course, a very serious artist. A lover of film, a lover of the camaraderie of artists, generous about his fellow cinematographers. What I will remember especially was his exceptional eye for colour, detail, texture, composition, and his ability to express this as we worked, with ease, grace, and generosity. He was a man from whom one learned daily, and our simple friendship was precious. Alex Thomson—artist, scholar, and gentleman.

Producer David Barron, who also worked on *Hamlet*, said,

> Alex was a wonderful and extraordinarily talented man who loved his work as a cinematographer. He was very generous with the great knowledge that he accumulated over the years, and I was lucky to be the beneficiary of his shared wisdom on many occasions. He told the

best stories, he had the best memories of the best times, and he was very funny. He was a true gentleman.

Thomson married professional sculptor Diana Golding [1939–] in 1963. She said, "Alex and I met in 1960 at the Star pub in Belgrave Mews West in London. We were together for forty-seven years."

Thomson's daughter, Chyna [1967–], worked with him on *Cliffhanger* and other films. She said of her father,

> I worked as a camera assistant for my father from 1984. We had such wonderful times shared on locations all over the world, and it was a joy to spend so much time with him on set, to watch him at work, and to work for him. He was a great leader for his electricians; the grips; the camera team, most notably Nic Milner, camera operator, and Tony Cridlin, key grip, who were with Alex for twenty-one films over two decades. Alex taught me, and many others, an incredible craft with great patience, understanding, and creativity. He was and always will be my favourite DP.

The last feature Thomson shot was *Love's Labour's Lost*. The last thing he shot was the British short *Listening* for Kenneth Branagh. For many years Thomson edited the BSC newsletter and went on to produce two books: *Outstanding Stills* and *Take One*, which was published after his death by BSC Entertainments Ltd. His wife, Diana, said, "I think the idea for *Take One* came about two years before he died. For seventeen years previously, he had been editing the BSC newsletter and always wrote a funny anecdote at the beginning about his own experiences in the film industry." *Outstanding Stills* was compiled with help of cinematographer Robin Vidgeon [1939–].

Alex Thomson passed away on June 14, 2007, at age seventy-eight. He was cremated in his *Cliffhanger* tee shirt. There is a bust at Pinewood Studios, which his wife, Diana, made. His friend Nicolas Roeg paid tribute to him and said,

> Alex was unique in the history of my life. We first met nearly sixty years ago at an Association of Cinematograph Technicians (ACT) (union) meeting—not ACCT, just ACT, before television was added. We became instant, laughing, serious friends. Our lives crossed and recrossed as we worked, lived, and grew in studios, on locations, in pubs and bars, ships, and airplanes. Making movies was our life. Alex operated for me for five or six years, and when I started to direct, he became my wonderful DP. He was just a brilliant and inspired cinematographer. He lived the film as much as the screenwriter or the actors.

Alex Thomson. *Courtesy of Alex Thomson*

How old were you when you started in the film industry, and how did you get into it?

I was always going to the cinema as a boy. I loved the cinema. I couldn't keep out of it, so I thought I would try and get into the film industry. I didn't have any connections. My father was a tailor's cutter in Bond Street, London, and one day he was measuring film producer Anthony Havelock Allan [1904–2003] for a suit. Havelock Allan produced for Cineguild. Director David Lean [1908–1991] and director Ronald Neame [1911–2010], who had been a cinematographer, were also involved in the company with Noel Coward [1899–1973]. My father, who had made clothes for Havelock Allan before, was talking to him about me and telling him how I loved the cinema and would like to work with films.

Havelock Allan said, "Send him down to Denham." I went to see him and he introduced me to Bert Easey, who was head of the camera department at Denham. Bert said, "I haven't got anything for you at the moment. Phone me in a week's time," which I did. I then phoned him every week for about eighteen months to two years. After that period he said, "You seem keen enough. You can start Monday."

Why did you choose cameras?
I didn't know how films were made, but I knew they had a camera. I started as a clapper boy on a film called *So Well Remembered.* What I didn't realise at that time was that Denham was the cream of the studios.

Were the studios what you imagined them to be?
It was absolute magic. I was so excited, and the cameraman on my first picture was Freddie Young. I later worked on the second unit of Young's *Lawrence of Arabia.* I wasn't in Jordan; I worked in Morocco with Nic Roeg, who went on to direct.

How long were you a clapper boy for?
I was a clapper boy until Denham closed. I then went to Pinewood because Denham and Pinewood were sister studios. Pinewood went four-waller, meaning freelancers were used instead of employed people. Bert Easey said they are looking for people at Technicolor, so I applied and I remained with them for around three years. There were two grades, an assistant technician and Technicolor technician. I became a focus puller and worked with Oswald Morris on *Moulin Rouge.* It was a great film to work on. Ossie Morris is so innovative and a lovely man. At that time he was quite a disciplinarian, as they all were. Ossie is one of my heroes.

Did you have a favourite studio?
Yes, I did. It was Denham. MGM at Elstree was also a nice studio. Elstree Studios are only a fraction of what they were. A Tesco food store occupies part of the area.

Have you worked in studios abroad?
I have worked at Warner Bros. in America. I worked with Sylvester Stallone in *Demolition Man* (1993) over there. I have also worked at Cinecitta in Rome.

Was *Demolition Man* shot entirely in the States?
It was all in the States. I also did *Cliffhanger* with Stallone, but that was in the Dolomites.

Where else have you been on location, and do you have a favourite?
I have done an enormous amount of location work, and my favourite place was Rome.

Out of all your movies, do you have a favourite?
My favourite photographically, the one I'm most proud of, is *The Sicilian* (1987), a Michael Cimino picture. Storywise, *Nothing but the Best* (1964) was my favourite. Nicolas Roeg photographed it, and I was the operator.

Which film was the most difficult?
Leviathan (1989), shot in Italy, was the most difficult. This was because we had to give the impression of shooting underwater when we weren't. I was flattered because Alan Ladd Jr. [1937–], who had money in the picture, came on the set when we were shooting something else and said, "Which tank did you use?"

Which of your films took the longest time?
It was *Legend* (1985), which took six months.

How long were you an operator before becoming a DP?
I operated on a number of films, including pictures for Nicolas Roeg, who was a DP before moving on to directing. I worked with him for around six or seven years.

What was your first as a DP?
My first was a black-and-white feature shot in Israel called *Ervinka*, starring Topol [1935–]. The first colour picture as DP was *Here We Go Round the Mulberry Bush* (1968), starring the late Barry Evans [1943–1997].

Did you have a favourite director?
Yes, Nicolas Roeg. I did a couple of pictures with him as his DP. He is a great raconteur, and he always made me laugh. We have a great friendship.

Did you have a camera you preferred?
I mostly used the Arriflex, but I have used Panavision quite a lot.

Have you won any awards for your work?
I had an Academy award nomination for *Excalibur* (1981), a John Boorman [1933–] film. I didn't win; I came second. I won BSC awards for *Legend* and *Hamlet*. They also presented me with a lifetime achievement award, and I also got the Golden Frog Award at Camerimage in Poland.

Do you miss the business since retirement?
I keep my interest up by editing the BSC newsletter, which is a quarterly pub-lication. People write to me and keep in touch, and I am also on the board of governors. I was president of the BSC in 1981 to 1982. I have been on the board for about twenty-five years.

Did or do you have any hobbies?
I never had any chance because of work.

What hours did you work?
In the beginning we worked five and a half days including Saturday morning. Later it varied. On some of the pictures, we worked six days a week. This is worked on most of them now. They can work up to fourteen or fifteen hours a day.

What do you think of digital?
I don't know how long it's going to take. Everyone knows film is better at the moment. Until it's proven that digital is better, people will carry on using film. I think digital is very good, but it is harder to control for a cameraman than film is. I suppose eventually when it is all digital people will get used to it. At the moment you haven't got the same range with digital. I feel film will be around for some time to come. The good thing about digital is you have more control regarding the grading. Also the special effects done digitally are excellent. I was on *Superman* (1978), and we spent hours trying to disguise wires, lighting them out, shading them, and all sorts of things.

What was your last feature film?
My last feature was Ken Branagh's *Love's Labour's Lost* (2000), after working fifty-six years in the business.

Do you sometimes look at your films on DVD and say to yourself, "I could have done that better"?
Yes, all the time. I don't need to look at a DVD. I've never been really satisfied. *The Sicilian* was the nearest thing to me being happy.

What films did you work on while you were at Technicolor, and was there a big staff?
Yes, there was a big camera department, and while I was there, I was put on dif-ferent jobs. Technicolor owned the cameras, and we would take the camera from Technicolor to the studio each morning and return them back for servicing. I

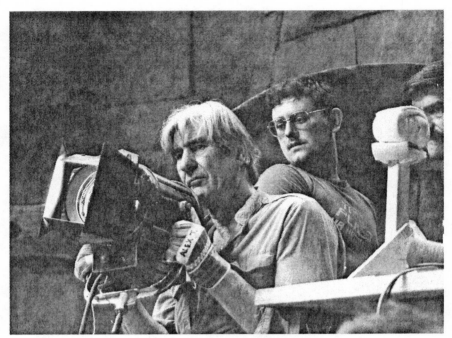

Alex Thomson on the set of *Labyrinth* (1986). *Courtesy of Alex Thomson*

became a Technicolor technician (focus puller) on a David Niven [1910–1983] film. Another film I worked on for them was *Richard III* (1955) with Laurence Olivier [1907–1989]. Technicolor employed around forty technicians. There was quite a few of us worked for them, including Christopher Challis [1919–].

On some films you operated as well as being the DP. Why was that?
It started on the film *Year of the Dragon*. The director, Michael Cimino, wanted me to do both jobs. I found I quite enjoyed doing both because I could see exactly what I was getting as a cameraman. After that, I did the two jobs on several pictures.

How many films did you make in the United States?
Not very many. I did *Alien 3* (1992), part of *Cliffhanger*, *Demolition Man*, *Executive Decision* (1996), *Raw Deal* (1986), *Track 29* (1988), *Date with an Angel* (1987), and *Year of the Dragon*.

Do you still keep an interest in retirement?
Yes, I continue to edit the BSC newsletter.

Alex Thomson and Peter O'Toole on the set of *High Spirits* (1988). *Courtesy of Alex Thomson*

When you were at Denham, did you pull focus, or didn't you do that until going to Technicolor?
I was a focus puller at Denham Studios. I think my last one was *The Rocking Horse Winner* (1949).

Did you usually keep the same crew?
I kept the same crew, especially when I was doing my own operating. My daughter worked with me from *Legend* onwards. She started as a clapper girl; then she went on to pull focus.

Filmography

Ervinka (1967, Ephraim Kishon)
Here We Go Round the Mulberry Bush (1968, Clive Donner)
The Strange Affair (1968, David Greene)
I Start Counting (1969, David Greene)
The Best House in London (1969, Philip Saville)
Alfred the Great (1969, Clive Donner)
The Rise and Rise of Michael Rimmer (1970, Kevin Billington)

The Night Digger (1971, Alistair Reed)
LHR (1972, Michael Fox)
Dr. Phibes Rises Again (1972, Robert Fuest)
Fear Is the Key (1973, Michael Tuchner)
Death Line (1973, Gary Sherman)
Rosie Dixon—Night Nurse (1978, Justin Cartwright)
The Cat and the Canary (1978, Radley Metzger)
The Class of Miss MacMichael (1979, Silvio Narizzano)
Game for Vultures (1979, James Fargo)
ABC Weekend Specials (1980, TV Series, "The Gold Bug," Robert Fuest)
Excalibur (1981, John Boorman)
The Last of Linda Cleer (1981, Bob Mahoney)
Once They Marched through a Thousand Towns (1981, TV Movie, Herbert Wise)
Eureka (1983, Nicolas Roeg)
Bullshot (1983, Dick Clement)
The Keep (1983, Michael Mann)
Electric Dreams (1984, Steve Barron)
Year of the Dragon (1985, Michael Cimino)
Legend (1985, Ridley Scott)
Raw Deal (1986, John Irvin)
Labyrinth (1986, Jim Henson)
Duet for One (1986, Audrey Konchalovskiy)
The Sicilian (1987, Michael Cimino)
Date with an Angel (1987, Tom McLoughlin)
Track 29 (1988, Nicolas Roeg)
High Spirits (1988, Neil Jordan)
Leviathan (1989, George P. Cosmatos)
The Rachel Papers (1989, Damian Harris)
The Krays (1990, Peter Medak)
Wings of Fame (1990, Otakar Votocek)
Mr. Destiny (1990, James Orr)
Alien 3 (1992, David Fincher)
Cliffhanger (1993, Renny Harlin)
Demolition Man (1993, Marco Brambilla)
Black Beauty (1994, Caroline Thompson)
The Scarlet Letter (1995, Roland Joffe)
Executive Decision (1996, Stuart Baird)
Hamlet (1996, Kenneth Branagh)
The Man Who Couldn't Open Doors (1998, Paul Arden)
The Troop (1999, Marcus Dillistone)
A Shot at Glory (2000, Michael Corrente)
Love's Labour's Lost (2000, Kenneth Branagh)
Listening (2003, Kenneth Branagh)
Der Letzte Flug (2004, Roger Moench)

Awards

The Gold Bug (1980), Emmy Award Best Cinematography
Excalibur (1981), Oscar nomination
Legend (1985), British Society of Cinematographers Award
Hamlet (1996), British Society of Cinematographers Award
British Society of Cinematographers Lifetime Achievement (2001)

Chris Menges, ASC, BSC

(1940–)

Chris Menges was born on September 15, 1940, in Kington, Herefordshire, England. He was always fascinated by cameras and photography and at seventeen went to work for American documentary filmmaker Allan Forbes. He did several jobs, including recording sound and helping in the cutting room. He says Forbes was a huge inspiration. Menges was unavailable for an interview because he was shooting *Extremely Loud and Incredibly Close* in New York for Warner Bros.

Following is an article published in the February 2010 issue of The American Cinematographer, *reproduced with the kind permission of the executive editor of* The American Cinematographer *magazine, Stephen Pizzello.*

Artistry and Conscience

BY MARK HOPE-JONES

Later this month, director of photography Chris Menges, ASC, BSC, will receive the ASC International Award in recognition of a 50-year career in film and television that has taken him to the far corners of the earth. It is a career that shows no sign of abating; he recently wrapped *London Boulevard* for first-time director William Monahan and *Route Irish* for long-time collaborator Ken Loach. These latest two credits illustrate a common thread that runs through Menges' work: the knack of teaming up with interesting new directors, often shooting their first films, and also sustaining relationships with directors across many years and many projects. Loach is a classic example: Menges made such an impression on the director while operating the camera on *Poor Cow*, Loach's first feature, that Loach asked him to photograph the next one, *Kes*, Menges' first movie as

cinematographer. *Kes* had a profound impact on British cinema and marked the beginning of a creative partnership that endures to this day.

Other acclaimed directors who worked with Menges early in their careers and sought him out again include Stephen Frears, Bill Forsyth, Neil Jordan, and Roland Joffé. The latter three established relationships with Menges during a period of intense creativity for the cinematographer, when he abandoned documentaries and turned his full attention to shooting features. He won Academy Awards for two collaborations with Joffé, *The Killing Fields* (1984; *AC* Apr. '85) and *The Mission* (1986; *AC* Feb. '87); the latter also brought Menges his first ASC Award nomination.

After he spent a decade focusing on directing, Menges returned to cinematography with Jordan's *Michael Collins* (1996; *AC* Oct. '96), earning another set of Academy and ASC nominations. He was nominated by the ASC and the Academy again last year, along with Roger Deakins, ASC, BSC, for Stephen Daldry's *The Reader,* a film Menges took over when production delays and previous commitments forced Deakins from the project. "When I started out, Chris was kind of my idol—and always has been, actually," says Deakins. "I think he's probably the greatest cinematographer working today."

Menges was born just over a year into World War II in the rural county of Herefordshire, England, a short distance across the border from where he now lives in Wales. Coming from a family of musicians who worked in the theater, he developed an early interest in the arts. He had a cousin with a job at the BBC, and it wasn't long before Menges' interest gravitated towards filmmaking. At the age of 17, he was introduced to Allan Forbes, who would become an early mentor. "At that time, we were living in North London, and I became an apprentice to Allan," recalls Menges. "He was an American making documentary films for the cinema and television in London. He was really the man who taught me the basics of cinematography, editing and sound. I was his assistant, and he was a one-man band, so I had a rich opportunity to learn different genres and techniques. He was a great teacher."

By the time Forbes returned to the United States, at the end of the 1950s, Menges had cut his teeth on a number of gritty social documentaries and dramas. He had also built up some useful industry contacts, and he quickly found a job in the cutting room at Derek Knight & Partners in Soho, which in turn led to work as a cameraman for Alan King Associates. One particularly influential person to whom he was introduced by Forbes was cinematographer Brian Probyn, BSC. Menges describes Probyn as "another very good teacher" and worked sporadically as his assistant on short films, including *The Saturday Men*, which came straight out of the naturalistic tradition of Free Cinema. In 1963, Menges joined the *World in Action* team at Granada Television and swiftly became a highly experienced cameraman. Over the next few years, his work-

Chris Menges on the set of *Kes* (1969). The boy looking through the camera is actor David Bradley. *Courtesy of Chris Menges*

ing relationship with Probyn continued; it was for Probyn that he operated on Loach's *Poor Cow*, Menges' first taste of feature-film work.

World in Action was a hard-hitting, investigative-journalism program that aired in Britain from 1963 to 1998. "They sent me all over the place with really good journalists like Alex Valentine, Stephen Peet and Michael Parkinson," says Menges.

> We covered news stories such as the fighting in Angola, the uprising in Zanzibar, the civil war in Cyprus, Spain, under Franco, and most importantly for me, we went to South Africa during the time of apartheid. Armed with a Bolex and looking a bit like a student, I went up to Bulawayo in Matabeleland with Alex Valentine to make a documentary about the Ndebele's support for the African National Congress, which was a real education. All of these things were amazing—to be that age and to be travelling, learning and seeing—but South Africa was important because when I was asked to direct *A*

World Apart, I knew I could film it in Bulawayo. I knew I'd have political support from the ANC groups I'd met and could give the city enough of a feel of Johannesburg, because, obviously, we couldn't actually shoot the film in South Africa.

Experiences such as these made Menges an international filmmaker from the earliest years of his career. Many of the documentaries he shot involved travelling to dangerous regions and taking extraordinary risks, especially the films he made with director Adrian Cowell. Their first collaboration was *Raid into Tibet*, a 30-minute documentary that followed a group of Khamba guerrillas as they crossed the border into Tibet and attacked a Chinese military convoy. Menges, Cowell, and journalist George Patterson accompanied the Khambas on a gruelling trek across the mountains and filmed the raid. Several Chinese soldiers were killed during the attack, and the raiding party eventually fled when one of the guerrillas was shot.

Menges and Cowell also worked together on a series of films about illicit opium production in the Golden Triangle. The pair had visited Burma during an earlier filmmaking tour of Southeast Asia, but their 1972–73 expedition into the Burmese mountains for *The Opium Warlords* proved far more treacherous. "We were with the Shan State Army, a group fighting for independence from Burma, and we had a lot of trouble," Menges recalls. "Remnants of the Kuomintang [who fled China after losing a power struggle with the communists after Work War II] had come to Burma to run the opium trade, and they declared war on the Shan State Army. For a year and a half, they chased us from mountain to mountain, ambushing us and trying to blow us up. During the long march from northern Shan State to the Thai border, we carried our shot rushes in polystyrene boxes on mules—much of the footage remained exposed and undeveloped for over a year. The five mules with our rushes had big crosses on them, and our instruction to the army was that they were the only ones to save when we were ambushed."

The 1960s and 1970s were dominated by documentary work for Menges, though he grabbed opportunities to build on his fiction-film experience between projects.

> Having just come out of the Amazon with Adrian Cowell on *The Tribe That Hides from Man*, where we were searching for the Kreen-Akrore [tribe] with the Txukahamae, I caught the train to Cheltenham the day after arriving back in London to operate on *If. . . .* That film was a learning curve for me and an important project for two reasons: one was working with [director] Lindsay Anderson, and the other was working with [cinematographer] Miroslav Ondricek [ASC, ACK], who had shot *A Blonde in Love*.

An appreciation for Czech cinema was one of the things that drew Menges and Loach together when they met on *Poor Cow.* "I suspect we were both profoundly affected by films coming from Czechoslovakia, such as *Peter and Pavla* and *A Blonde in Love*—Milos Forman's early films," says Menges. "Those films had a real sense of irony, of sensitivity, of catching the moment and of natural light. They were moving and also funny." Loach recognized that Menges' skills as a documentary cameraman could help give *Kes* a similar style. "Doing documentaries, you learn to catch everything that comes at you," says Menges. "I'm sure that must have been partly what appealed to Ken about my work."

Though his documentary experience undoubtedly informed Menges' approach to drama, the cameras generally used for the two genres differed far more at the start of his career than they do today. In 1963, when Menges joined *World in Action,* Éclair released the NPR, the first silent, portable 16mm camera with a coaxial magazine. "It was a revolution because you could pick it up and walk with it," says Menges. "You had a reflex viewfinder that swivelled with your eye, so you could boom the camera up and down and your eye would stay with the eyepiece." By contrast, "on *Kes,* the camera was in a huge, lead-lined blimp that took two people to lift it off the ground."

Interestingly, the freedoms and limitations of different formats and genres led Menges to the same conclusion: what the camera does is always subordinate to what is happening in front of it. "Shooting handheld with the NPR, you suddenly realized it's no good getting great pictures if you can't hear what people are saying," he explains. "In a way, the real test when you're on a film set is to shut your eyes and listen to the dialogue." On *Kes,* the equipment was cumbersome and the work rate slow, but for Menges, it was a fascinating experience because he learned so much about what makes a fiction film succeed. "The first thing about *Kes* is that it's beautifully written," he says. "The next thing is the sensitive direction and great acting, and then, almost down at the bottom of the list, are the framing and photography."

The catalyst for Menges' eventual renunciation of documentary work was a British film he made in Spanish Harlem called *East 103rd Street.* He explains,

> It wasn't until then that I realized I'm scared of documentaries, because I recognized that however hard you try not to exploit people, you can end up in a situation where you do. That film was put out in America, and I wasn't consulted; it was about a family with a drug history, and I think I should have been allowed to discuss it with the family before it was broadcast in New York. Also, ATV got about $30,000 for the transmission, and I think that money should have been put towards something that helped the family and helped with the addiction in New York. What they did was rotten, and that's why I stopped.

Following this disquieting experience, Menges made a decisive transition into feature films. After shooting *Looks and Smiles* (1981) for Loach, he was asked to work on *Angel*, Neil Jordan's first film. "Neil is a writer from a totally different tradition," says the cinematographer. "It was exciting because he didn't know much about movies, and I was learning Irish politics. For Neil, it was a true baptism of fire, and in a way, it was also that for me."

Another director to make a strong impression on Menges at that time was Alan Clarke, for whom he shot *Made in Britain*. Menges describes Clarke as

> probably the best director I've worked with other than Ken Loach. He was a complete inspiration because everything was Steadicam or handheld; every time we did a shot, he would harden it up and give it real energy. Alan was a champion at catching the moment. It was totally different from what Ken does, and yet they both have enormous energy and a kind of logic that serves the writing.

While working on *A Sense of Freedom* with director John MacKenzie, Menges met Forsyth, who later asked him to shoot *Local Hero*. Set in a small fishing village on the west coast of Scotland, the film charmed critics and audiences alike; its exquisite location photography won universal praise and brought Menges his first BAFTA nomination. "Bill is a smashing bloke and a really good director," says Menges.

> I don't know why the hell he doesn't make more films. It was just a fabulous experience. One day, Burt Lancaster was sitting in his chair on the office set, and I was looking at his desk while we were waiting. I moved two of the pens on the desk, and this voice growled, "Don't touch my props. They're my memory." Even that was an education: actors' props are important to them!

The accolades garnered by almost every film Menges worked on during that period led to one opportunity after another. "It probably helped that *Kes* was a well-liked film, and when *Angel* came out, [producer] David Puttnam agreed to have me on *Local Hero*," says Menges. "Then, when *Local Hero* came out, Roland [Joffé] asked me to do *The Killing Fields*, and Puttnam agreed to that as well." Joffé was determined to give *The Killing Fields*, which is set amid the horrors of the Khmer Rouge regime in Cambodia, an authentic feel. "Roland wanted someone who'd been in a few bloody conflicts," says Menges.

> In addition to what happened in Burma, I'd done several films for the BBC in Vietnam. During prep, we went to Thailand and talked endlessly about how to give it the quality of the documentaries I'd shot in Saigon. *The Killing Fields* was an extraordinary film, and it

was entirely Roland's vision. A lot of talented people gave their hearts to it, but he made that film, and as far as I'm concerned, it was Roland who won the Oscar for cinematography.

Before taking a break to try his hand at directing, Menges shot *The Mission* for Joffé, an experience he does not look back on as fondly as *The Killing Fields*, despite the fact that it earned him another Oscar. He is dismissive of his directorial efforts during the years that followed, though *A World Apart* won awards at Cannes and from the New York Film Critics. "At least two of the films I made were complete disasters, ill-conceived and badly made," he says. "So to be invited back to shoot *Michael Collins* and to work with Neil [Jordan] and [operator] Mike Roberts and all those actors was very, very important. It's a film I warm to myself, and it was lucky that he asked me, because I was a bit of a grump at that stage."

Since then Menges has worked on a steady stream of interesting projects, including Jim Sheridan's *The Boxer*, for which he earned an ASC nomination (*AC* June '98); Sean Penn's *The Pledge*; Jordan's *The Good Thief*; Frears' *Dirty Pretty Things*; Tommy Lee Jones' *The Three Burials of Melquiades Estrada*; and Richard Eyre's *Notes on a Scandal*. "I think the things I go for are good writing and a good story, and hopefully something with political energy," he says. "The problem is that what you read on paper may not necessarily turn out to be a good film. You can only give it your best and pray." Menges continues to operate the camera on his films. "For me, looking through the finder during rehearsals and during a take helps me discipline my sense of framing, of how to catch a character, of light, and of how to tell the story. I believe that if you don't operate, you lose a lot of those skills because you're probably looking at a video monitor that gives you no real sense of the performance or the light."

When Deakins left film school in the mid-1970s, he sought Menges out to ask his advice about how to become a documentary cameraman. "One of the first television documentaries I did was about a 'round-the-world' yacht race," says Deakins. "Chris and I were working for the same TV company at the time, and I'm sure he'd already turned the job down." Menges recalls it distinctly: "Oh, God, I just couldn't do it—be on a yacht going round the world and be sick every day!" Deakins took the job on and was excited to be using one of the cameras Menges had recently brought back from Burma. Two decades later, Deakins was equally excited to share cinematographer duties with Menges on *The Reader*. "I'm flattered to be on the same [title] card as him, really," reflects Deakins.

Since becoming an ASC member in October 2003, Menges has visited the clubhouse and met his fellow members, but he notes, "It's a long way from the Radnorshire hillside where we live, surrounded by sheep! But I get *American Cinematographer* every month. I've been reading it since I was seventeen, and I

Chris Menges. *Courtesy of Chris Menges*

find the combination of information and ideas totally exhilarating; without it, one could feel really isolated and miss out on learning new ideas and tricks." As for the ASC International Award, he says, "I don't know why I've been chosen, but I'm really thrilled."

The following is an interview conducted for the twenty-fourth ASC Awards. Reproduced by kind permission of Martha Winterhalter, publisher of American Cinematographer *magazine.*

A Conversation with Chris Menges, ASC, BSC

BY BOB FISHER

Where were you born and raised?
My grandfather was a violin player who was born and raised in Germany. He moved to England in 1890 to teach students to play the fiddle. I was born on a farm in Herefordshire, England. My family moved to London when I was 3 years old when my father became music director at The Old Vic Theatre.

You obviously didn't follow in your father's footsteps, but do you see a connection between creating music and cinematography?

There is definitely a connection. Both music and cinematography are arts, which require mastering a complex craft. I learned to trust my instincts, and above all, I learned that tone is more important than perfect technique.

When and how did you decide you were going to be a filmmaker?
I was always fascinated by cameras and photography. When I was 17 years old, I went to work for our neighbour Allan Forbes. He was an American filmmaker who made documentary films for cinema. Allan shot documentaries all over Italy, France, and Britain. I was his assistant. I also recorded sound and helped him in the cutting room. Allan was a huge inspiration for me.

How did you get started as a cinematographer?
I began shooting films for *World in Action*, a weekly current affairs documentary series, when I was 21 years old. I draw on those experiences every time I work on a new project.

You were 22 years old when Nelson Mandela was imprisoned for leading an armed struggle and the African National Congress was made illegal in South Africa. You roamed the streets of Johannesburg dressed like a tourist shooting 16mm film with a Bolex camera. You shot other documentaries in war zones all over the world, including *The Opium War Lords* in the jungles of Burma. Tell us about that experience.
I spent two years in Burma on two different trips in 1963 and 1972 during a very brutal civil war between different ethnic groups who were pushed into the union of Burma by the British. Those types of documentaries expose you to a different world. You learn about composition, and how it affects the story, and about natural lighting. You experience those things by observing. You also learn to fit into the environment with the indigenous people and that there is no one right way to tell a story. The experience of being a fly-on-the-wall while shooting documentaries helps you develop as a filmmaker. I think everybody who wants to be a filmmaker can benefit from shooting documentaries with a handheld camera.

That's just a snapshot of your documentary endeavors, which also took you to places ranging from the Ho Chi Minh Trail during the war in Vietnam to the streets of Harlem. You mentioned Allan Forbes. Were there other films and cinematographers who influenced you during that early stage of your career?
I recall seeing *The 400 Blows*, which was directed by François Truffaut and shot by Henri Decaë; *A Blonde in Love*, directed by Milos Forman and shot by Miroslav Ondrícek (ASC, ASK); and *Medium Cool*, directed and shot by Haskell

Wexler (ASC). They were awe-inspiring films with cogent stories that went into great depth. For a couple of years, I worked as Brian Probyn's assistant. He was another important mentor. I was his camera operator when he shot *Poor Cow* in 1967. Ken Loach was the director.

You shot *Kes*, your first narrative film, in 1969. Please share a memory.
The joy of *Kes* was in the writing, the brilliant performances, and skillfull story-telling. Brilliant! It was a special film and the kind of experience we dream about.

***Kes* was not a bad way to start your career as a narrative film cinematographer. That film won two BAFTA awards and four other nominations. You followed *Kes* with a number of real-life dramas, including *After a Lifetime*, which focused on a family living in Liverpool, and *Bloody Kids*, living in the south end of London. Were there other pivotal experiences during that period?**
In 1980, I shot a remarkable television movie called *Made in Britain* entirely with a steadicam. Alan Clarke was the director. I also spent five months as the second unit cinematographer on *Star Wars: The Empire Strikes Back*. It was a great learning experience, working on a big-budget film under the delightful team of (director) Irvin Kershner and (cinematographer) Peter Suschitzky (ASC).

You came onto the international scene when you earned your first Oscar in 1985 for *The Killing Fields*. Share some insight into that film.
Again, I was fortunate to work with an incredibly talented director. Roland Joffé had a clear vision for the story he wanted to tell. It's a story about what happened in Cambodia during the Pol Pot regime when more than 2 million people were murdered. Roland wanted the film to tell the story of a dirty war and a time of pain and darkness for the people of Cambodia. I was thrilled at having the opportunity to work with Roland because he has such a strong visual sensibility. Many talented people worked on *The Killing Fields*, including production designer Roy Walker, and the best camera operator, Mike Roberts. That helped make the experience of working on this film very special for me.

You earned your second Oscar for *The Mission* in 1987, which was also directed by Roland Joffé. That film took place in the jungles of Brazil during the 18th century. Spain and Portugal had established colonies and had made the native people who were living in the jungle slaves. Jesuit priests from Spain built a number of missions above a waterfall with the goal of converting native people to their religion. The story takes a drastic twist when an emissary from the pope said the native people have to leave the missions and return to the jungle. Please share some memories.

It began with discussions with Roland and David Puttnam, who produced the film. I drew on memories of a television documentary called *The Tribe That Hides from Man* that was directed by Adrian Cowell. We shot that documentary in the Amazon jungle in South America in 1968. The air around the mission was thick with white, steamy mist created by the waterfall. We recreated that look by using several water pumps to generate a fine spray of vaporized water, which reflected the beams of sunshine that came through the trees and created light and shadows on the ground.

The ASC Outstanding Achievement Awards began in 1987, and Feature Films was the only category. You were nominated for *The Mission*. The other nominees were Jordan Cronenweth, ACS, for *Peggy Sue Got Married*; Don Peterman, ACS, for *Star Trek IV: The Voyage Home*; Jimmy Crabe, ACS, for *The Karate Kid: Part II*; and Tony Pierce-Roberts, BSC, for *A Room with a View*. There was an awards dinner at the ASC's Hollywood clubhouse hosted by legendary actor Gregory Peck. What do you remember about that night?
It's hard finding the right words to describe my feelings about that evening. I remember the sense of history that I felt being at the clubhouse and the camaraderie that filled the air. I had been reading about the ASC and its members since I was an assistant cameraman when I was 18 years old. Now, I was meeting and talking with its members.

You took a bit of a hiatus from cinematography in order to try your hand at the helm as a director. *A World Apart* was the first film you directed in 1988. It took place in South Africa during the days when you shot your first documentary in 1962 about the banning of the African National Congress. You won the Grand Jury Prize at Cannes, the New York Film Critics Award as best director, and various other awards and nominations. You directed several other films after that.
I was immensely proud of *A World Apart*, but the next three films I directed were rather depressing experiences.

You returned to cinematography when you collaborated with writer/director Neil Jordan on *Michael Collins*, a film about an Irish revolutionary. You earned your third Oscar nomination for that endeavor in 1997.
Neil had shown me an early draft of the script in 1982 when I shot a movie called *Angel* with him. *Michael Collins* took place during the turn of the 20th century. Neil wanted to recreate the grimy, sooty look that was common in Dublin during that time in history. The streets were lit with carbon arc lamps, and there was smoke in the air from coal-burning fires. I used smoke cyan filters and the ENR process at Technicolor to help create a nearly monochrome look.

You followed *Michael Collins* with a number of interesting films, including *The Boxer, The Pledge, Dirty Pretty Things,* and *The Yellow Handkerchief.* You earned your forth Oscar nomination in 2009, which you shared with Roger Deakins, ASC, BSC, for *The Reader.* Roger began shooting the film, but he had to leave after around 30 days because he had another commitment. You stepped into the breach. It was a seamless transition. What do you recall about that ambitious endeavor?

That was an unusual situation. Redmond Morris, the line producer, called and told me what the story was about. I had read the book written by Bernhard Schlink that the movie is based on. The story is set in post–World War II Germany. It involves a man's relationship with an older woman who was accused of a war crime. I wanted to know more about what happened during that period. My grandfather was a German who migrated to England. I wondered if he would have gotten caught up in that insane and barbaric time in European history if he had stayed in Germany. I met with (director) Stephen Daldry and also watched the film that Roger had shot. I thought it was wonderful. I felt comfortable finishing the film because Roger and I think alike about using light and shadows to create a natural feeling. There is one thing I will never forget. We filmed a scene in the Majdanek concentration camp in Poland. It was a heartbreaking experience. It was impossible to be there without crying your heart out.

In general, what are your thoughts about the collaborative process between cinematographers and directors?

I don't know a cinematographer, certainly not myself, who has won an award or contributed to a meaningful movie who wasn't collaborating with a highly visual director. Part of it is luck, getting to work with the right director and script, and then it takes an incredible amount of hard work. The inspiration comes from the words and from inside the characters. All you have to do is bring your soul and great energy.

One of the unique things about filmmaking is that it is a collaborative form of artistic expression. What are your feelings about that collaborative relationship?

It goes beyond collaborating with directors. You are working with production and costume designers, makeup artists, gaffers, and of course everyone on your crew to get composition, camera movement, and focus that delivers.

Tell us about the film which you just completed shooting.

Route Irish is a story about a private security contractor in Iraq who rejects the official explanation of a friend's death and tries to find out more about what happened to him. The film is directed by Ken Loach. It is our 12th collaboration.

We filmed the Iraq scenes in Jordan and other scenes in Liverpool, England. I think it's an important and interesting story.

Ron Prince, editor of *The British Cinematographer* magazine, travelled to the Welsh borders to meet double-Oscar-winning cinematographer Chris Menges, BSC, at home, and to discover more about his work on *The Reader*.

The Reader is not an easy film. It wasn't a particularly straightforward production, with cast availability creating many hiatuses. The subject matter is challenging. The visuals are stark. The critics have found it hard to equate the point of counterpointing of sex and Nazism. Researching details about the concentration camps for this piece has been a chilling affair. And the man responsible for shooting two thirds of the film lives in a remote spot where Wales and England meet. Yet it's already earned its joint cinematographers, Chris Menges, BSC, ASC, and Roger Deakins, BSC, ASC, nominations at the ASC annual awards, plus a Golden Globe for Kate Winslet as Best Supporting Actress. With the awards season just beginning, who knows what other glories lie ahead?

The $40 million motion picture production of *The Reader*, produced by the Weinstein Company, Neunte Babelsberg Film (currently in production with Tarantino's *Inglourious Basterds*) and Mirage Enterprises, is pretty much true to the best-selling book about post–WWII Germany, written by law professor and judge Bernhard Schlink in 1995. Partly autobiographical, it deals with the cascade of personal and national guilt as subsequent generations struggle to comprehend the Holocaust, romantic trauma, and the transformative power of the written word. Schlink's book, adapted for the big screen by David Hare (*Wetherby*, *The Hours*), was well received in his native country, and the United States, winning several awards. It became the first German novel to top the *New York Times* bestseller list, and Oprah Winfrey made it her book club selection. It has been translated into 37 languages and is included in the curricula of college-level courses in Holocaust literature, and how many reading groups is anybody's guess.

"I am fascinated by that whole period of German history," muses Menges, who won Academy awards for his work on *The Killing Fields* and *The Mission*.

> My grandfather was German. My uncle was a navigator in RAF/Polish airforce. I was brought up during the war in London, dodging the doodlebugs. So I had an investment and wanted to know more about what happened for myself. The story is complex and hurtful, and uses a child as a metaphor for a generation of Germans affected by what happened to Germany, and subsequent generations, under the Third Reich.

The story follows 15-year old Michael Berg (David Kross) in post–WWII Heidelberg in Germany, who becomes drawn into a passionate but secretive af-

fair with Hanna (Kate Winslet), a 36-year-old tram conductor. Michael discovers that Hanna loves being read to, and their physical relationship deepens. But, despite their intense bond, Hanna mysteriously disappears one day, and Michael is left confused and heartbroken.

Eight years later, while Michael is a law student observing the Nazi war crime trials, he is stunned to find Hanna back in his life—this time in the courtroom on trial for allowing 300 Jewish women to perish in a fire at a church that she was watching as part of her duties as an SS guard at an extermination camp near Auschwitz. During the trial, both Hanna and Michael could save Hanna from being sentenced to life in prison by admitting her illiteracy, but they don't.

As time passes, the older Michael (Ralph Fiennes), a divorcée with an all-but-estranged daughter, tries to reconcile the truth with his feelings for Hanna. He tapes readings of books and sends them to her, and she eventually learns to read. However, the day before her release, she commits suicide. Michael visits one of the survivors of the fire, the principal witness at the trial, seeking some form of redemption and offering Hanna's meager savings. She points out how inappropriate their relationship was, how it damaged him, and that forgiveness does not come so cheaply. After the meeting, Michael goes to visit Hanna's grave for the first and only time, with his daughter.

Menges' involvement with *The Reader* began in October 2007 with a telephone call from producer Redmond Morris, enquiring about his availability. The production, which counts Harvey and Bob Weinstein amongst the executive producers and Anthony Minghella and Syndey Pollack as producers, had already got underway with Roger Deakins having shot for 31 days in Germany, but he was unable to continue on the film.

"I've known Roger for the best part of 30 years, and am a great admirer of his work. Even so, I called him immediately to make sure he was OK with me picking up the reins," says Menges. "I had worked with Stephen Daldry before on film tests for *The Amazing Adventures of Kavalier & Clay* and was naturally drawn to the subject matter."

The swapping of cinematographers confirmed, Menges immersed himself in prep and went to Berlin for a week during December 2007, working particularly closely in the production office with Daldry; Claire Simpson, the editor; production designer Brigitte Broch; costume designer Ann Roth; and makeup designer Ivana Primorac—to get a clear understanding of where the production was going.

In terms of the artistic references, he says

> There was a lot of talk about the drawings of Picasso and the films of Polish director Andrzej Wajda, particularly the trilogy of *A Generation*, *Kanal*, and *Ashes and Diamonds*. They are truly fascinating studies of political and social evolution in Nazi-occupied and postwar

Poland. They have a great strength in the framing, the use of light, sense of realism, and energy—all highly appropriate values for this film and very important references for me.

As for taking over the cinematography from Deakins, Menges says

I studied Roger's material and thought that a lot of what he had shot was wonderful. We think about many things in terms of photography in very similar ways. We both prefer to use bounced or natural lighting, are keen on catching improvisation, and we both like to operate the camera. So it was not very difficult to follow on. The only slight change I made was to the stock. Roger shot on Vision2 500T 5218, and I changed to Vision3 5219, as I like that stock.

He also inherited Deakins' crew that included gaffer Bjoern Susen and focus puller Andy Harris. "I brought in Adrian McCarthy as dolly grip. I could not have got anywhere without someone as good as Adrian. He's focussed in the script, hears the words, and moves the camera in response to the performance of the actors," he says.

After preproduction meetings, Menges then spent a week visiting locations in Berlin and Cologne before starting to shoot the Fiennes' prison scenes and locations in the Czech Republic.

However, it was during the 10-day Christmas break that news came that Nicole Kidman, who was to play Hanna, was pregnant and had discounted herself from the production. In the first two months of the New Year, Menges found himself travelling back and forth between Berlin, London, and New York, shooting scenes for the film and screen tests with Kate Winslet, now cast in the role of Hanna. The production schedule saw Menges typically shooting in week-long or fortnightly blocks, interspersed with significant breaks according to the actors' availability, with very little of what was being shot in consecutive running order. Indeed, the passionate scenes between Michael and Hanna, which feature in the first half of the film, had to wait until the very end of the production schedule when actor David Kross turned 18 on July 4th.

In all, Menges shot for 67 days during his stint on the film and comments, "I have never shot on-off, on-off like this before. I am used to getting up ahead of steam and going for it." That said, when it came time to shoot the passionate scenes on a stage at a studio in Cologne, Menges was expecting to spend two weeks rehearsing and shooting and to have everything meticulously planned. "But great intentions sometimes fall away. We actually shot them really fast within two days."

It is this sense of the unexpected that Menges says he really thrived on during the production.

I like working with Stephen Daldry. He likes a certain amount of chaos, a sense of anarchy on set. I like that sense of spontaneity too. I quite enjoy a set where the creative energy might change, might develop, and might provoke something interesting. I like to operate and capture that. Stephen is a gracious man, talented, fun, and enjoyable to work with. He brings out the poetry in people's work, and that's rewarding.

But there were some harrowing moments. During April 2008 Menges, David Kross and a small German crew made their way to the well-preserved Majdanek concentration camp on the outskirts of the city of Lubin in eastern Poland for a two-day shoot. During WWII this was where mass transports of Jews began arriving in April 1942, during the period that Auschwitz was being converted into an extermination camp. People driving past the camp while it was in operation had completely unobstructed views of the smoke wafting from the top of the tall brick chimney of the crematorium and the gas chamber building just a few yards from a busy street. In the film, Majdanek doubles for the camp Michael visits where Hanna had been a guard and where she had weak and sickly women read to her before they were sent to the gas chambers—either to make their last days more bearable or maybe to guarantee their entry to the chambers so they would not reveal her secret.

"It was an incredibly awful experience," recalls Menges, who framed some of the film's most iconic, symbolic, and potent images there. "It's impossible to be there without crying your heart out for the poor souls who suffered so badly and who had been tortured and killed. There was a big group of Israeli schoolchildren at the time of our shoot, and they were completely shattered by the experience. You cannot be but profoundly troubled by being there. It's hell on earth."

And it's here we perhaps get to the core of Menges' *raison d'etre* for working on the film and his career path in cinematography.

> *The Reader* is not a story of redemption or forgiveness. It's about how a new generation of Germans came to terms with what the earlier generation had done. It asks the question: If you love someone who is guilty, do you become entangled in their guilt? You cannot help but get emotionally drawn into this material. I only work on films that I can learn from. My work is my university, and the work I do is about educating myself. That's why I wanted to do this story. In fact, the crew, who were predominantly German, gave their hearts and souls to this production. Many of them are living with that contradiction of denial.

The Reader was shot on Super 1.85:1, 3-perf, with a camera, lens, and lighting package supplied by Arri in Munich, and a sizeable 640,000 feet of stock

being used, which Menges puts down to frequent scene changes, particularly those which explore the relationship between Hanna and Michael.

Regarding the lighting, Menges says the biggest problem was shooting in Germany in the winter. "It can be incredibly dark, wet, and dreary, even with fast stock. In general I chose, like Roger did, to work with bouncing light from multiple sources to keep things looking as naturalistic as possible and to respond to the performances."

For the bath and sex scenes in Hanna's apartment, Menges simulated natural daylight to make it sympathetic to the euphoric moments for the young boy. For the scenes in Majdanek, he used available light to capture the cold, devastating feeling of the ghostly camp, and for the courtroom scenes, he mixed blue and tungsten to create the austere formality of a war trial. The prison was lit with Xenon lights and fluorescents, "to make it feel cruel and cold."

In terms of camera movement, Menges believes the relationship between the camera and the actors is incredibly important.

> You have to live in the moment, to respond to the actors' performances, so that things are alive. That's the wonderful thing about operating. I like a volatile, moving camera and could not imagine working without a dolly grip and focus puller responding to the dialogue. I like handheld too, as it gives you an urgency and frees you up, although there's not much handheld in the film.

Although film dailies were occasionally used as a guide to monitor the work done at the lab, Menges mainly viewed dailies on DVD or Arri LocPro. "I really miss the chance to sit down and watch film dailies with the director and also miss the conversation about shot density you would have with the film grader, who would then take the material away and produce great rushes. In many ways working with photochemical had a purity to it. It's a big loss, but it's the world we live in now."

The Reader was given a DI grade on Lustre at Technicolor in New York by Tim Stipian.

> The producers wanted me to attend, and I would expect to attend. I have never been asked not to, but I can see how a DP [director of photography] might get excluded from this process these days. But you have to say it's a very odd thing to employ someone to bring so much that is original to the table in terms of lighting, framing, composition, and performance and then not to ask them to have a major hands-on role in maintaining that through postproduction. In DI today you can manipulate the images so much that you have to be very careful not to lose your way and lose the concept of what

you shot. That's why I keep a notebook plastered with references on every production.

In an online retort to a wide-of-the-mark *Guardian* review, Professor Julian Dodd uses the adjective *toe-curling* to describe the disturbing emotions *The Reader* stirs up. Of course, films are there to keep us entertained, but for Menges, "they also need to challenge us and help us come to terms with the world in which we live." *The Reader* was never meant to be an easy film. In this respect, he classes it alongside Ken Loach's *Kes*; Alan Clarke's *Made in Britain*; *The Killing Fields*, directed by Roland Joffé; and Stephen Frears' *Dirty Pretty Things*, when asked to compare it to other films he has shot during a long and distinguished career that shows no signs of slowing.

Filmography

A Boy Called Donovan (1966, Charles Squires)
The War Game (1966, Mia Zetterling)
Abel Gance: The Charm of Dynamite (1968, Ken Brownlow)
Kes (1969, Ken Loach)
Black Beauty (1971, James Hill)
ITV Sunday Night Theatre (1971, TV Series, Ken Loach)
Loving Memory (1971, Tony Scott)
Gumshoe (1971, Stephen Frears)
It's a Lovely Day Tomorrow (1975, John Goldschmidt)
Dummy (1977, Frank Roddam)
Last Summer (1977, Stephen Frears)
ITV Playhouse (1977–1978, TV Series, Stephen Frears)
A Sense of Freedom (1979, John MacKenzie)
Black Jack (1979, Ken Loach)
Bloody Kids (1979, Stephen Frears)
The Gamekeeper (1980, Ken Loach)
Auditions (1980, Ken Loach)
A Question of Leadership (1981, Ken Loach)
Babylon (1981, Frank Rosso)
Looks and Smiles (1981, Ken Loach)
Couples and Robbers (1981, Clare Peploe)
East 103rd Street (1981, Chris Menges)
Made in Britain (1982, Alan Clarke)
Warlords of the 21st Century (1982, Harley Cokeliss)
Angel (1982, Neil Jordan)
Walter (1982, Stephen Frears)
Local Hero (1983, Bill Forsyth)

The Red and the Blue: Impressions of Two Political Conferences—Autumn (1983, Ken Loach)
Comfort and Joy (1984, Bill Forsyth)
The Killing Fields (1984, Roland Joffé)
Which Side Are You On? (1985, Ken Loach)
Marie (1985, Roger Donaldson)
Winter Flight (1986, Roy Battersby)
The Mission (1986, Roland Joffé)
Walter and June (1986, Stephen Frears)
Fatherland (1986, Ken Loach)
Shy People (1987, Audrey Konchalovskiy)
High Season (1987, Clare Peploe)
Michael Collins (1996, Neil Jordan)
The Boxer (1997, Jim Sheridan)
The Pledge (2001, Sean Penn)
Dirty Pretty Things (2002, Stephen Frears)
The Good Thief (2002, Neil Jordan)
Concert for George (2003, David Leland)
Great Performances (2004, TV Series Documentary)
Criminal (2004, Gregory Jacobs)
Tickets (2005, Abbas Kiarostmi, Ken Loach, and Ermanno Olmi)
The Three Burials of Melquiades Estrada (2005, Tommy Lee Jones)
North Country (2005, Niki Caro)
Notes on a Scandal (2006, Richard Eyre)
The Yellow Handkerchief (2008, Udayan Prasad)
Stop-Loss (2008, Kimberley Peirce)
The Reader (2008, Stephen Daldry)
Route Irish (2010, Ken Loach)
London Boulevard (2010, William Monahan)
Extremely Loud and Incredibly Close (filming 2012, Stephen Daldry)

As Director

CrissCross (1982)
A World Apart (1988)
Second Best (1994)
The Lost Son (1999)

CHAPTER 14

Walter Lassally

(1926–)

Walter Lassally was born on December 18, 1926, in Berlin. He decided at the age of fifteen that he wanted to be a feature film cameraman. Two months before the outbreak of World War II, he came to England and settled in Richmond-upon-Thames, London, England. In 1946 he became a clapper boy on *Dancing with Crime* (1947), made at Riverside Studios, London, and directed by John Paddy Carstairs [1910–1970]. Ten months after joining Riverside, the studios and its associated studios at Twickenham and Southall closed. Lassally says it was mainly due to the inefficiency of the operation. Some pictures took too long to make. He went on to shoot documentaries and work on features. His first feature as a director of photography (DP) was *Another Sky* (1954). His operator was Gerry Turpin [1925–1997]. In 1961, his first film for director Tony Richardson [1928–1991] was released. It was what is known as a kitchen-sink drama called *A Taste of Honey* (1961). He made two more films for Richardson, *The Loneliness of the Long Distance Runner* (1962) and *Tom Jones* (1963), made in colour. The operator on all three was Desmond Davis [1926–]. That genre was popular at that time. Other films in the same category included *Room at the Top* (1959) and *Saturday Night and Sunday Morning* (1960), both photographed by Freddie Francis [1917–2007] and his operator Ronnie Taylor [1924–]. In 1964 Lassally photographed and operated on *Zorba the Greek* (1964), directed by Michael Cacoyannis [1922–].

Lassally says he didn't find television work less satisfying than feature film work. He says that in the late 1970s he did TV work in America, usually on tight budgets and schedules, but many had good stories.

He was head of the camera department at the National Film and Television School from 1988 to 1992. Lassally published his autobiography in 1987 called *Itinerant Cameraman* published by John Murray Publishers, Ltd. He has also written a number of magazine articles for several publications, including

Walter Lassally. *Photo by David H. Lyman*

American Cinematographer and *Sight and Sound*. He now lives on the Greek Island of Crete.

Your father worked with film, didn't he?

My father wasn't keen on me going into the film business, which he categorised as a mess, which it was and still is. He was in a different branch of the industry because he was an industrial filmmaker. He was forced to stop working when I was age six, by the coming of the Nazis. We had an animation bench in our flat, and occasionally I was allowed to turn the handle or something. I think that may have been the beginning of my interest. I was interested in feature films, and that was an area my father had nothing to do with.

I worked in a stills laboratory. At the age of fifteen, I knew I wanted to be a feature film cameraman. I knew that with a certainty that is remarkable because a lot of people are not certain what they want to do at that age.

As soon as I left school, which was during the war, I started to get as close to the business as I could. That meant that I worked for a short while as a processing grader. I made blocks for newspaper photos. I then worked for two years in

a laboratory that processed still film, mainly taken by amateur beach photographers who turned in twenty rolls a day and forty on weekends.

You also went to work on documentaries, didn't you, shooting on 16mm?
Yes, I went in and out. I took whatever job I could. I was aiming to become a clapper boy, and I finally got my foot in the door with a little bit of help from my father, who met the head of cameras at Riverside Studios in England. He took me on after much trying as a clapper boy in 1946. The job only lasted ten months because the studio and its whole group of studios shut down. It was one of the perennial crises of the industry.

You shot a film called *Smith Our Friend* (1946) and then *Saturday Night.*
Yes, this was the first bit of cinema material I shot, which came about because a friend of mine, Derek York [1927–1994], who was also very interested in getting into the industry combined forces with me. *Smith Our Friend* was shot on 16mm and was silent.

After making it we went on to shoot *Saturday Night*, which was never finished. Producer Leon Clore [1918–1992] saw some of it and offered me my first job as a lighting cameraman on a public service commercial. Originally *Saturday Night* was to be twenty minutes long but was expanded to thirty-three minutes to qualify for what they called featurette quota.

Why wasn't *Saturday Night* finished?
Well, that is a very long story, but basically it was quite ambitious. It had a cast of twenty people, and Bryan Forbes [1926–] played the lead. When we could, work was dictated by the availability of people and equipment. It was shot at weekends over a four-year period from 1948 to 1952. In 1952 Derek became dissatisfied with the material he shot in 1948. He wanted to reshoot it, and I could see a never-ending process beginning. Then Bryan Forbes decided to get married and move to America, so we very quickly recorded his lines because sound recording in those days before tape was a very difficult process. There were a lot of difficulties, and the thing just ground to a halt. A while ago there was an attempt to resuscitate it because the material still exists, but it was never edited.

When did you light your first picture?
I got the chance to light my first feature in 1954. Gavin Lambert, who at that time was the editor of *Sight and Sound* magazine, had filmmaking ambitions. He got hold of a Scottish laird to put up the money for a project. Initially they were going to film a Pirandello play. This proved impossible because of negotiation problems with the Pirandello family, so Gavin rather quickly came

up with another subject, which was called *Another Sky*. It was shot entirely in Morocco in 1954.

I much preferred lighting to operating. In England and America, an operator had to be used. In Greece I could do my own operating, so I did both jobs. As from my first Greek film in 1955, I operated myself. I gradually learned to become better at it. I much prefer doing it if there is time.

What cameras did you prefer?
I always worked with Arriflex. The Mitchell, which was popular all over the world, had a severe drawback for me compared to the Arriflex, which was the parallax problem. You could not see a direct image when you were filming. To me the Parallax was a serious drawback, so I always favoured Arriflex, which was a very flexible camera. In twenty minutes or so, you can convert it from a small handheld camera with a 200-foot magazine to a studio camera in a blimp for feature films. Later, I used the Panaflex because circumstances dictated it.

Did you have any favourite films which you shot?
I can't really pick one film, but the very brief period when I worked for Tony Richardson [1928–1991] for Woodfall I remember with affection. It was very productive and very friendly, but it only lasted eighteen months. That produced three films: *A Taste of Honey*, *Loneliness of the Long Distance Runner*, and *Tom Jones*. The operator on all three was Desmond Davis, who later became a director. The films are still worth looking at. A while ago I was invited to introduce them at a festival in France.

Which films did you enjoy working on the most?
I enjoyed working on all the Woodfall films and all my Greek films because the Greek films were a completely different experience where you were surrounded by people whose experience was limited but enthusiasm was totally unlimited.

Are there any DPs today that you admire?
No, I am afraid not. I think the whole thing has gone downhill very severely. Decent camera work, in my opinion, doesn't seem to be desired these days. There are people working, like Roger Deakins [1949–], who I worked with, who is a very good cameraman. Oliver Stapleton [1948–], who started at the National Film School, is also a very good cameraman.

There are people who are producing very good work, but it is very difficult. There are a number of factors that make the exercise of the job very difficult. One of the factors is the lack of a frame. I don't know if you are aware of this; many people aren't. Since 1953, the year cinemascope was invented, we have not had a standard frame, which means there can be no guarantee that what you are

seeing through the viewfinder is what the spectator will see, either in the cinema or on television. It is almost a guarantee that it is not what they will see. What they will see is decided by the individual cinema and by the telecine operator on the telecine machine.

If you don't have a frame where you know exactly that this is the top left-hand corner and this is the bottom right-hand margin, you cannot compose your pictures properly. You can no longer guarantee that what you film is what you see.

What was the British film industry like when you joined it?
Well, it came to me quite quickly that it was in a state of chaos when I joined the industry as a clapper boy. Any normal operation was an exceptional state.

Did you prefer shooting in colour or black and white?
I've always preferred black and white because it is much more subtle. Colour is there because it's there. It's not there because you put it there unless you talk about a totally studio-made film. The moment you step outside, a lot of the colours are there because they are there and that is it. You can modify it a bit with filters and tricks, but it cannot be manipulated, I would say stylised, in the same way that black and white can.

How long did it take to shoot *Tom Jones* and *Zorba the Greek*?
Tom Jones took around fifteen weeks. The last week was done under the supervision of the people who put up the money to make sure we didn't waste any money. Then it turned out to be a huge success. That and *Zorba the Greek* have similarities and big differences. They both took fifteen weeks to make. One is black and white (*Zorba*) and one is colour. One I operated on (*Zorba*), the other I didn't, so those two are keystone films in my experience. They were made within two years of each other.

Did you use the same crew?
For a while. I had the same crew through the Woodfall period. I had the same crew in Greece, which was really just my assistant. I had seven people in the States I tended to work with. Sometimes my English crew travelled with me, and sometimes I picked up local people, so there was a mixture.

Did you have a favourite director?
I very much enjoyed working with Tony Richardson, who I made six features with. Also I enjoyed working with American George Schaefer [1920–1997]. I also made TV films with him.

Walter Lassally and Angela Lansbury. *Courtesy of Media Productions, Inc.*

As a cinematographer did you always use a light meter?
I used a light meter but just to confirm what I already knew. You get a sort of eye for it. You have a certain lighting style and a certain lighting level that you get used to, and then you put up the meter, and it usually says what you think it will say. It's a backup to give you confidence.

What do you think of digital? Do you still take an interest in the business?
Oh yes, I take an interest in the business, but it mainly turns to regret these days. I am not one of those that say film is far superior because that is not true anymore. In the next few years, digital will be taking over from film, particularly in cinemas. I think cinemas will completely go digital in the not-to-distant future.

Did you shoot commercials?
Very few because I couldn't stand the people that did them.

Apart from your Oscar for *Zorba the Greek*, what awards have you won?
I have won a number of them, including the American Society of Cinematographers International Award.

Filmography

Another Sky (1954, Gavin Lambert)
The Passing Stranger (1954, John Arnold)
A Girl in Black (1955, Michael Cacoyannis)
A Matter of Dignity (1957, Michael Cacoyannis)
Day Shall Dawn (1958, A. J. Kardar)
As Dark as Night (1959, Terence Young)
Beat Girl (1959, Edmond Grenville)
Our Last Spring (Eroica) (1959–1960, Michael Cacoyannis)
Maddalena (1960, Dinos Dimopoulos)
Aliki in the Navy (1960, A. Sakellarios)
A Taste of Honey (1961, Tony Richardson)
Liza and Her Double (1961, Dinos Dimopoulos)
Electra (1961, Michael Cacoyannis)
The Loneliness of the Long Distance Runner (1962, Tony Richardson)
Tom Jones (1963, Tony Richardson)
Psyche (1963, Alexander Singer)
Zorba the Greek (1964, Michael Cacoyannis)
Assignment Skybolt (1966, Greg Tallas)
The Day the Fish Came Out (1966, Michael Cacoyannis)
Open Letter (1967, George Stambolopoulos)
Oedipus the King (1967, Philip Saville)

Joanna (1967, Michael Sarne)

The Adding Machine (1968, Jerome Epstein)

Three into Two Won't Go (1968, Peter Hall)

Twinky (1969, Richard Donner)

Something for Everyone (Great Britain title: *Black Flowers for the Bride*) (1969, Richard Donner)

Le Mans (1970, Lee H. Katzin)

To Kill a Clown (1971, George Bloomfield)

Savages (1971, James Ivory)

Gun before Butter (1972, Peter Zadek)

Happy Mother's Day, Love George (1972, Darren McGavin)

Malachi's Cove (1972, Henry Herbert)

Autobiography of a Princess (1974, James Ivory)

The Wild Party (1974, James Ivory)

The Web (1974, Claude Zaccai)

The Clown (1975, Voytech Jasny)

Pleasantville (1975, Ken Locker and Vicki Polon)

Ivo (1975, Voytech Jasny)

The Great Bank Hoax (1976, Joe Jacoby)

The Blood of Hussain (1976–1977, Jamil Dehlavi)

Die Frau Gegeniber (*The Women across the Way*) (1977, Hans Noever)

Hullabaloo over Georgie and Bonnie's Pictures (1978, James Ivory)

Too Far to Go (1978, Fielder Cooke)

Something Short of Paradise (1978, David Helpern)

The Pilot (1978–1979, Cliff Richardson)

Gauguin the Savage (1979, Fielder Cook)

The Price of Survival (1979, Hans Noever)

Life on the Mississippi (1979, Peter H. Hunt)

Engel aus Eisen (*The Iron Angel*) (1980, Peter H. Hunt)

The Private History of a Campaign That Failed (1980, Peter H. Hunt)

Memoirs of a Survivor (1980, David Gladwell)

The Mysterious Stranger (1981, Peter H. Hunt)

Mystery at Fire Island (1981, Bob Fuest)

Tuxedo Warrior (1981, Andrew Sinclair)

Heat and Dust (1982, James Ivory)

Private School (1982, Noel Black)

Puddn'head Wilson (1983, Alan Bridges)

The Bostonians (1983, James Ivory)

The Bengal Lancers (1984, Steven Weeks)

Children in the Crossfire (1984, George Schaefer)

Adventures of Huckleberry Finn (1984, Peter H. Hunt)

Stone Pillow (1985, George Schaefer)

Mrs. Delafield Wants to Marry (1985, George Schaefer)

Awards

Zorba the Greek (1964), Oscar Award Best Cinematography
Heat and Dust (1984), British Academy of Film and Television Arts nomination
The Bostonians (1984), British Society of Cinematographers nomination
Marburg Camera Award (2005)
American Society of Cinematographers International Award (2008)

Wolfgang Suschitzky

(1912–)

Wolfgang Suschizky is a legendary photographer and cinematographer. Known as Su or Wolf, he was born in Vienna on August 29, 1912. His father, Wilhelm, and his uncle Philipp opened the first socialist bookshop in Vienna. Later, they set up the publishing house Anzengruber, specialising in social criticism and pacifist themes. Suschitzky trained as a photographer at the Hohere Graphische Bundes-Lehr und Versuch-Sanstalt in Vienna for three years. He was taken to the cinema from an early age. He says an older cousin smuggled him in to see the 1926 film *The Phantom of the Opera*.

After studying photography with Rudolph Kappitz in 1934, he left Vienna and went to Amsterdam, photographing the city's poor Jewish areas. In 1935 he came to England, where he established himself with photo reportages for magazines, including *Illustrated Picture Post* and *Animal and Zoo* magazine. He said he used Rolleiflex and several single-lens reflex cameras before settling on a top-of-the-range Hasselblad.

From 1937 to 1938, he worked on the *Charing Cross* series. The scenes he photographed have become classics of modern black-and-white photography. Suschitzky says it was those pictures that led him to work with Paul Rotha [1907–1984], one of the people involved in the documentary movement. Rotha was a producer with Strand Films, based in London's Oxford Street. Later, they moved to Soho, off Oxford Street. Suschitzky first worked as an unpaid assistant for Rotha, shooting films at the zoo with a young director/cameraman by the name of Paul Burnford [1914–1999].

Rotha went on to form Paul Rotha Productions, continuing until 1944. He then became involved in the Documentary Technicians Alliance (DATA), the first film cooperative in Britain. Suschitzky was one of the cofounders and worked for them for twelve years. He was given time off if somebody else offered him an interesting job. During that time he went to New York to work on

the *Wisdom* series. In 1951 he photographed his first feature, *No Resting Place*, directed by Paul Rotha. He says he shot it like a documentary, and it was filmed entirely on location, like most of his films on location. Studio films included *The Small World of Sammy Lee* (1963). His son, Peter (*see* chapter 6), and his grandson, Adam, are cinematographers.

What got you interested in the film business?
I was always attending films as much as I could, and I was just lucky to get an introduction to Paul Rotha. He said to me, "You can join a young cameraman who is working at the zoo." He said, "I can't pay you because you have no working permit." That was in 1937. It was the tail end of the British documentary movement. Paul Rotha ran Strand Films, and many of the documentary people were engaged there, and I was lucky to meet a lot of them.

Why did you choose cameras?
I started doing photography in Vienna and did a bit in England in 1935, photographing children and taking portraits. I thought the British documentary movement was very good because they maintained that they wanted to make films useful to society, and as an old socialist, that appealed to me.

Did you start on the clapperboard?
The documentaries were mainly shot silent, so we didn't need the clapperboard. We had number boards, and I would load the 35mm Newman Sinclair camera. It was a clockwork camera that didn't pull more than 100 feet of film.

Did you ever use the Debrie Parvo?
Yes, for sound, which in documentary we couldn't afford often. When we had sound, I used the clapperboard.

What was your first feature?
It was a film called *No Resting Place*. It was my first feature as a cameraman. I didn't do focus pulling or operating on features. I always called myself a cameraman. I thought it rather pompous calling myself a director of photography [DP]. The film directed by Paul Rotha was shot on location, which was rather rare in those days because most films were made in studios.

Did you have a favourite movie?
It is difficult to say. There were several I enjoyed very much. One of the first was *The Bespoke Overcoat* (1956), directed by Jack Clayton [1921–1995], which was his first film as a director. Previously he had produced films but never directed.

The company Romulus gave him six thousand pounds to make a short film, which he made for that price. It won an Oscar for best short film that year.

Were there any of your fellow DPs you admired?
Yes, Douglas Slocombe is one of them. He is a great and lovely man. I have always admired his work, and there are many others, including Freddie Francis and Oswald Morris.

Were your features mainly shot on location?
Yes, most of the films I worked on were filmed on location. Some were done in studios, for instance *The Small World of Sammy Lee*, starring Anthony Newley [1931–1999]. *Get Carter* (1971) was shot entirely on location.

Did you have a favourite studio that you worked in?
No, I didn't have a favourite. Sometimes I worked in very small studios and only once or twice in big studios, such as Shepperton.

Were you always a freelance?
Yes, I stuck with documentaries but was given time off if someone wanted to employ me on a feature. I worked for Paul Rotha Productions, and later that split, and we formed the first cooperative film unit in Britain, and I worked for them for twelve years. In between working for them, I did quite a lot of work for NBC in New York, including the *Wisdom* series.

Are there any films you particularly enjoyed working on?
I liked very much working on *Get Carter* with Michael Caine [1933–]. I would often have lunch with him and the director, Mike Hodges [1932–]. Other films I enjoyed include *Theatre of Blood* (1973) and *Ulysses* (1967). The director of *Ulysses* worked a five-day week, which was nice. We also had a great location in Dublin and wonderful actors. *Theatre of Blood* had a great cast. Vincent Price [1911–1993] was the star, and he shook hands with everyone on the first day of shooting.

What was Michael Caine like to work with?
He was very professional. He was always there when he was needed and always knew his lines. He was a very pleasant person.

Did you find most actors good to work with?
Yes, most of them were very pleasant. Anthony Newley on *The Small World of Sammy Lee* said, "I don't know how to light a star." I got on well with Virginia McKenna [1931–], who has kept in touch. I filmed *Ring of Bright Water* (1969)

Milo O'Shea and Wolfgang Suschitzky (far right) on the set of *Ulysses* (1967). *Courtesy of Wolfgang Suschitzky*

with her and her husband, Bill Travers [1922–1994]. They were both very nice people, and we had great fun making the film.

Which film did you dislike working on?

I can't say; there wasn't any I didn't really like. I was always treated well by directors and producers and got on well with my new crew. If they had any problems, I was always on their side.

Did you prefer working in black and white or colour, or didn't you mind?

I didn't mind, really. I never worked with Technicolor. I began to work with colour when colour negative came out. It was almost easier to work in colour than black and white. Black-and-white filming requires you to light much more carefully and to get some modulation in the actor's face.

Did you work abroad a lot?

I didn't work in studios abroad, only on location. It was mainly for the National Broadcasting Corporation in New York. They saw some of my films and asked me if I would make a film in Delhi, India.

Did you have a favourite camera?
No, I didn't mind. The equipment was decided by the producer. It depended on what he could afford. The Panavision was very good.

Were any of the films difficult?
Every setup is a new problem, and that makes the work interesting. I was very lucky because I had decent people to work with. I also had very good operators and focus pullers.

How long did it take to shoot *Get Carter*, and can you remember the stock used, as it had a documentary look?
Yes, probably it was Eastman stock. It took around four or five weeks to shoot. We only had a main unit on the film.

What advice would you give to a new cinematographer?
I would advise him to work a month or two in the cutting rooms. I would have liked to have spent a bit of time in them but never got the chance. I had to learn from a director how a scene was analysed. I would sometimes go to the cutting room and watch the editor at work.

Did you prefer a particular stock?
I liked working with Fuji and Eastman.

Did you usually stay with the same crew?
I changed crews quite a lot and had different operators. Most DPs now do both jobs. Some cameramen like to operate; my son, Peter, does. For me the operators contributed and helped me a lot. Some cameramen prefer to operate because they can see exactly what they get.

Did you ever do both jobs?
No, not on a feature. Only on documentaries.

Did you have a favourite director?
Most of them were good to get on with. I liked Mike Hodges a lot on *Get Carter*. Another favourite was Jack Clayton, who was a charming man.

Did you always use a light meter?
Yes, I always used a light meter.

Would you name some of your favourite films?
I liked very much working on *Ulysees*, *Get Carter*, *Theatre of Blood*, and *Entertaining Mr. Sloan* (1970).

What do you think of the business today?
I have been out of it for many years now, and I think it is almost criminal how crews are worked sixteen to eighteen hours a day. You can't be creative for those hours. Unfortunately the unions no longer have the same power. In my day we had a strong union, and if the director wanted to work an hour or two overtime, they would have to ask us if we would. Now you have to sign for the longer hours, and I think that is awful. People would work quicker and get more done if they are refreshed. The hours they work now are exhausting.

What do you think of cinematography today?
It is wonderful. You never see a badly photographed film. I haven't seen one, and I see quite a lot being a member of BAFTA.

What do you think of special effects today?
They are fantastic. I don't know how they get them. If you can create something new, it doesn't matter. It is a tool. It is more important to have a good story. Some films rely more on the special effects.

What do you think about digital?
I don't know. It depends on what the cameraman and director do with it. Any tool can create something; even a pencil can make a work of art. If you have a tool which is more flexible and easier to work with, it should be used. I am glad I am out of it because I am not very good on electronics. Many cameramen still prefer film. It gives better quality on a large screen.

What TV work did you do?
I made a television film in India for Granada called *Staying On* (1980). It was about a British officer who decides to stay on after independence because he could live better on his pension in India. It starred Trevor Howard [1913–1988] and Celia Johnson [1908–1982] and was filmed in the North of India. The two hadn't worked together since *Brief Encounter* (1945). Trevor behaved very well. He didn't drink too much. It was a nice film to make. I also worked on *The New Adventures of Charlie Chan* (1957–1958) and *Worzel Gummidge* (1979–1981).

Did you like TV work as much as feature work?
I liked both. One of my earliest pieces of TV work was a pilot episode of *The Invisible Man* (1959).

Can you relate some of your memories on the set?
Usually we had a lot of banter. Working with a crew is always much nicer than working on one's own in photography. When Vincent Price was making *Theatre of Blood*, he liked to smoke between shots. One day the focus puller went and

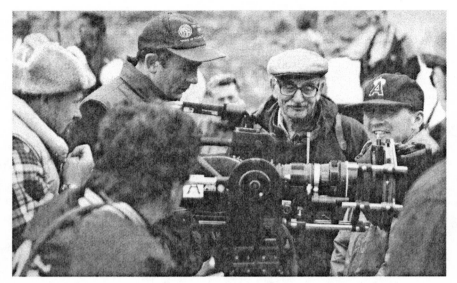

Wolfgang Suschitzky (in glasses) filming a commercial in Ireland for Irish Spring. *Courtesy of Wolfgang Suschitzky*

cut off the burning end of his cigarette. The next time he came to measure the distance for the next shot Vincent produced scissors and cut the tape.

Did you ever consider becoming a director?
No, I never did because I don't like telling other people what to do.

Did you shoot commercials?
I shot hundreds of commercials. One of them was for Schweppes. Commercials are sometimes more difficult to shoot than features, but the pay can be a lot better.

What was it about *The Bespoke Overcoat* and *Get Carter* that stood out?
The *Bespoke Overcoat* had a wonderful story and wonderful actors. Jack Clayton was a great director, and the picture was fun to make. Alfie Bass [1916–1987] was such fun to work with. He was underrated. He had to rely on his comic performances. He was made up to look like he was an old man, and one day just before lunch, we went out and people didn't notice that it was a young Alfie Bass made up to look old. The film was shot in a former church, which wasn't easy to work in. *Get Carter* was a good story. The actors were great, and Mike Hodges, the director, was very good to work with.

What was the still equipment you used?

I started with a Rollieflex. Later I went on to single-lens reflex because longer lenses are required to photograph animals. So I worked with all sorts of single-lens reflex cameras until I settled on a Hasselblad. I had one of the first ones, which I took all over the world. When I got older, I went on to 35mm.

What was the operator Jeff Seaholme [1913–1974] like to work with? He worked with Douglas Slocombe on several Ealing films, didn't he?

He was a marvellous operator. Yes, he worked on several films with Douglas Slocombe. He was his best before lunch because he liked a drink at lunch times.

Filmography

Debris Tunnelling (1943, Kay Mander)
Penicillin (1944, Kay Mander and Alexander Shaw)
Children of the City (1944, Budge Cooper)
New Builders (1944, Kay Mander)
Birthday (1946, Budge Cooper)
No Resting Place (1951, Paul Rotha)
The Oracle (1953, C. M. Pennington-Richards)
The Bespoke Overcoat (1956, Jack Clayton)
Birthright (1958, Sarah Erulkar)
The New Adventures of Charlie Chan (1957–1958, TV Series)
Cat and Mouse (1958, Paul Rotha)
Invisible Man (1959, Ralph Smart)
Stone into Steel (1960, Paul Dickson)
Lunch Hour (1961, James Hill)
Cradle of Genius (1961, Paul Rotha)
Den hvide hingst (1961, Harry Watt)
The Small World of Sammy Lee (1963, Ken Hughes)
Trinidad and Tobago (1964, Geoffrey Jones)
Emma (1964, Anthony Perry)
Design for Today (1965, Hugh Hudson)
Snow (1965, Geoffrey Jones)
The River Must Live (1966, Alan Pendry)
The Specialist (1966, James Hill)
Sands of Beersheba (1966, Alexander Ramati)
The Tortoise and the Hare (1967, Hugh Hudson)
Ulysses (1967, Joseph Strick)
The Vengeance of She (1968, Cliff Owen)
Les Bicyclettes de Belsize (1969, Douglas Hickox)
Ring of Bright Water (1969, Jack Couffer)

The Art of Claude Lorrain (1970, Dudley Shaw Ashton)
Entertaining Mr. Sloan (1970, Douglas Hickox)
Get Carter (1971, Mike Hodges)
Some Kind of Hero (1972, Marvin Lichtner)
Living Free (1972, Jack Couffer)
Theatre of Blood (1973, Douglas Hickox)
Moments (1974, Peter Crane)
Something to Hide (1976, Alistair Reed)
John and the Magic Music Man (1976, Ciarin Scott)
Falling in Love Again (1980, Steven Paul)
Staying On (1980, Silvio Narrizano)
Worzel Gummidge (1979–1981, TV Series)
Good and Bad at Games (1983, Jack Gold)
The Young Visitors (1984, James Hill)
The Chain (1984, Jack Gold)
Claudia (1985, Anwar Kawadri)
Riders to the Sea (1987, Ronan O'Leary)

Ronnie Taylor

(1924–)

Ronald Josiah Taylor was born on October 27, 1924, in Hamstead, London, England. He went into the film business at the age of nineteen, working at Lime Grove Studios in Shepherds Bush, London, England. His first job was with notable cinematographer Freddie Young [1902–1998] on *The Young Mr. Pitt* in 1942. After serving in the army, he went back to the industry and eventually became a camera operator, working on numerous memorable productions. He went on to become a director of photography (DP) and won an Oscar for *Gandhi* (1982).

What got you interested in the film business?

I was nineteen at the time. Jack Swinburne was the manager of Gainsborough Pictures, which was at Lime Grove Studios, Shepherds Bush, London. I was invited to have a look around, and as soon as I went into the studio, I fell in love with it. I went in during the early stages of the war. Because a lot of film people had been called up, promotion was quick, and I was pulling focus in the early stages of my career. I started on *The Young Mr. Pitt*, photographed by Freddie Young. I also pulled focus on *The Man in Grey* (1943), which starred Stewart Granger [1913–1993].

Why did you choose cameras?

I was very keen on photography and developing. Camera work was my bag. That is what I wanted.

What did you operate on?

Gainsborough closed in 1949. I then went to Pinewood as an operator. I had also done some operating at Gainsborough. I worked at Ealing Studios with Douglas Slocombe [1913–] and later shot films in Brazil, staying for four years.

I then went back to Pinewood and worked with Freddie Francis [1917–2007] on Karel Reisz's [1926–2002] *Saturday Night and Sunday Morning* (1960) and *The Innocents* (1961), directed by Jack Clayton [1921–1995]. I did some second unit work, one of them being *The War Lover* (1962), starring Steve McQueen [1930–1980]. I then went to live in Spain and went to work on the second unit of *The Fall of the Roman Empire* (1964). I also worked on *The Magnificent Showman* (1964). In 1965 I returned to the U.K. and was on the TV series *The Avengers* (1961–1969). I went on to work on *Morgan: A Suitable Case for Treatment* (1966), another Karel Reisz film, also Bryan Forbes's [1926–] *The Wrong Box* (1966) and *Oh! What a Lovely War* (1969), filmed in Brighton, which was Richard Attenborough's [1923–] first stint at directing.

Did you find going from operator to DP difficult?
Not really. I'd worked with some very good people, including Freddie Francis and Douglas Slocombe, keeping my eyes open, so I wasn't fazed by the responsibility.

Did you have a favourite camera?
It was the Mitchell BNC.

Did you have a favourite film?
I had three favourites: *Oh! What a Lovely War, Gandhi,* and *Sea of Love* (1989). It took Richard Attenborough around fifteen years to set up *Gandhi* because of obtaining cooperation from the Indian government. *Sea of Love* was shot in New York and Toronto, Canada.

After Gainsborough it was all freelance. I was under contract in Brazil for two years, and then they asked me to stay on for another two.

Did you have a favourite studio?
Pinewood was one of them.

Were there any films you didn't like working on?
I was asked if I'd operate on *Barry Lyndon* (1975), directed by Stanley Kubrick [1928–1999]. Stanley was a difficult director. He kept wanting to check through the lens. It went on for several days. I then said I wanted to go, but Kubrick wanted me to stay. But he still continued to look through the camera. I left this picture because of his interfering.

Did you prefer colour or black-and-white photography?
I didn't photograph many black-and-white films. *The War Lover* was one of the few, where I worked on the second unit.

Are you still keen on films?

Oh yes, I am. In fact we have a film festival in Ibiza. I've been awarded their achievement award, which is quite nice.

Did you ever consider directing?

There was a time when I considered it. It was around the time I shot *Oh! What a Lovely War*. I didn't really have the push to go through with directing, so I continued operating, which is one of the loveliest jobs because you have the closest relationship with the director than anybody. Later, I decided to become a DP.

Did you enjoy being a DP as much as operating?

As I said, the relationship with the director was a close one. The operator in those days would work out the sequence with the director more than the DP would. After operating for several years, I decided I wanted to move on.

Did you find the transition difficult?

Not really. When I was an operator, I kept my eyes open, observing how things were lit.

How old were you when you retired?

I retired around the age of seventy-five. The problem is the hours were very long, and when you get into your seventies, your energy level isn't as high, so it becomes a bit of a strain. I don't miss the film business now. I am very happily retired in a nice warm place.

Filmography

Two and Two Make Six (1962, Freddie Francis)
Tommy (1975, Ken Russell)
Circle of Iron (1978, Richard Moore)
Savage Harvest (1981, Robert E. Collins)
Gandhi (1982, Richard Attenborough)
High Road to China (1983, Brian G. Hutton)
The Hound of the Baskervilles (1983, Douglas Hickox)
Master of the Game (1984, TV Miniseries, Kevin Connor and Harvey Hart)
Champions (1984, John Irvin)
Splitz (1984, Domonic Paris)
Nairobi Affair (1984, TV Movie, Marvin J. Chomsky)
A Chorus Line (1985, Richard Attenborough)
Foreign Body (1986, Ronald Neame)
Cry Freedom (1987, Richard Attenborough)

Opera (1987, Dario Argento)
The Experts (1989, Dave Thomas)
Sea of Love (1989, Harold Becker)
The Rainbow Thief (1990, Alejandro Jodorowsky)
Popcorn (1991, Mark Herrier and Alan Ormsby)
From Time to Time (1992, Jeff Blyth)
Age of Treason (1993, TV Movie, Kevin Connor)
Shadow of Obsession (1994, TV Movie, Kevin Connor)
Good King Wenceslas (1994, TV Movie, Michael Tuchner)
Redwood Curtain (1995, TV Movie, John Korty)
The Steal (1995, John Hay)
The Phantom of the Opera (1998, Dario Argento)
Splat! (1999, Marcus Dillistone)
Non ho Sonno (2001, Dario Argento)

Anthony Dod Mantle

(1955–)

Anthony Dod Mantle was born in 1955 in Oxford, England, and moved to Denmark in 1985. In his early twenties, he decided to travel the world and developed an interest in still photography. It was while he was in India with its breathtaking landscape that his love of the subject was recognised. On his return to England, he applied to the London College of Printing and got a place. He was there from 1980 to 1984, obtaining a degree in photography. He then went to the National Film School of Denmark from 1985 to 1989.

Today Dod Mantle is very much in demand and shoots a lot digitally. *Slumdog Millionaire* (2008) was shot using a mixture of film and digital equipment. Digital was used because the cameras are quiet and portable, enabling Mantle and the director, Danny Boyle [1956–], to shoot quietly and not create to much disturbance around the communities. A 35mm camera wouldn't have allowed that because setting up shots with heavy cameras would have slowed things down. Because of the new digital technology, it was possible for Dod Mantle to move around very quickly, enabling him to throw himself around the slums, capturing the reality. The camera used was a silicon imaging SL-2K Mini with gyrostabilizers.

Were you interested in photography as a child?
No, not at all. If I had a camera as a kid, I don't remember it. I bought my first camera around the age of twenty-one. Prior to that I had no interest in photography. My mother is a painter, and I was surrounded by images. I was used to a world outside my own eyes and outside other people's.

When did you develop an interest in photography?
I was in Denmark and took up a photography course. I then bought my first camera, went to India, and took lots and lots of stills.

Anthony Dod Mantle. *Courtesy of Anthony Dod Mantle*

What got you interested in cinematography?

I did a B.A. at the London College of Printing. I started it at the age of twenty-six and finished it at twenty-nine, which is quite late for a B.A. I came out feeling the taste of film. At the college I started as a cinematographer, did a fine art course, and found my way through mixed media. When I left I was slightly unsure what I wanted to do. I loved the control of the still image and that you're the master of the moment but decided to go to film school in Denmark and did a four-year course in cinematography, qualifying at the age of thirty-four.

What was your first feature?

My first feature was the *Terrorists* (1992), made in Germany with Philip Gröning [1959–], a young German director who had seen my graduation film. He is an interesting director and quite a good image maker. I had the script translated each day, and it was a very renegade, new-wavy, super 16mm film, blown up to 35mm. It was an angry but artistic film.

Did you do focus pulling (focusing the image)?

Yes, I did. Even after three years B.A. and four years film school, I came out feeling I wanted to try focus pulling, which is a hard job. I worked on a feature in Poland. I was confident but made mistakes and learned how incredibly difficult focus pulling is and loved the fact I've done it. It has helped me understand how important it is to take care of your crew.

You were a DP [director of photography] from the early 1990s.

I started as a director of photography in 1990 or '91. I did a lot of documentaries shot on super 16mm. I did my first feature around that time and then went on to Danish features. I think my work in documentaries was always slightly forced artistically. My interest in the world is a balance of politics and poetry, and my documentaries were about that. Pushing quite hard to the poetic side of documentary filmmaking naturally led me into features.

Have you always operated as well as being the DP?

I have always operated, not out of arrogance. I could work with an operator, but my training and upbringing has been through documentaries and low-budget features where I have always operated. One of the reasons Danny Boyle wanted to work with me was because I could also operate.

Some jobs I have to operate on, and on others I can be more cautious, standing a little bit back or operate with someone else. The last film I have just done in South Africa, the *Dredd* (2011) film, is a 3D film, and on that you cannot operate if you want to see the 3D at the same time. I had to keep an eye on the monitor, so I had to have an operator. We converted a camera so I could operate as well.

How many do you have on your crew?

It varies enormously. In India we had many people because there was a lot of cameras required. Each job is different. Generally British crews are bigger than European crews. Things got quite big on *127 Hours* (2010). We had two crews working, and in each crew we had more than one camera, sometimes four. I need special people. I tailor my crews from job to job.

Do you prefer using digital equipment?

My palette changes from story to story. I have no preference, but digital is getting better and better. There is less obvious debate now about what is shot digitally and what is on film. I was out there early with different formats because I have grown up in a free art family. My education has been equally fine art as it has been industrial and technical, so I have a natural balance for my own well-being. I have never felt hampered by one or the other.

You can give digital the film look, can't you?
Some say yes; some say no. A different hundred answers there. Now it is easier because it is ultimately down to resolution and obviously technical training. It is a lot different now than it was before. Recording on digital format is so much better now. Only five years ago, you had to watch your highlights and your blacks much more. You had to watch how the colours bled and the image break up, etc.

Would you tell me about *Slumdog Millionaire*?
I started out expecting to shoot more of it on film than we did. I always knew we were going to use digital and film because we knew we would have to move around fast and needed equipment that would allow us to do that. I needed small, lightweight digital cameras. I couldn't use 16mm steadicam equipment because of space. I had to find cameras that could come down in that space and that were good enough. Forty percent was shot on film, and 60 percent digital. Going back to India was a full-circle experience because it was there that I pointed a still camera for the first time in my life, so *Slumdog* has a special place in my heart.

What films did you enjoy the most?
Most of the films I have worked on have been positive experiences. As well as *Slumdog*, *Celebrations* (1998) had a special place in my heart because we dared and defied, quite radically, traditions.

28 Days Later . . . (2002) has a place in my heart because it cemented my relationship with Danny Boyle but also it was quite radical. I suppose I'm subconsciously saying, "It's nice if I do stuff that has a slight degree of radical provocation or achieve something special." As far as the experiences, it was enjoyable doing them all. It's very rare I have a bad experience.

Which was your most difficult film?
I would say *Antichrist* (2009), directed by Lars von Trier [1956–], was one of the hardest because of the kind of territory we were in, the nature of the film, which included anxiety, and because it was a psychologically unpleasant territory area for the whole crew.

How did you feel when you won an Oscar for *Slumdog Millionaire*?
I just wanted to make sure my legs worked. It was wonderful, and the best thing for me was that we all did well: The film did well, technically we did well, awards came our way, and a lot of people in the world saw it.

What was it like working on *127 Hours*? Was it difficult?

That was bloody hard. It was physically tough. Physically it was one of the hardest films I have done. I did it back to back with *The Eagle* (2011), on which I spent three months in Scotland and a month in Budapest.

For *127 Hours* we built replicas of the canyon, which were harder to work in than the real thing. Eighty-five percent of the film was shot digitally.

Do you have a film stock you prefer?

I have shot more on Kodak than I have on Fuji. It's a case of availability, not taste. I have worked on all stocks, and both Kodak and Fuji supply us with great stocks. We are very privileged compared to twenty years ago. Back then they had to expose more carefully because film wasn't as sensitive. More and bigger lights were required, and to get a special look, it took a great deal of bravery because you had to manipulate the film in a disciplined way to get it to look different. We still do that today to some extent.

Are there any DPs today that you admire?

I think what I admire is a collective homage to us all. I am most attracted to the diversity of cinematography. There are people I like more than others. I like travelling around the world, talking to cinematographers. One of our responsibilities is to hold onto our own voices. Together with directors and the stories, we maintain this unforeseeable diverse profile that cinema has or should have. It may change; it may be that cinemas are not what they were in a year or ten years' time. Maybe people will be looking at things on demand at home with incredible screens, which may mean the smaller cinema screens will have to go because there would be no point in seeing them any longer. I don't go to a cinema with small screens because I may as well see the film on a large TV.

Do you see 3D lasting?

It's difficult to say. Having spent six months on it, I think if they don't collectively work on developing to make it easier, I can't see it lasting. Some films are much more interesting and perhaps appropriate in 3D. I don't see it as an emphatic way forward at all. I'm wary. I'll know more when I see the film (*Dredd*). I've worked my body half dead on it in the last half year.

Do you work long hours?

Yes, I do. I do twelve, and by the time I've finished, I have done fourteen and sometimes sixteen hours. I often do six-day weeks, which is a killer. You have got to love the business.

Would you like to direct?

It has occurred to me. I'm privileged to be working with the people I am working with and getting projects I feel bring something I couldn't have thought of myself. At the moment no, but it could come. I think Nic Roeg [1928–] is one of the few examples of a cinematographer who became a director. He was a superb DP and became an even more superb director. I don't think I can say that about any other cinematographer who has moved on to directing.

As a cinematographer have you always used a light meter?

After I have shot the first week of a feature, I usually know where I am with it and use the light meter less and less. I always have it with me.

The following article is by Ron Prince, editor of British Cinematographer *magazine.*

With his bulldog, "Eddie-Monster," curled up at his feet and his family retiring to bed, Anthony Dod Mantle, DFF, BSC, spoke to Ron Prince via Skype about his work on *127 Hours*, *The Eagle*, and *Dredd 3D*. The cinematographer had just come back from collecting a prestigious award in Marburg, Germany, so we kicked off with that.

What were you doing in Marburg?

They presented me with the 2011 Camera Award and a cheque the size of a surfboard, physically speaking. It's a noble event and humbling to get this award, with previous winners like Raoul Coutard, Jost Vacano, and Robbie Müller. They screened every single film I've ever done in Marburg from about December onwards—*Dogville, 28 Days Later* . . . , *Antichrist, Slumdog,* the whole lot—and people had written dissertations about the films and my work. They knew me. Marburg is a university town, with intellectuals, professors, writers, journalists, students, theatre people. There were classes around the clock for three days where I discussed my work in detail on stage. People have stored up questions and theories, and you find yourself embedded in discussing work that sometimes can be difficult to revisit after so long. It was exhausting but a great honour.

Tell us about your work on *127 Hours.*

It's a little bit of chemistry between digital and celluloid. There was no doubt we would have to use digtal. The maliciously tight physics of the canyon defined our approach. Danny (Boyle) was insistent on portraying a feeling of imprisonment, and there was no way I, nor Enrique (Chediak), could film with a camera on our shoulders. So I worked with HD Rentals out of Los Angeles to strip the bodies off some SI2Ks and came up with three different cameras—a fist cam with C-mount lenses that could get intimately close to James Franco's face, mouth, and neck, plus two gyro-based handheld cameras

with PL mounts for Zeiss and Cooke lenses. HD Rentals supplied the gear and rebuilt the equipment to the extent that they could to meet my needs, but I brought in my loyal colleague and HD camera supervisor Stefan Ciupek to finalise and organise the last details. Without Stefan we would have been in trouble. There was so much last-minute prep, with location logistics and other recces, that we had precious little time. Added to this we were developing a workflow that could support the turnaround of two camera crews shooting parallel, one with me and one with Enrique.

There were several video elements to the story too, as the real-life Aron left video messages about his predicament—a visual epitaph—using a digital consumer camera, which we matched pretty closely. I also used several Canon 1D, 5D, and 7D DSLRs to shoot generic material where I felt it worked. We shot timelapses and other relevant images about his route into the canyon that are revisited during the film in the form of a DSLR still-image burst montage executed wonderfully by our VFX supervisor Adam [Gascoyne] from the Union VFX company.

We also built a bridge and a contrast between these scenes and the rest of the film, especially the landcapes, which we shot on film with rebuilt Moviecam Compacts from Denny Clairmont in Los Angeles. We shot on mixed daylight and tungsten Kodak stocks, underexposing sometimes for mood and grain.

Danny Boyle and Anthony Dod Mantle on the set of *Slumdog Millionaire* (2008). *Courtesy of Anthony Dod Mantle*

What creative references did you use for *The Eagle*?
As a rule I normally look at photographs, paintings, and drawings, rarely at other films. For me it's about images that invoke a mood. *The Eagle* has lots of mud, blood, nature, and textures, lots of hardship too. Kevin Macdonald (director) and I looked at Arcimboldo's paintings for organic textures and talked about Tarkovsky's use of desaturated, gentle hues of the colours in nature. In search of inspiration and insight for the harsh conditions the Scottish Seal people lived in, we looked at WW2 concentration camp art and graphic images made by anonymous Polish artists portraying the dead. I also pulled out shots from my computer—macro stills of nature on *Antichrist*, some lens baby images I shot on *Wallander*, images with weird halations from *Brothers of the Head* when I shot the neg back to front. I also found a cross-processed shot from *Millions* that Nigel Walters and Daf Hobson helped me to shoot.

How long did you have to shoot *The Eagle*?
We lined up for about five weeks and shot for eight weeks in Budapest and then went immediately to film in Scotland for four weeks.

You had to shoot in Hungary and Scotland, so how did you prepare?
It was always going to be shot on celluloid, well apart from the odd dribble of naughty Canon 5D stuff that I can't help doing. As a film that take places north and south of Hadrian's Wall, I went on long recces with Kevin to see how we could best bring together the dust and summer sun of Budapest with the crazy climate of the west coast of Scotland. In Budapest I wanted especially to see the areas where they were building the forts, as I knew I had to work out every single camera angle to disguise the trees and vegetation utilising, in worst cases, side lighting and whenever possible shooting against the light. This was the only way upfront that I could kickstart the desaturation, subdue the colours, so they would match the Scotland shoot. I also spoke to designer Michael Carlin very early on about the height of the walls, not just for shooting 360 degrees, but about positioning the lighting on set. It's an historical story, with only fire or candlelight, so it was all about how to get naturalistic lighting, reflecting off the walls and the floor, through windows. I knew that a great deal of top lighting would be necessary on some of the sets. I did plenty of testing with filmstocks using lots of filters and worked very closely with Adam Glasman, the DI colourist at Ascent 142 (now Deluxe 142). I come up with colour palattes on films, which I mark on the slate. *The Eagle* had eight or nine looks. Before the shoot I calibrated my computer as closely as possible to the ones in the DI suite to make sure we were on the same page.

I heard you did some unusual things with exposures?

I had to combat the electric brilliance of modern-day stocks to give the film an historic feel. During tests I underexposed, pull-processed and push-processed, did technical bypasses and cross-processes, and then went to Adam in the DI suite to see what I could also achieve there. We really knocked the negative around with diffusion and even got an ARRI Relativity noise reducer in. On the shoot I push-processed every single stock, Fuji and Kodak, between one or two stops—the 500 ASA went close to 2,000 ASA, and the slower 250 ASA I pushed to 800 or 1000 ASA. Along with Adam, I have to thank Darren Rae and his team for their consistent support.

Tell us about your camera and lighting packages.

Thomas Neivel, my gaffer, and I worked with Russell Allen at ARRI in London on the cameras and lenses. We had several ARRICAM LTs and ARRICAM Studios. They found some old Cooke Panchos and new Cooke S4s and supplied cranes and tracks, good old-fashioned stuff. I used a lot of filtration, especially my own filters. We had a mixture of tungstens and HMIs that we got from ARRI's rental partner, Vision Team, in Hungary.

How do you work with Thomas, your gaffer?

He worked with me on *The Last King of Scotland*, *Brothers of the Head*, and all of the films I've shot with Danny Boyle. It's a great advantage to have someone who knows me as a person, my tastes, and can deal with the rental houses whilst I am tied up in other matters.

How did you go about creating the dream/nightmare sequences?

They were a bit like the cerebral journeys in *127 Hours*. There were nightmares and flashbacks, and you have to separate these for the audience. I shot the nightmares using combinations of layers of glass, filters, rags, flares, strange shutter dragging—lots of things to degrade the image. For the flashbacks I used high-contrast filters glued to lens babies and torches shining into the lens. I also used the DI to take the looks a lot further, twisting the overall colour palattes of each, with yellow being a predominant colour for the flashbacks.

Were there any surprises while you were shooting?

Even though I knew Scotland was a tough call, weatherwise it was cold, dark, and the rain was punishing and incessant. You could see it visibly stinging the actors' faces. It haemorrages moisture; no wonder there are so many golf courses. The light moves all the time too, which made exposures very tricky. We were

shooting in some pretty inaccessible places on the west coast, and there was a lot of lugging to do. What with climbing around canyons on *127 Hours* and the rigours of Scotland, these films got me fit, as well as nearly killing my camera team. It is always a pleasure to see Alastair Rae come out with his steadicam, but when he appeared wearing football boots, you knew it was going to be a muddy day.

What are your thoughts about the DI process?
I adore the DI. It's a very creative part of filmmaking, with so much potential. But a DI must only be possible with the DP, no matter how brilliant the grader, and I like to contract myself into the grade whenever possible. A director may have been living with their project for months in an edit, whilst the DP has been off shooting elsewhere. In the DI everything comes together: the images, the audio and music, and the DP comes with fresh eyes. The director, producer, designer, costume designer, art department all get the chance to see the film properly, far more than in the online. I've got amazing tools at my disposal, not just for colour, but to adjust the textures, the balance, the framing, so I can make the story tighter and better right to the very end. It's an unbelievably creative place to be.

What can you tell us about *Dredd*?
Kevin's brother, producer Andrew Macdonald, approached me a while ago. It's written by Alex Garland, a very astute, creative writer, who I've known since *28 Days Later* It was shot in South Africa on 3D—around thirteen weeks principal and seven weeks second unit photography. It's a dangerous film, in the sense that the story places itself precariously on the floorboards of an action sci-fi genre film whilst underneath there's a no less entertaining allegorical comment about this kind of cinema and the violence that tends to come with this kind of product. Visually we have gone at it hammer and tongues. We shot entirely digitally, in scope, using RED MX cameras and SI2Ks, Phantom Flex highspeed, and multiple rigs shooting at the same time on first and second unit. I built some new camera rigs that can take you very close to the action. It won't look so much like the action films we're accustomed to, and the audience won't have things thrust in their faces every five minutes. I hope it will be more painterly. If we get it right, it will be a cross between *Blade Runner* and *A Clockwork Orange*.

How do you feel cinematography is changing?
Fast. The palettes have always been there for the taking, but they've moved on from B&W, colour, 16mm, and 35mm into HD. Ever since my graduation film, I have never feared new technologies. I've always found them interesting to play with. Cinematography today is exciting, as we have far superior and a

far more diverse range of image capture systems than ever. But this does make it harder, more complex for cinematographers. It's a head-screw. If you can get your head around them, new technologies give you an incredible trump card into assisting as a responsible image maker, in trying to keep cinema alive, and to extend the possibilities of what the visual language is all about. It's entertainment. It's an art form. It's our job, first and foremost, to push audiences. I am fascinated by technology and feel we should be allowed and encouraged to use new technologies—so long as you can argue the logic behind using them. It's about honesty, being open-hearted, open-minded. We get employed because of our standards, expertise and knowledge, and our love for the job. But there's a small percentage of something else that you bring, your potential variation in the cocktail, that will make the production different and why they choose one from another. I feel I must not get lazy, complacent, nor go on autopilot. I have to keep reviving the child in me that asks, "How could I do this better, or how could I do this differently?"

Filmography

Kaj's Fodselsdag (1990, Lone Scherfig)
Die Terroristen! (1992, Philip Gröning)
Words (1994, Jens Loftager)
The Beast Within (1995, Carsten Rudolf)
Operation Cobra (1995, Lasse Spang Olsen)
Kun en Pige (1995, Peter Schroder)
Black Veil (1996, Arjanne Laan)
De Storste Helte (1996, Thomas Vinterberg)
Det Store Flip (1997, Neils Grabol)
Fredens Port (1997, Thomas Stenderup)
Agnus Dei (1997, Caecilia Holbek Trier)
Eye of the Eagle (1997, Peter Flinth)
Transformer—A Portrait of Lars von Trier (1997, Stig Bjorkman and Fredrick Von Krusenstjerna)
Festen (1998, Thomas Vinterberg, uncredited)
Mifune's Last Song (1999, Soren Kragh-Jacobsen, uncredited)
Bornholms Stemme (1999, Lotte Svendsen)
Julien Donkey-Boy (1999, Harmony Korine, uncredited)
En Verdensomsejling under Bordet (1999, Maria Wolbom)
The Man with the Tuba (2000, Anders Gustafsson)
D-dag (2000, Soren Kragh-Jacobsen, Kristian Levring, Thomas Vinterberg, and Lars von Trier)
Strumpet (2001, TV Movie, Danny Boyle)
Vacuuming Completely Nude in Paradise (2001, TV Movie, Danny Boyle)

28 Days Later (2002, Danny Boyle)
It's All about Love (2003, Thomas Vinterberg)
Dogville (2003, Lars von Trier)
Krig (2003, Jens Loftager)
Small Avalanches (2003, Birgitte Staermose)
The Pact (2003, Heich Maria Faisst)
Millions (2004, Danny Boyle)
Lost Generation (2004, Charlotte Sachs Bostrup)
Dear Wendy (2005, Thomas Vinterberg)
Manderlay (2005, Lars von Trier)
Brothers of the Head (2005, Keith Fulton and Louis Pepe)
Sophie (2006, Birgitte Staermose)
The Last King of Scotland (2006, Kevin Macdonald)
Istedgade (2006, Birgitte Staermose)
Just Like Home (2007, Lone Scherfig)
A Man Comes Home (2007, Thomas Vinterberg)
Trip to Asia: The Quest for Harmony (2008, Thomas Grube)
Country Wedding (2008, Valdis Oskarsdottir)
Slumdog Millionaire (2008, Danny Boyle and Loveleen Tandan)
Imagine (2008, TV Series, Geoff Wonfor)
Wallander (2008, TV Series, Philip Martin)
Antichrist (2009, Lars von Trier)
Paradis (2009, Jens Loftager, Erlend E Mo, and Sami Saif)
127 Hours (2010, Danny Boyle)
The Eagle (2011, Kevin Macdonald)
Dredd (2011, Postproduction, Pete Travis)

CHAPTER 18

Sir Sydney Samuelson, CBE
(1925–)

Sydney Wylie Samuelson was born on December 7, 1925, in London. He is the son of film pioneer, producer, and writer George Berthold Samuelson [1889–1947], who was the creator of both Worton Hall and Southall Studios in West London. Worton Hall, Isleworth, housed one of the earliest film production companies in the United Kingdom.

Sydney Samuelson first worked as a rewind boy at the Luxor Cinema in Lancing, England. He went on to become a trainee assistant for Gaumont British News in the cutting rooms at Lime Grove Studios (now demolished) in West London. After serving in the RAF during World War II, he joined the colonial film unit as a trainee camera assistant and eventually went on to become the U.K. government's first British film commissioner in 1991. In 1954 he set up Samuelson's, hiring out film equipment. This was first done from his spare bedroom in Finchley, North London. This grew into a company that was known by the film industry worldwide.

Sir Sydney Samuelson, CBE, though retired, is still very much involved with the film industry.

Did you do any projection work in the RAF?
The first thing I did when I was posted to a new RAF station was to find who was in charge of the camp cinema and ask if they needed an experienced projectionist. I would get to do the projection work for two or three nights a week, which gave me extra money. We had about three changes of programme a week, and they were in huts but proper little cinemas. I think the nicest, most charming aspect of watching a movie in a camp cinema, as compared to projecting in it, is, if you were sitting in the audience, you got this wonderful feedback. If someone on the screen asked a provocative question, the answer, often rude,

always witty, came from somewhere within the audience before the actor on screen got a chance to answer.

In Britain at that time, there was rationing. I remember showing a Dr. Kildare picture, which had Kildare's mother giving him four eggs for breakfast. This scene had everyone roaring with laughter because at that time civilians only got one egg a week.

When did you join the colonial film unit?
I joined it in 1947. This is how it came about. I was job hunting and going to have lunch with my brother, David, who worked as a Movietone News cameraman. Before I got to Movietone, I passed the colonial film unit headquarters in Soho Square. I had no idea what it was or what they did, but I went in to see if I could get a job.

I was extremely lucky for two reasons. One was that the doyen producer there was an eminent old gentleman called George Pearson [1875–1973], who was quite famous in the silent days. He saw me, and it turned out that he had directed films for my father. He said, "I don't think we have got anything at the moment. Hal Morey is our chief cameraman. I know he is in. Would you like to see him?" I did, and Morey said, "Have you any experience of cameras?" I said, "Yes, I've got a little bit." He asked me if I knew what a Newman Sinclair was. I said, "I do." My brother was using one at Movietone. Here is where the luck came into it again. Morey said, "Can you load a Newman Sinclair magazine?" I said, "Oh yes, I could do that all right." He said, "I'm just going to lunch. When I come back, you can show me what you can do." The luck was he was just going to lunch. I went round to Movietone and said to my brother, "Will you show me how to load a Newman Sinclair magazine?" and he did. When I went back to Morey, I loaded the magazine, and he gave me a job as a trainee assistant cameraman.

Did you hire sound equipment as well as camera gear?
We hadn't got into sound equipment at that time. It was cameras and later ancillaries. Our first base was a half shop in Hendon, London. I considered that to be pretty risky, it was the first time we had an overhead. Before that I was the one that serviced the cameras, and my wife did the paperwork. When we moved to the shop in 1959, I took on a member of staff because my wife could no longer do the invoices because she was bringing up our children.

We started to increase the number and different kinds of lenses and cameras. Also, we had dollies and tracks. Eventually we got into sound recording equipment. There was a British firm, Leavers Rich, who made a magnetic recorder that could be synchronised with the film camera. It was called "Synchro pulse." Later, we had the Nagra tape recorder, which was a revolution because it was

so good and so small. Before magnetic recording, sound was recorded optically. The sound was recorded on 35mm, and a three-ton truck was needed to house the equipment and its stack of batteries. There was a sound crew of four, which consisted of the sound recordist, the boom man, the sound camera operator, and a sound maintenance man. In those days there were four people on camera and four on sound. When the Nagra came along there wasn't much to do for two of the sound crew. However, for a while the union insisted that four people were still needed. This left two of them on a salary with nothing to do.

What I found interesting was that when I first started going to Hollywood because of our representation of Panavision, which started in 1964, the sound people didn't rate the Nagra. For some years afterwards, they were still using recordings on 35mm, not optical, but magnetic. They were still using the big truck and all those people. They were very late in adopting the Nagra as a sound system.

Did you deal with the industry in the States?
The big American companies didn't know we existed until Panavision was getting on its feet in a fairly big way in Los Angeles. Their anamorphic system was similar to Cinemascope but better, less distortion on close-ups. They took over the leading role of widescreen anamorphic photography from Cinemascope. The preferred system became Panavision. Panavision only operated from America and had no representation anywhere else at that time.

Some pretty big movies were being shot in the U.K. Some productions wanted to rent Panavision, but they would have to bring it in from the States and send it back afterwards. I remember the very first film we were associated with before we officially became representatives of Panavision; it was one of the Bond films, *Thunderball* (1965). The company, Eon, brought in the Panavision equipment from Los Angeles. They were shooting in Weymouth, England, and found that some of the equipment wouldn't fit together. It was this that made Panavision make up their mind that they needed representation where the filming was going on, not over five thousand miles away. Very soon after that I went over to Panavision, and we did a deal. From then on we stocked a range of their equipment. It was very complex because although we didn't buy the lenses, we held them for Panavision.

Did you stock any 65mm equipment?
We did supply 65mm productions. One of them was Stanley Kubrick's *2001* (1968). We brought in equipment from Panavision in Los Angeles. We supplied it and sent it back afterwards. There wasn't enough demand in the U.K. to have equipment of huge value sitting on the shelves waiting for the next 65mm job. The last 65mm film we supplied was *Ryan's Daughter* (1970).

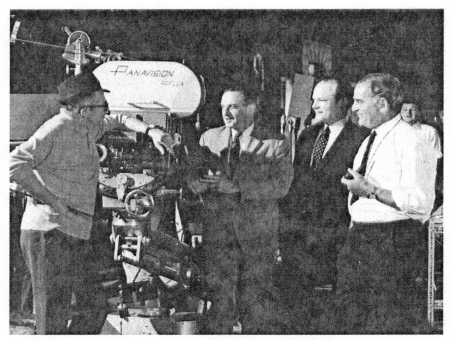

(Left to right) Billy Wilder, I. A. I. Diamond, Sydney Samuelson, and Christopher Challis on the set of *The Private Life of Sherlock Holmes* (1970). *Courtesy of Christopher Challis*

In 1991 you became the first British film commissioner. How did this post come about?

Well, there had been moves by the industry to get government support for the idea of an organisation to promote the British film production sector. The prime minister at the time, Margaret Thatcher [1925–], was keen, and they decided to make the money available, not a great deal, 1.3 million per year for an organisation to promote, particularly abroad, the British production sector—in other words to track, say, what Steven Spielberg was planning. If it was a film that was going to need a European location, the British film commissioner, for example, would determine to see Spielberg and say, "You're doing a picture called *Saving Private Ryan* (1998). You are going to need to reproduce D Day on a beach in Europe. Let us show you the many suitable beaches in the U.K. As you well know, we have got a structure that can't be matched in any other European country, and furthermore we speak the same language as all the key Americans you will bring with you." That was really the plan.

I was just about to retire from the Samuelson Group because I was sixty-five. The Thatcher government had said to the Department of Trade and Industry,

"Find somebody to set up what would be called the British Screen Commission." The then-minister for Trade and Industry was Lord Hesketh. He put his staff on to finding the right person. Eventually, I got a call to go to his office to talk to him. At that time I didn't really know why. He explained to me that Margaret Thatcher had told him that she would see that the money was provided, but he had to find the right person because there hadn't been a U.K. film commissioner or commission before.

Hesketh said, "I understand you are about to retire. You know your way around the British film industry, and your name keeps coming up." I considered it to be the greatest ego massage I had ever had. Originally they wanted it to be called the British Screen Commission. I said, "That won't do it. It's got to be the British Film Commission because everybody, especially in America, knows what a film commission is for. It is to help filmmakers and to attract filmmakers to any given place." So it became the British Film Commission. I remained in the post for six years.

When were you knighted?
I was knighted in 1995. The citation was services to the British Film Commission. I was knighted by Prince Charles, which my wife and I were very pleased about because we know him a bit, in so much as we sometimes met him at our little studio in Cricklewood when he was going to introduce some charity film or whatever and we would shoot it for him. Also, when I was president of the Cinema and Television Benevolent Fund, he would often come with the queen or his grandmother, the queen mother, to the Royal Film Performance. I would meet the royal party when they arrived at the Odeon Leicester Square and talk to them throughout the evening. After I had been knighted, Prince Charles invited my wife and I for lunch at St. James's Palace. I was very pleased that he was the one that tapped my shoulders with his sword.

Filmography

The Changing Face of Europe (1951, Documentary)
The Secret of the Forest (1956, Darcy Conyers)

Paul Wilson

(1925–)

Paul Wilson was born on March 15, 1925, and joined the film industry in 1943 at Lime Grove studios in Shepherds Bush, London. At eighteen he volunteered for the navy and became a photographer on the aircraft carrier *Glory*. After leaving the navy he returned to the Lime Grove studios, which were later taken over by the BBC. He says he photographed some of the Japanese surrender. Wilson became a camera operator in the late 1950s. He moved around a lot, shooting on main and second units. He says he carefully made a note of everything he worked on. Not everything he was involved with is listed on the web. He has worked on more than one hundred films. Asked how he fitted vacations in he said you sometimes stayed in the location and invited your family over—you could never book a vacation because you never knew when the next job would come up. Wilson finished his long career in special effects before computer-generated images came about.

What got you interested in working in the film business?
My grandfather was a photographer, and he got me interested in film. During the war my father was a film and theatre critic for the *Star* newspaper based in London. He wasn't particularly a filmgoer, though I was. One day he asked me during school holidays if I'd like to go and look around Ealing Studios. I must have been around fourteen at the time. I took one look and thought, "This is where I want to work." Later, I got a job at Gainsborough Pictures, which were at Lime Grove, Shepherds Bush, London, England. The studios were eventually run by the BBC. They sold the studios, and housing is now on the site.

I joined the studio in 1943, and the first film I worked on there was *The Man in Grey* (1943) as a clapper boy. Later that year I went into the navy, and when I came out, I was promoted to an assistant cameraman. Around 1947 Lime

Grove closed as a film studio. Later, I became an operator and also did some DP [director of photography] and special effects work. I have worked on 120 films.

How did you get into special effects work?
It was down to director/producer Dick Lester [1932–] how I came to get the job in special effects. I was shooting a commercial with him in Switzerland, and he got a phone call asking him to become a producer on *Superman* (1980). Lester introduced me to the supervisor of special effects, Derek Meddings [1931–1995]. We formed a partnership that lasted for several years.

Would you tell me about working on the Beatles films?
I went to work on *A Hard Day's Night* (1964) because several cameras and cameramen were required to shoot it. Director of photography was Gilbert Taylor [1914–], and the main camera operator was Derek Browne [1927–2010]. We used at least two cameras but quite often three. Some of the film was shot in the Scala Theatre in London's Charlotte Street, where five cameras were in use. Other cameramen included Jack Atcheler [1923–2000], sometimes credited as Jack Atchelor, and Austin Dempster [1921–1975]. Derek Browne was the only one credited.

Were there several cameras used on *Help!* (1965)?
Yes, there were. There was a mixture of Arris and Mitchells.

Who else worked with you on the picture?
David Watkin [1925–2008] was the DP. Freddie Cooper [1928–1997] was a focus puller who also did some operating. The film overran, and I had to leave to go onto something else, so Freddie took over the operating, and John Palmer became his focus puller.

How long did it take to shoot it, and where were the locations?
It took around twelve weeks. We had about three weeks in Austria, followed by four in the Bahamas. The rest was in the studio at Twickenham and locations around London.

What were the Beatles like?
They were full of fun, but they couldn't do the same thing twice. Dick Lester decided to use several cameras to help this breach of etiquette.

What hours did you work on *Help!*?
They were pretty reasonable. They were 8:30 to 6 p.m., five days a week.

Paul Wilson, Paul McCartney, and camera assistant Frank Elliot on the set of *Help!* (1965). *Courtesy of Paul Wilson*

Were there any difficulties on *A Hard Day's Night?*

A lot of shots on *A Hard Day's Night* were handheld, using Arriflex cameras. There were shots involving television sets, and to keep in sync with the television picture, we shot those scenes at twenty-five frames per second instead of the normal twenty-four. A lot of handheld shots were done on train sequences that were shot at weekends. As real carriages were used, it was sometimes difficult to get the shots.

What was it like working on *Where Eagles Dare* (1968), and where were the locations?

It was shot in Austria. We had a huge second unit on that as well. We started shooting just after Christmas and continued until July. Back in England we shot a lot of material at MGM Studios, now gone. The cable car scenes were shot in Austria and at MGM.

What were Richard Burton [1925–1984] and Clint Eastwood [1930–] like to work with?

They were fine. Burton could be a bit awkward sometimes, but as far as the camera crew went, he was good. I know he was awkward at times with the production people. I remember Burton making a remark that always stays with me. We were shooting quite late doing front projection work, which took a long time to set up. There was a close-up of Burton, with front projection shots of a bridge in the background. We put a couple of boxes on the floor for him to stand on, and the shot required him to tape up a roll of explosives. He missed his step and knocked his shin. He stormed off the set and said, "All this for a measly million dollars."

What was Margaret Rutherford [1892–1972] like on the Miss Marple film *Murder at the Gallop* (1963)?

She was a lovely lady. She always remembered your name. The film was made at MGM in black and white. It took around eight weeks to shoot. I remember we started on that film just after Christmas, and it started to snow. When we shot locations, we had to remove the snow, as it wasn't supposed to be snowing. The location work was shot in Amersham. Arthur Ibbetson [1922–1997] was the DP, who I'd worked with on several pictures.

What was it like working with Judy Garland [1922–1969] on *I Could Go on Singing* (1962)?

It was quite a difficult film to shoot. The moment Judy Garland was doing her songs, she was fine. It was when she was to do acting she became difficult. We never knew what she was gong to do; it was like shooting a newsreel. At the end of the film, the director, Ronald Neame [1911–2010], gave me a tankard inscribed "For stamina." When we were shooting, we just had to be ready for her. Sometimes she would move sideways when it should have been forward.

We were on location in Folkstone, and one evening Ronnie Neame, Arthur Ibbetson, and myself had dinner with her. After dinner we asked if she minded if we smoked. She said, "As long as they are not cigars." Her early recollections when she first started as a young girl were all the executives standing around puffing on cigars while they told her what she was going to do the next week, not just filming but also her private life.

Would you tell me a bit about *Anne of the Thousand Days* (1969)?
It took around four months to shoot. It was filmed at Shepperton and various locations. Richard Burton was also in that. We didn't have any problems with him at all on that film, probably because the hours weren't so long.

What got you into special effects work?
I'd been involved on *Moby Dick* (1956). On that we had tremendous amount of model work with the whale. We were over a year on it, and I thought at that time, "There has got to be a better way of doing this." Years later, I worked with Richard Lester a lot on commercials and a couple of films. He got the job as the producer on the first *Superman* (1978).

Did it take a long time to set up special effects?
The setting up sometimes took a long time, not so much the shooting. Sometimes it took a whole day.

I see that you were on *Chariots of Fire* (1981) as the second unit director/ cameraman?
Yes, I shot a lot of the running sequences, some in slow motion, which were shot at 120 frames per second.

You worked with Charles Chaplin [1889–1977] on *Countess from Hong Kong* (1967). What was he like?
It was an experience. He was very old fashioned. In the wedding scene, I suggested that we tracked into the cake. Chaplin said, "I don't want any of that Hitchcock stuff in my picture." He was getting on in years when he made that film. Occasionally he would demonstrate to someone what he wanted him or her to do, and the old Charles Chaplin could be seen. There would be a flash of his early years.

What was Hitchcock [1899–1980] like to work with on *Frenzy* (1972)?
Hitchcock was also getting on in years when he directed *Frenzy*, but he was still an interesting man to work with. He knew what the camera was seeing all the time. He would say, "What lens have you got on Paul?" I would say, for example, "A 35mm," and he would know what it was covering. He said, "You have to keep them on the edge of their seats." It was great working with people who knew what they were doing. With some directors you would stand on the set and realise that if you didn't say something and say where to put the camera, the director wouldn't know. In England, not so much now, you had the operator working in close coordination with the director. In America the DP would do everything and tell the operator what to do. Here we worked very closely

with the director, getting the setups and choosing the angles while the DP got on with the lighting.

What was it like working on *The Railway Children* (1970), and what was the director Lionel Jeffries [1926–2010] like?
It was good. I admired Jefferies because it was his idea to make the film. He left it to us where we put the camera, and he was good with the actors. The film took around twelve weeks. We were six weeks in the studio and six weeks on location. We used the Keighley and Worth Valley Railway in West Yorkshire. It was the first time they had a film company there, and they were falling over themselves to be helpful. Train enthusiasts loved it because the old railway was being used and they were being paid for it.

Which was your most difficult as an operator and in special effects?
As an operator I think it was *Where Eagles Dare*. On special effects it was *Superman*.

When did you retire, and what was your last film?
I retired at seventy-seven on the film *Die Another Day* (2002).

Filmography

The Man in Grey (1943, Leslie Arliss)
Time Flies (1944, Walter Forde)
Love Story (1944, Leslie Arliss)
Miranda (1948, Ken Annakin)
Broken Journey (1948, Ken Annakin and Michael C. Chorlton)
A Boy, a Girl and a Bike (1949, Ralph Smart)
The Huggetts Abroad (1949, Ken Annakin)
The Sound Barrier (1952, David Lean)
Single-Handed (1953, Roy Boulting)
Front Page Story (1954, Gordon Parry)
Father Brown (1954, Robert Hamer)
The Sleeping Tiger (1954, Joseph Losey)
Seagull over Sorrento (1954, John Boulting and Roy Boulting)
The Golden Link (1954, Charles Saunders)
The Black Tent (1956, Brian Desmond Hurst)
Moby Dick (1956, John Huston)
The Baby and the Battleship (1956, Jay Lewis)
Dry Rot (1956, Maurice Elvey)
Saint Joan (1957, Otto Preminger)
Sea Wife (1957, Bob McNaught)

Action of the Tiger (1957, Terence Young)
Next to No Time (1958, Henry Cornelius)
The Horse's Mouth (1958, Ronald Neame)
The Angry Hills (1959, Robert Aldrich)
The Boy and the Bridge (1959, Kevin McClory)
Virgin Island (1959, Pat Jackson)
Solomon and Sheba (1959, King Vidor)
Holiday in Spain (1960, Jack Cardiff)
Never Let Go (1960, John Guillermin)
Hallmark Hall of Fame (1960, TV Series, David Greene and Clive Donner)
The Canadians (1961, Burt Kennedy)
A Story of David (1961, Bob McNaught)
The Inspector (1962, Philip Dunne)
I Could Go on Singing (1963, Ronald Neame)
Nine Hours to Rama (1963, Mark Robson)
Murder at the Gallop (1963, George Pollock)
The Wild Affair (1963, John Krish)
The Chalk Garden (1964, Ronald Neame)
A Hard Day's Night (1964, Richard Lester)
Fanatic (1965, Silvio Narizzano)
Help! (1965, Richard Lester)
Sky West and Crooked (1966, John Mills)
A Funny Thing Happened on the Way to the Forum (1966, Richard Lester)
A Countess from Hong Kong (1967, Charles Chaplin)
The Mikado (1967, Stuart Burge)
The Dirty Dozen (1967, Robert Aldrich)
Petulia (1968, Richard Lester)
Where Eagles Dare (1968, Brian G. Hutton)
The Bed Sitting Room (1969, Richard Lester)
The Looking Glass War (1969, Frank Pierson)
Anne of the Thousand Days (1969, Charles Jarrot)
The Railway Children (1970, Lionel Jeffries)
The Last Valley (1971, James Clavell)
Willy Wonka and the Chocolate Factory (1971, Mel Stuart)
Mary, Queen of Scots (1971, Charles Jarrot)
Frenzy (1972, Alfred Hitchcock)
The Three Musketeers (1973, Richard Lester)
Billy Two Hats (1974, Ted Kotcheff)
Juggernaut (1974, Richard Lester)
The Four Musketeers (1974, Richard Lester)
The Little Prince (1974, Stanley Donen)
Brief Encounter (1974, Alan Bridges)
Royal Flash (1975, Richard Lester)
Robin and Marian (1976, Richard Lester)
Joseph Andrews (1977, Tony Richardson)
History of the World: Part I (1981, Mel Brooks)

Special Effects Filmography

Superman (1978, model photography, Richard Donner)

Moonraker (1979, visual effects cameraman, Lewis Gilbert)

Superman II (1980, director of photography: miniature unit, Richard Lester and Richard Donner, uncredited)

For Your Eyes Only (1981, visual effects photographer, John Glen)

The Dark Crystal (1982, director of photography: miniature effects unit, Jim Henson and Frank Oz)

Superman III (1983, additional model photography—uncredited, Richard Lester)

Krull (1983, visual effects photography, Peter Yates)

Supergirl (1984, visual effects photography, Jeannot Szwarc)

Santa Clause (1985, visual effects photography, Jeannot Szwarc)

Spies Like Us (1985, visual effects photography, John Landis)

Labyrinth (1986, cameraman: model unit—uncredited, Jim Henson)

Little Shop of Horrors (1986, cameraman: model unit Frank Oz)

The Princess Bride (1987, model photographer: model photography unit Rob Reiner)

Batman (1989, visual effects photographer: visual effects unit, Tim Burton)

The Witches (1980, director of photography: model unit, Nicolas Roeg)

The Neverending Story II: The Next Chapter (1990, director of photography: visual effects unit, George Miller)

Hudson Hawk (1991, director of photography: The Magic Camera Company, Michael Lehmann)

Cape Fear (1991, director of photography: The Magic Camera Company, Martin Scorsese)

GoldenEye (1995, visual effects photographer, Martin Campbell)

Cold Lazarus (1996, TV Miniseries, model cameraman—one episode, Rennie Rye)

Tomorrow Never Dies (1997, miniature photographer, Roger Spottiswoode)

Die Another Day (2002, photographer: model unit, Lee Tamahori)

CHAPTER 20

Derek Browne

(1927–2010)

Derek Browne was born September 5, 1927, in Kenton, Harrow, Middlesex. He started in the film industry at fourteen and went on to work with a great number of directors and DPs. He worked on six films as a DP. His wife, Isobel, is writing his life story, a record to pass on to family. She says he was working on *A Farewell to Arms* when his first child was born and did not see the baby for six weeks. Sadly, Derek, who had not been well for some time, passed away on December 16, 2010.

What was it like working with the Beatles on *A Hard Day's Night* (1964)?
It was very hard work. It was one of those films that required several cameras. We used the American Mitchell and handheld Arriflex.

You were the main camera operator. Who was your focus puller?
My focus puller was Roy Ford.

Were the Beatles friendly?
They were marvellous. They realised they were the hottest thing since sliced bread. They liked us, we liked them, and we all had a lot of laughs. It was so different from ordinary filmmaking. It was great working with Gilbert Taylor [1914–] because he was such a good cameraman and he just let you get on with it.

Where did you start in the film business?
I started in the business at the age of fourteen at Denham Studios. A lot of people were in the armed services, and they were short of camera people. I pestered them for a job and eventually became a clapper boy. The first film I worked on was *On Approval* (1944).

Derek Browne. *Courtesy of Derek Browne*

Were you interested in cinema as a child?
I loved the cinema and would go to our local cinemas in Hayes and Southall in West London.

How long were you a clapper boy for?
I was a clapper boy until 1945 and then became a focus puller. I then went into the army. When I came out, I was back in the film business after a couple of weeks.

Do you have a favourite film you have worked on?
I think *A Hard Day's Night* has to rate pretty highly. *Room at the Top* (1959) with Freddie Francis [1917–2007] was another.

What would you say was your most difficult film?
That's a difficult one. Probably it was *Fiddler on the Roof* (1971) with Oswald Morris [1915–]. I wasn't down to operate on it, but I did operate on some sequences. They were so difficult. To make something of them, you really had to think about it, such as where are you going to put the camera and what are you going to make the camera do. I only did about twenty minutes of the film, but it was a huge challenge. I got on very well with Ossie Morris. I worked with

him on a film called *Heaven Knows, Mr. Allison* (1957). One of my daughters was named after the film, and Ossie mentions this in his book *Huston, We Have a Problem* [Scarecrow Press, 2006].

Which of your films took the longest to shoot?
I think the longest was *A Farewell to Arms* (1957), starring Rock Hudson [1925–1985]. That took around seven months. We started in the Dolomites and finished at Cinecitta in Rome.

Is there anything that stands out about *A Hard Day's Night*?
My lasting memory of that film is the noise of the crowd.

Did you have a favourite place to work?
It was the Caribbean. There were some wonderful locations.

Which was your most difficult film?
Probably the most difficult and challenging was *Bear Island* (1979), shot in Alaska. What made it difficult was the cold. We worked a short day because daylight was from around 9:30 until 3:30 in the afternoon. We had to work very fast. Don Sharp [1922–], the director, was very good. He did his homework and would sit down with us and the actors and discuss the film in detail.

Filmography

The Demi-Paradise (1943, Anthony Asquith)
On Approval (1944, Clive Brooke)
A Canterbury Tale (1944, Michael Powell and Emeric Pressburger)
They Knew Mr. Knight (1946, Norman Walker)
Boys in Brown (1949, Montgomery Tully)
The Man Who Never Was (1956, Ronald Neame)
A Hill in Korea (1956, Julian Amyes)
Heaven Knows, Mr. Allison (1957, John Huston)
A Farewell to Arms (1957, Charles Vidor and John Huston)
Room at the Top (1959, Jack Clayton)
Peeping Tom (1960, Michael Powell)
The Queen's Guards (1961, Michael Powell)
Mystery Submarine (1963, C. M. Pennington-Richards)
A Hard Day's Night (1964, Richard Lester)
The Bedford Incident (1965, James B. Harris)
Stop the World: I Want to Get Off (1966, Philip Saville)
Accident (1967, Joseph Losey)

Beach Red (1967, Cornel Wilde)
Work Is a 4-Letter Word (1968, Peter Hall)
A Midsummer Night's Dream (1968, Peter Hall)
Three into Two Won't Go (1969, Peter Hall)
Perfect Friday (1970, Peter Hall)
Carry On Henry (1971, Gerald Thomas)
Zeppelin (1971, Etienne Perier)
Shirley's World (1971, TV Series, Ralph Levy and Ray Austin)
For the Love of Ada (1972, Ronnie Baxter)
A Warm December (1973, Sidney Poitier)
The Last of Sheila (1973, Herbert Ross)
From beyond the Grave (1974, Kevin Connor)
The Beast Must Die (1974, Paul Annett)
QB VII (1974, TV Miniseries, Tony Gries)
The Land That Time Forgot (1975, Kevin Connor)
Trial by Combat (1976, Kevin Connor)
At the Earth's Core (1976, Kevin Connor)
High Velocity (1976, Remi Kramer)
The People That Time Forgot (1977, Kevin Conner)
Welcome to Blood City (1977, Peter Sasdy)
The Amsterdam Kill (1977, Robert Clouse)
Warlords of Atlantis (1978, Kevin Connor)
Damien: Omen II (1978, Don Taylor and Mike Hodges)
Escape to Athena (1979, George P. Cosmatos)
Arabian Adventure (1979, Kevin Connor)
Bear Island (1979, Don Sharp)
The Great Muppet Caper (1981, Jim Henson)
Trail of the Pink Panther (1982, Blake Edwards)
The Dark Crystal (1982, Jim Henson and Frank Oz)
Curse of the Pink Panther (1983, Blake Edwards)
Hold the Dream (1986, TV Movie, Don Sharp)
Six Bandits (1986, Don Sharp)
An African Dream (1987, John Smallcombe)
Jane and the Lost City (1987, Terry Marcel)
Consuming Passions (1988, Giles Foster)
Act of Will (1989, TV Series, Don Sharp)
Indiana Jones and the Last Crusade (1989, Steven Spielberg)
Great Expectations (1989, TV Miniseries, Kevin Connor)
Journey to the Centre of the Earth (1989, Rusty Lemorande and Albert Pyun)
Memphis Belle (1990, Michael Caton-Jones)
Hamlet (1990, Franco Zeffirelli)
Hostage (1992, Robert Young)
Just Like a Woman (1992, Christopher Monger)
Jewels (1992, TV Movie, Roger Young)

Age of Treason (1993, TV Movie, Kevin Connor)
Bopha! (1993, Morgan Freeman)
Jane Eyre (1996, Franco Zeffirelli)
The Apocalypse Watch (1997, TV Movie, Kevin Connor)

As Cinematographer

Prey (1978, Norman J. Warren)
Prisoners of the Lost Universe (1983, Terry Marcel)
The Last Days of Pompeii (1984, TV Miniseries, Peter R. Hunt)
Lady Jane (1986, Trevor Nun)
The Phoenix and the Magic Carpet (1995, Zoran Perisic)
The Apocalypse Watch (1997, TV Movie, Kevin Connor)

Index